Graniteware

Collectors' Guide
With Prices

Vernagene Vogelzang and Evelyn Welch

Front Cover (L to R): Blue barge tea kettle, "Corona" fruit design plate, Chrysolite baking pan, yellow and white teapot, gray biscuit cutter. Welch Collection.

Back Cover: Rare one-burner kerosene stove, complete with all six parts, height 13″, see "Stoves."

Front Cover Photograph: Bob Calmer
Back Cover and all other photography:
Vernagene Vogelzang

Copyright © 1981
Vernagene Vogelzang
and Evelyn Welch

Reprinted with
New Price Supplement, 1987

10 9 8 7 6 5 4 3

ISBN 0-87069-326-3

Library of Congress
Catalog Number 80-51583

Published by

Wallace-Homestead

Wallace-Homestead Book Company
201 King of Prussia Road
Radnor, Pennsylvania 19089

One of the
ABC PUBLISHING
Companies

Preface and Acknowledgments

Evelyn and I were introduced by a mutual friend who knew we had a mutual interest—antiques.

Evelyn has collected graniteware for forty-four years. She has over sixteen hundred pieces. She also has boxes filled with magazine clippings, addresses and phone numbers, old invoices, notes, letters, pamphlets, labels and anything else that's pertinent.

Besides that, she has old manufacturers' catalogs and early magazines, as well as contemporary books on kitchenware. She is a library of graniteware.

It is her expertise that determined the price guide. She was conscientious in valuing each item, careful to consider its age, its condition and its demand.

We have enjoyed blending our knowledge and talents, becoming friends and bringing this book to fruition.

We especially want to thank Marcia Breon for introducing us and Elaine Erwin for a tremendous amount of help.

Thanks to the following people who graciously loaned their graniteware to be photographed: Marcia Breon, Mary Jane Castagne, Lucy Colthar, Reginald Corrigeux, Jo Ann Costley, Elaine Erwin, Larry Erwin, Lenore Fultz, Russ Harrison, Sharlene Harrison, Bruce Johnson, Patty Marshall, Mary Martini, Marjorie Merenda, Lacey Singleton, Jere Warden, Jo Ann Warden, Debra Welch, Sally Wheaton and Eileen Wilson.

The prices shown under the photographs in this book are those that applied in 1980. Compare them to current values listed in the section beginning on page 137. Publishing this book in 1981 brought Granite Ware to the attention of experts, collectors, and the general public and added importance and value to objects. It also increased the demand for rare or unusual pieces. Trademarks and paper labels identify manufacturers, date items, and contribute to higher prices. Advertising and Exposition items are coveted and bring premium figures. Condition is the prime factor in determining value, followed by scarcity, color, form, and geographic demand. Particular items made in old red-and-white mottled; blue-and-white; colbat blue-and-white; brown-and-white; and Chryso-lite (green-and-white with dark blue bead) command the highest prices; but many pieces were never made in those colors. Because some companies made gray ware, only, at a rate of 75,000 pieces per day more gray is available now.

A gray table setting for eight, complete with tureen, gravy boat, caster set, butter dish, teapot, sugar bowl, creamer, and spooner is a possibility if one chooses to deligently search, wheedle, and spend several thousand dollars. A metal-trimmed, gray butter dish in mint condition recently brought $430 at auction, and $350 was paid for a miniature, metal-trimmed cuspidor. Another example is a blue-and-white muffin pan that sold for $175, while its gray counterpart brought $37.50.

Photo by Madge Payne

About the Authors

Vernagene Vogelzang is a freelance writer and photographer. She has published magazine and newspaper articles. One of her recent photographs of a mosaic by Beniamino Bufano, appears on the cover of the *Journal of Housing*, Washington, D.C., March, 1981. *Graniteware: Collectors' Guide with Prices* is her first book.

Evelyn J. Welch grew up in the Gold Rush country and, at an early age, appreciated the charm and durability of graniteware long before it became a popular collectible. She remembers her mother using it. Evelyn still uses many of her kitchen pieces and displays the collection attractively in her ranch home.

For many years, she gathered facts hoping to write a definitive reference book for collectors. This book is the realization of a lifelong pursuit and she continues to search for information and items to add to her collection. She is considered an authority by dealers and collectors all over the United States.

Contents

Graniteware: What It Is

The name *graniteware,* given to all enamelware made from 1870 to 1930, was probably coined from the trade name Granite Iron Ware made by the St. Louis Stamping Company, one of the first manufacturers.

However, it's interesting to speculate how this particular name became the generic name, for the trade names of other early manufacturers were also used to refer to the new ware. It was termed *agateware* from the Lalance and Grosjean Manufacturing Company's trade name and *enameled ware* from the Bellaire Stamping Company's name.

Other names were *glazed-ware, speckleware, granite ironware,* and *granite steelware.*

It may have been named for the rock, granite. Much of the early ware did look like granite, flecked with white or marbled gray. And its qualities of strength, durability and hardness were stressed in advertisements.

In addition, it was made of some of the same minerals—quartz and feldspar—and by a similar process of heating and cooling.

Whatever its origin, the name graniteware caught on and so did the cookware. It was light in weight and easy to clean. It was coated with a glassy glaze that prevented it from being affected by fruit or vegetable acids. And it was decorative.

When it became mass produced in the 1870s, it provided many people with tools and equipment to make life easier and more pleasant.

Early Experiments and Patents

Enameling metal in the United States began before 1850, but it was far from being a new process.

The ancient Egyptians and Assyrians built the walls of their palaces with lovely lustered enameled bricks. They also made enameled jewelry, as did the Greeks and Romans.

Enameled artifacts have been found in Ireland and England. The Chinese created splendid examples of cloisonné and champlevé.

Cast iron pots were first enameled in Germany at the Königsbronn foundry in Württemberg in 1788, according to Earl Lifshey in *The Housewares Story*. Other trials and tests by Europeans followed.

Charles Stümer was experimenting in the United States before 1850. Probably others were too. A United States patent for the *Improvement in Enamels for Iron* was issued to Stümer of New York, July 25, 1848. In the text of the patent, Stümer explained that he did not claim to have invented the enameling of iron or other metals or any new way of applying the enamel. His patent was for the glaze, which he identified as compositions A and B.

Composition A contained gravel-sand, silver gilt, white clay and saltpeter. These should be mixed together, melted, poured out and cooled. This material, he instructed, should be pulverized by grinding and added to water in which gum arabic had been dissolved.

The thin coating which resulted should be painted on iron that had been cleaned by "pickling." The patent states:

"The piece of coated metal is then put in an oven heated to a very high degree, when it becomes heated or burned onto the metal, almost like the metal itself, or perhaps even harder and more tenacious than the parts of the metal itself. I cannot give the precise degree of heat or the time for remaining within the oven; but this must be learned by trying pieces and frequent examinations, when the eye will detect that it is sufficiently burned, which may be varied by many circumstances."

Composition B contained glass, gravel-sand, oxide of tin, borax, soda, saltpeter, white clay, magnesia, white chalk and oyster shells. This, too, should be pulverized, mixed with gum-water, laid on and burned in the same way.

Stümer had high hopes for his endeavor, as illustrated in his patent:

"The nature of my invention consists in providing an enamel for iron and other metals which will retain its adhesion to the metal, and particularly is it not capable of being crumbled or broken off by blows or by heat, thus possessing the quality of comparatively commingling with the surface of the metal. Thus it is far superior to any known enameling for metals, and may be modified so as to render it in all the shades of colors in full variety."

Thus Stümer was one of the people who led the way in enameling in the United States. Three other groups followed: the Niedringhaus brothers, Jacob J. Vollrath, and Charles Lalance and Florian Grosjean. They became the largest and most prestigious manufacturers of graniteware in the United States.

W. F. and F. A. Niedringhaus established the St. Louis Stamping Company in the early 1860s. The earliest marked piece included in this book is a cookbook labeled Patent Granite Iron Ware, Trademark Registered June 9, 1874, St. Louis Stamping Company.

Jacob J. Vollrath established his company in Sheboygan, Wisconsin, in 1874. His son remembered his father experimenting with a molten mass coating on a cast iron pan but Vollrath did not enamel steel until 1892. He believed that the United States steel was not good enough for enameling.

The Lalance and Grosjean Manufacturing Company was founded in 1850, in New York, and they, too, worked on perfecting their enameling skills. They introduced graniteware at the Philadelphia Centennial Exposition in 1876, and won the highest award for their Agate Iron Ware. Fairs and exhibitions were the primary means of advertising at that time.

Lalance and Grosjean entered their Blue and White mottled kitchen utensils at the Paris Exhibition in 1878, and won the Grand Gold Medal, and again in 1884, they won a Grand Gold Medal in New Orleans.

Despite the prizes, the *New York Times,* March 1890, wrote, "Domestic enameled ironware is not very durable." Foreign ware, they believed, was more attractive and would last three times as long due to its steel base. Several American pieces in this book, however, date back to May 30, 1876, and they are in remarkably fine condition. Many others, signed Granite Iron Ware, May 30, 1876 and July 3, 1877, are also in excellent shape.

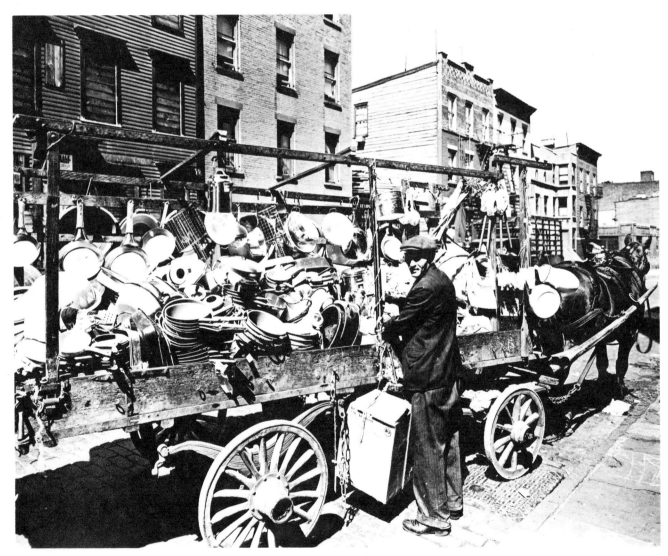

Peddler's wagon laden with graniteware and other housewares. New York City.
The Bettmann Archive

Graniteware Manufacturers, Retailers, Jobbers and Labels

Geology, geography and technology made it possible for creative men to stamp sheet steel utensils, dip them in enamel and make a profit.

Vast deposits of iron were found in the United States, and the Bessamer Converter made twenty-five tons of iron into steel in less than fifteen minutes. The Great Lakes and many rivers provided the water needed to make steel and to transport the products. Men learned skills from friends and relatives in Europe and established factories around Pittsburgh and St. Louis, the centers of steel production in the 1870s.

Many other manufacturers located in the cities north and east of St. Louis.

The following list of manufacturers is as complete as possible; however retailers and jobbers are included only when the manufacturer is unknown, as they frequently bought unmarked merchandise and marked it with their own names.

Sears, Roebuck and Company bought some of their enamelware from Lalance and Grosjean. Pictured in this book is one of their Peerless Gray Ware buckets on which the trademark L & G Agate Ware has been blotted out, but is still visible.

"Aetna" paper label.

The American Rolling Mill Company, Middletown, Ohio. "Armco" advertised in April, 1929, *Good Housekeeping Magazine* as "Porcelain Enamel on Ingot Iron."

"Arrow" paper label.

The Asception Company, New York. "Hospital Quality Enameled Ware" is white with navy trim.

Baltimore Stamping and Enameling Company, Baltimore, Maryland. "Samson" and "Oriole Ware" paper labels.

Banner Stamping Works. "Titan Enameled Ware" and "Ivorine."

Belknap Hardware and Manufacturing Company.

The Bellaire Enamel Company. "Beco Ware" label was round with long-legged bird printed on blue.

Bellaire Stamping Company, Bellaire, Ohio, established October 16, 1871. Experimented with enameling in the 1880s. 1890: Fire destroyed the company; new plant built in Harvey, Illinois, for porcelain enameling. Made "Kapner-ite" and "Columbian Enameled Steel Ware," "Columbian Enameled Ware," and enameled steel advertising signs. Adopted trademark eagle in circle, March 6, 1894. "Columbian" was adopted from the Columbian Exposition, Chicago, 1893. 1900: Fire destroyed plant. June, 1902: New factory built in Terre Haute, Indiana, named Columbian Enameling and Stamping Company. 1968: Joined General Housewares Corporation Cookware Group, P.O. Box 4066, Terre Haute, Indiana 47804.

Belmont Stamping and Enameling Company. Bell-shaped label with banner and words "High Grade Enameled Ware." Ware is ivory with green handles and trim.

Biddle Hardware Company. Their 1910 catalog advertised "El-an-ge Mottled Gray Enamel," "Onyx" which is rich brown and heavily mottled

with white, and "Turquoise," blue and white mottled on the outside, pure white inside. Also advertised in popular magazines: white, gray, and brown and white mottled enameled ware.

"Bonnie Blue," made in USA, 1923. Turquoise with white scallops and dots. Similar pieces have been found marked "Germany."

Canton Stamping and Enameling Company, Canton, Ohio. Made gray ware only.

"Cat's Eye Grey Steelware" paper label.

Central Stamping Company, Newark, New Jersey, founded 1834. 1931: Sold to Republic Metalware Company. 1944: Merged with Lisk Manufacturing Company to form Lisk Savory Corporation. Made "Agate Steelware," 1889, September 2, 1902, April 26, 1904, and November 8, 1904; "Primo Grey Enameled Ware," September 2, 1902, April 25, 1904, November 8, 1904; and "Primo Aluminum Enameled Ware," April, 1892, November 8, 1904. They also made "Sterling Gray Enameled Ware" and "Dresden Aluminum Enameled Ware" patented 1892, 1903, 1904.

"Chef-ette Enameled Ware Made in USA" paper label is red with picture of lady.

"Chrysolite" is dark green with white vein marks, white interior, edged in deep blue. It won a Silver Medal and Diploma at the Paris World's Fair in 1900.

Cleveland Metal Products Company, 7608-7632 Platt Avenue, Cleveland, Ohio. Made "Aladdin Enameled Steel." Advertised in October 18, 1919, *Saturday Evening Post*.

Cleveland Stamping and Tool Company, Cleveland, Ohio. Made "Lava" and "Volcanic Enameled Ware."

Columbian Enameling and Stamping Company, Terre Haute, Indiana. See Bellaire Stamping Company history. Made "Hoosier Gray Ware—Extra Quality," "Universal Practical Enamelware," "Onyx World's Best," and "Sanitrox Ware." Ad states that they are the "Largest exclusive manufacturers of enamelware in the World." "Onyx" came in three colors: "Onyx" regular, the brown and white mottled; "Onyx Queen," shaded green on white with white interior; "Onyx" white. They featured exclusive "Onyx" utensils designed by domestic science authorities. An ad in the June, 1924, *Good Housekeeping Magazine* offered an eighteen-piece starter set of "Sanitrox" for $15 post prepaid. Their trademark is the letter "C" encircling "E&S Co."

Coonley Manufacturing Company, Cicero, Illinois. Made blue and white enamel.

C. S. & E. Company, Canton, Ohio. This must be the Canton Stamping and Enameling Company but we have no proof. Made "French Gray Steelware, Patent June 14, 1904." Pieces were given with purchase of Voigt's Crescent Milling Company products.

Dover Stamping and Manufacturing Company, 385 Putnam Avenue, Cambridge, Massachusetts. Advertised complete line of enamel wares and specialties. Made gray mottled ware, blue and white, white and "all fancy colors."

Enterprise Enamel Company, Bellaire, Ohio. Made "Corona Enamel Ware," in blue and other colors and a floral and fruit design. Made of heavy enameled steel, not to be confused with the contemporary lightweight ware. Also "Daisy White."

Federal Enameling and Stamping Company, Pittsburgh, Pennsylvania. Used "Iron City" and "Federal Enameling and Stamping Company" labels.

Fletcher Quality Porcelain Enamel, Charlestown, West Virginia.

Geuder, Paeschke and Frey Company, Milwaukee, Wisconsin, founded in 1880. Were manufacturers and jobbers. Made "Cream City Gray Ware," named for the dairy industry. 1911: Began making porcelain enamelware. 1957: Discontinued consumer division to concentrate on industrial and commercial products. This company was one of the most

important manufacturers of kitchenwares in the United States.

"Gray Goose" paper label.

Grunden-Martin Manufacturing Company, St. Louis, Missouri. Makers of "Parrot Ware." Old label has six parrots; later labels, one. Trademark is a circle enclosing the capital letter "G" superimposed on the capital letter "M."

Haberman Manufacturing Company, New York. One of six to merge and form the National Enameling and Stamping Company in 1899.

Haller Manufacturing Company, New Orleans, Louisiana. One of six to merge and form the National Enameling and Stamping Company in 1899.

"Hardwick" name embossed on ashtray.

Hibbard, Spencer and Bartlett and Company, State Street Bridge, Chicago, Illinois. Jobbers who sold "H.S.B.Co.-Revonoc," "Chrysolite," "Royal Enameled Ware," "Nesco," and "White Enameled Ware," made in Germany. Also made "Nu Blu" and "Iris."

"Ideal" embossed on enamelware.

Iron Clad Manufacturing Company, Cliff Street, New York, N.Y., and Cicero, Illinois. Made "Ironclad, Patent July 10, 1888," and "Salamander Ware" in 1893. "Salamander Ware" had an additional bottom made of copper attached so that an air chamber was formed, permitting a free circulation of air. This prevented burning or scorching or injury to the vessel. Also made "Hearthstone." They claimed to be the largest and oldest manufacturer of enameled ware.

Jones Metal Products Company, West Lafayette, Ohio. Paper label states "Hospital and Surgical Ware."

Keen and Hagerty Manufacturing Company, Race, Ostend, Clements and Creek Streets, Baltimore, Maryland. Made "Gray Flint Enameled Ware." Merged with five others to form NESCO in 1899.

"Keystone Enamel Ware, American Process" red paper label in diamond shape.

Kieckhefer Brothers, Milwaukee, Wisconsin. Merged with five other companies to form NESCO in 1899.

Lalance and Grosjean Manufacturing Company, Woodhaven, New York, established 1850. "L & G" became the largest and one of most skilled manufacturers in the country for metal stampings. Founders: Florian Grosjean and Charles Lalance, made equipment for the government for four wars. Made "Agate Iron Ware," "Crystal Steel Ware, Patent June 5, 1883," "Blue and White Enameled Ware," "Blue and Blue Enameled Ware," "White Enameled Ware," "Agate Nickel-Steel Ware, Patent 1897," "Flint Grey Enameled Ware," "Enamel Cooking and Sanitary Wares," "El-an-ge," "Pearl Agate Ware," "Regal Steel Ware," and they also made Sears, Roebuck and Company's "Peerless Grey Ware." Their trademarks are burned in the enamel. In 1901 "L & G" began using the Blue Label in addition to others.

"Leader, Pure Enameled Ware USA" paper label.

Lisk Manufacturing Company, Clifton Springs, New York, founded in 1889. Located in Canandaigua, New York, according to their 1923 catalog. 1944: Merged with Republic Metalware Company to become the Lisk Savory Corporation. Famous for the Lisk Self-Basting Roaster. Colors: robin's-egg blue, turquoise, cadet blue, cobalt blue, white, brown, gray and dark green.

Lisk Savory Corporation formed in 1944, with the merger of the Lisk Manufacturing Company and the Republic Metalware Company. 1956: Purchased the U. S. Stamping Company.

Manning-Bowman and Company, Cromwell, Connecticut, established in 1859, by Thaddeus Manning and Robert Bowman. Was founded by Thomas Manning and Son in 1849. One of the oldest firms in the housewares business. 1872: Refinanced by the Meriden Britannia Company and moved to Meriden. Concentrated on porcelain enamelware

embellished by metal bands and handles. Trademark reads "Patent Perfection Granite Iron Ware Girdles the Globe." Also made "Decorated Pearl Agateware," and "Seamless Ivory Enameled Ware with Planished Copper Rim." August, 1945, sold to Bersted Manufacturing Company, Chicago. This company was purchased by McGraw-Edison in 1948. Name survives as Manning-Bowman Division of the McGraw-Edison Company of Booneville, Missouri.

Marietta Hollow-Ware and Enameling Company, Marietta, Pennsylvania.

Matthai-Ingram Company, Baltimore, Maryland. Merged with five other companies to form NESCO in 1899. Made "Greystone Enameled Ware."

Montgomery Ward and Company. Retail distributor for a large variety of colors, quality and sets.

Moore Enameling and Manufacturing Company, West Lafayette, Ohio. Made "La Fayette Quality Ware."

National Enameling and Stamping Company (NESCO), formed in 1899 with the merger of the St. Louis Stamping Company, the Haberman Manufacturing Company, Haller Manufacturing Company, Keen and Hagerty, Kieckhefer Brothers, and Matthai-Ingram 1955: Sold to Knapp-Monarch Company of St. Louis, which sold to the Hoover Company in 1969. 1979: Hoover sold Nesco and Knapp-Monarch trade names to Crown Industries, Binghampton, New York. Made "Nesco Royal Granite Enameled Ware," "Royal Granite Steelware," "Pure Greystone Enameled Ware," and "Diamond Enameled Steelware." First Nesco label was paper on which was printed a gray kettle. This was the trademark of the St. Louis Stamping Company.

The New England Enameling Company, Middletown, Connecticut, and Portland, Connecticut. Made "New England Quality Ware, Made in USA." They were the exclusive agents for the German-made "Paragon Lion Brand Enameled Ware."

Nichthauser and Levy, 96 Beekman Street, New York. In 1904 they advertised kerosene oil stoves with reservoirs of seamless enameled ware which made them leak proof. This is the only indication that tabletop kerosene stoves were made in the United States.

Norvel Shapleigh, merged with Shapleigh Hardware Company in the early 1900s. Distributed "Shamrock Ware," "Blue Diamond Ware," "White Diamond Ware," "Sage," "Bluebelle Ware," "Thistle Ware," "Stewart Rozwood Enameled Ware," and one brand made by The Success Enameling and Stamping Company by the name of "Dixie Ware."

"Opal Iron Ware." "L & G" is visible under ink blot.

Pacific Hardware and Steel Company made "Blulite Enameled Ware."

Polar Ware Company, Sheboygan, Wisconsin. In 1924 made all white. In 1928, made "Polar Colored Enamel Ware" in coral red, jade green, powder blue and canary yellow.

Reed Manufacturing Company, Newark, New York. Famous for its Reed Sanitary Self-Basting Roaster embossed "Reed." Colors of turquoise, white with dark trim, white with floral pattern, white with black speckles, dark gray and brown.

Republic Metalware Company, established in 1905, formerly the Sidney Shepard and Company, of Buffalo, New York. 1931: Bought Central Stamping Company. 1944: Merged with the Lisk Manufacturing Company to form the Lisk Savory Corporation. Made "Savory," in 1909. Also made "Magnolia," "Hearthstone," "Niagara," and "Steel Gray Enamelware." Used "Handihook Pot Cover" paper label marked "Patented December 17, 18, 1912."

Republic Stamping and Enameling Company, Canton, Ohio, founded June, 1904. 1952: Sold to Ekco Products Company. Enamelware discontinued. Made "Old Hampshire Gray," "Old English Enameled Ware," "Old English Gray Ware, Purity and Quality, U. S. Patent June 1904," and "Republic Ware." Colors: white with ebony and ivory with jade

green and ivory with mandarin red.

St. Louis Stamping Company, St. Louis, established in the early 1860s by W. F. and F. A. Niedringhaus. Made "Granite Iron Ware, Patent May 30, 1876, May 8, 1877." 1899: Merged with five other companies to form NESCO.

Saks Stamping Company, Long Island City, New York. Made "Service Hospital Enamel Ware" in gray with dark trim.

Sears, Roebuck and Company, Chicago, established in 1893. Retail distributors for "True Blue Enamel Steelware," "Acme Ironstone Enamel Ware," "Eclipse Ironstone Enamel Ware," "Imperial Stove Hollow Ware," and "Peerless Grey Ware" (made by "L & G").

Shapleigh Hardware Company, St. Louis, Missouri, established 1843. Became Norvel Shapleigh in early 1900s.

Sidney Shepard, Bath, New York, 1836. Became Sidney Shepard and Company when Thadeus Crane became a partner in 1838. 1905: Changed name to Republic Metalware Company.

"Steel Gray Guaranteed Ware, Patent June 14, 1904."

Stransky and Company, 9 to 15 Murray Street, New York, N.Y. Made "Stransky Steelware."

The Strong Manufacturing Company, Sebring, Ohio. Made "Blue Blend," "Alice Blue," "Concord," "Ripe Concord Grape," "Everglade," "Emerald Ware," "Oceanic." Claimed to have originated blended enamelware. Early catalog indicates they moved from Bellaire, Ohio, as Sebring is printed over Bellaire. "Everglade," "Oceanic," "Concord," and "Emerald" were made in Bellaire.

The Success Enameling and Stamping Company, St. Louis, makers of "Dixie Ware" distributed by Norvel Shapleigh.

United States Stamping Company, Moundsville, West Virginia, founded 1901. 1956: Sold to Lisk Savory. Factory recently closed. Made "U. S. Bisque," "U. S. Ivory," and "U. S. Opal." Trademark "U.S.S." is stamped in white on dark colors. Made military supplies.

Vollrath Company, Sheboygan, Wisconsin, 1874, established by Jacob J. Vollrath. One of the early large manufacturers of enamelware, Vollrath learned "wet" enameling from a friend in Germany. He began enameling stamped sheet steel utensils in 1892. Company discontinued the manufacture of porcelain enamelware in 1962, according to Carl P. Vollrath, Vice President and Secretary, 1980, and great grandson of Jacob J. Vollrath. 1927: Began making colors to harmonize with the kitchen.

West Mansfield Enameling Company, West Mansfield, Ohio.

Foreign Manufacturers and Labels

Boas Brothers, 80 Beekman Street, New York, N.Y., and #6 Gipsstrasse, Berlin, Germany. Manufacturer of German enameled ware.

"Elite," registered in Austria. Made pale green and white.

General Steel Wares Limited, Canada. Made "Pearl Ware," "Diamond Ware," and "Crystal Ware." Two different shield-shape labels, one marked "SMP," the other, "GSW Quality."

Godin and Cie, A Guise Aisne, Bte S.G.D.G. No. 5. French.

George Haller Originals, Germany. Makers of kerosene stoves.

"Kokums," made in Sweden, white with dark blue trim.

Libertas—Prussia, Germany. Trademark has eagle's head.

McClary Manufacturing Company, London, Canada.

"Paragon," Germany. Lion brand trademark. New England Enameling Company was the exclusive agent for this ware.

The Perfection Cooking Utensils, Germany. 1892, Muncie, Indiana. Agents were Charles E. Zeigler and John H. Wilson.

"Made in Poland" label is a teakettle marked with an "S."

Swedish Enameled Ware. Trademark stamped into each piece marked "KER." White with deep blue trim, sold by Markt and Hammacher Company, New York, N.Y.

Riess Werke 3/4, Germany. Has brick color with gray interior.

How It Was Made

The Canton Stamping and Enameling Company of Canton, Ohio, advertised their Gray Ware by sending their customers postcards which pictured how it was made.

The following nine cards are from a set of ten sent to Mr. G. H. Coonrad who operated a hardware store in Rome, New York. They are postmarked June 3, 1910, through 1911.

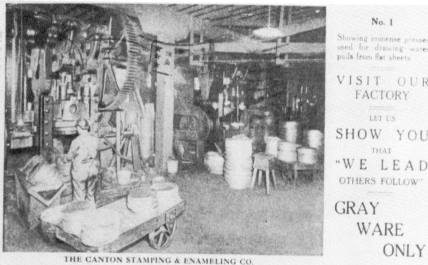

Showing immense presses used for drawing water pails from flat sheets

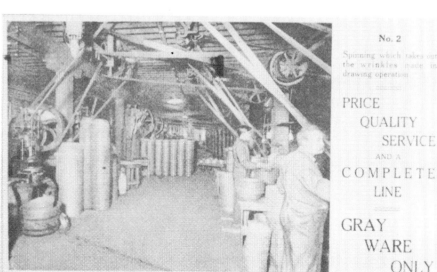

Spinning which takes out the wrinkles made in drawing operation

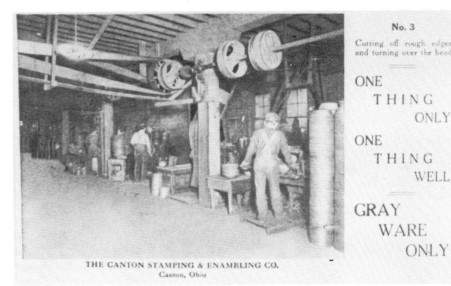

No. 3

Cutting off rough edges and turning over the bead

ONE
THING
ONLY

ONE
THING
WELL

GRAY
WARE
ONLY

THE CANTON STAMPING & ENAMELING CO.
Canton, Ohio

Cutting off rough edges and turning over the bead

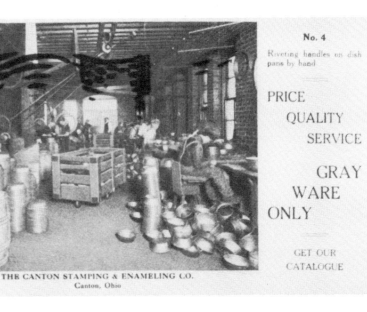

No. 4

Riveting handles on dish pans by hand

PRICE

QUALITY

SERVICE

GRAY
WARE
ONLY

GET OUR
CATALOGUE

THE CANTON STAMPING & ENAMELING CO.
Canton, Ohio

Riveting handles on dish pans by hand

No. 5

A corner in our Pieced Ware Department Double Seaming bottoms in coffee pot bodies

NO
LEAKERS
IN OUR

PIECED
WARE

GRAY
WARE
ONLY

THE CANTON STAMPING & ENAMELING CO.
Canton, Ohio

A corner in our Pieced Ware Department Double Seaming bottoms in coffee pot bodies

16

Pickling Department The black shapes are treated in various baths, entirely removing all grease scale and dirt preparatory to enameling

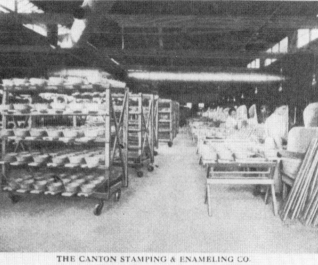

No. 6

Pickling Department The black shapes are treated in various baths, entirely removing all grease scale and dirt preparatory to enameling

PRICE?
Yes, we have it

QUALITY?
The very best

SERVICE?
Try us

GRAY WARE

THE CANTON STAMPING & ENAMELING CO.
Canton, Ohio

Dipping Room No. 1 The ware is dipped in semi-liquid enamel, placed on racks and run in dryers

No. 7

Dipping Room No. 1 The ware is dipped in semi-liquid enamel, placed on racks and run in dryers

GRAY
WARE
ONLY

THAT'S WHY
ITS
SO GOOD
AND
SO CHEAP

THE CANTON STAMPING & ENAMELING CO.
Canton, Ohio

Dipping Room No. 2 Where we handle the difficult ware; also showing our heating and lighting system

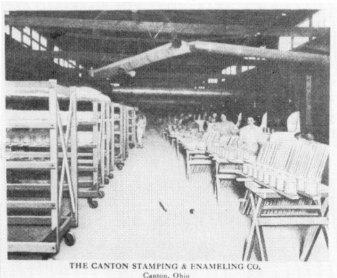

No. 8

Dipping Room No. 2 Where we handle the difficult ware; also showing our heating and lighting system

YOU CAN GIVE
LARGER PIECES
IN
GRAY WARE
FOR
SPECIAL SALES

BIG PIECES
CROWD
YOUR STORE

THE CANTON STAMPING & ENAMELING CO.
Canton, Ohio

17

*DRY ROOM Ware ready for fusing furnaces.
CAPACITY? Does this look like it? This
room is 350 ft. long and 320 ft. wide. We
operate 24 hours daily and have a daily average
capacity of 75,000 pieces in GRAY WARE
ONLY*

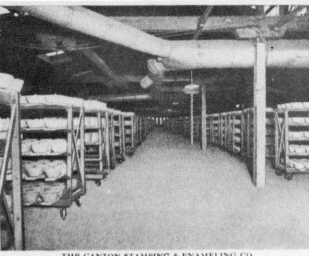

No. 10

DRY ROOM
Ware ready for fusing
furnaces

CAPACITY?

Does this look like it?
This room is 350 ft.
long and 320 ft. wide.
We operate 24 hours
daily and have a
daily average capacity
of 75,000 pieces in

GRAY
WARE
ONLY

THE CANTON STAMPING & ENAMELING CO.
Canton, Ohio

The Appeal

Henry IV once said that it was his goal to put a chicken in every pot. Apparently it was the ambition of the enamelware manufacturers to provide a pot for every task.

In one of their first magazine advertisements in 1889, Lalance and Grosjean proclaimed that Agate Iron Ware came in two thousand styles and sizes; and in 1900, they offered five thousand different kinds of Agate Nickel-Steel Ware.

The Lisk Manufacturing Company reported that over two million house-wives were using their Self-Basting Roaster in 1923.

In addition to the more common pieces, there were fudge pans, beer pots, scalloped oyster patties, cigar ash receivers and ant cups. Manufacturers devised descriptive terms for their products and catalogs pictured such items as Windsor dippers, Berlin kettles, convex saucepans, crown cover knobs and snipe-lip ladles. Special equipment was made for photographers, nurses, milkmen, bakers, cowboys, children, soldiers, gold miners, grocers and druggists.

The public was enthusiastic.

Free spoons were advertised in the *Ladies Home Journal* by the Bellaire Stamping Company and they received fifty thousand requests.

The housewife liked its looks and its weight. Iron pots were heavy and plain. Tin rusted badly but graniteware was "as smooth as glass," the ad said, and "that is why hot water is all that is needed to remove grease, dirty germs or odor of yesterday's cooking and make this ware clean and sweet even after years of constant daily use."

The housewife also liked its price. She could buy a complete set of twenty-four pieces for $4.37, through the Sears' catalog. And for eight cents each, she could buy a kitchen spoon, a soap dish, a two-quart saucepan, a wash basin, a long-handled skimmer or a nine-inch pie pan.

And she liked the colors. It came in shamrock green, hearthstone gray, magnolia white, mandarin red, thistle purple, robin's-egg blue, and turquoise pearl. It was mottled, marbled, speckled and swirled.

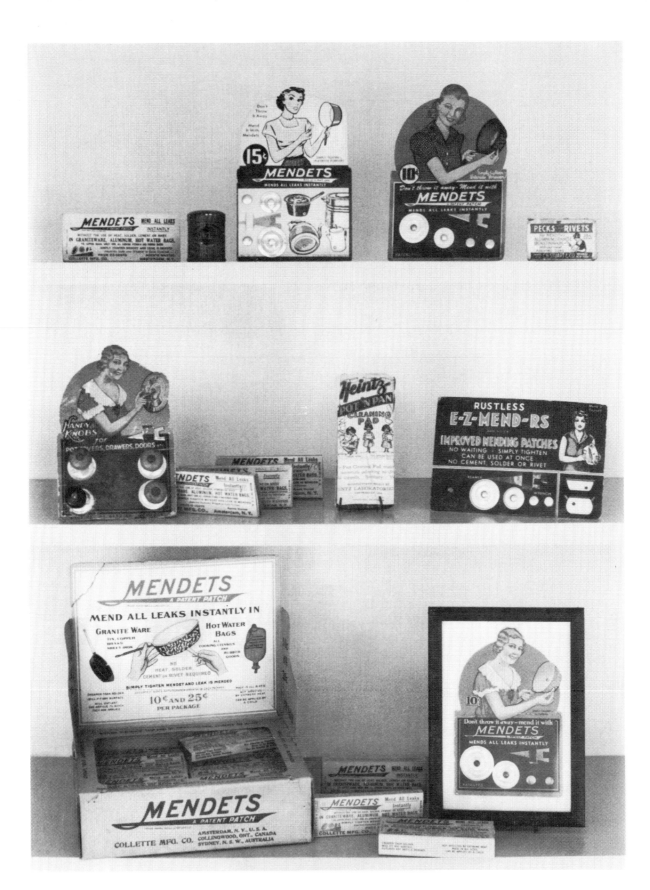

Mendets

Row 1: Box of Mendets, dated "Dec. 18, 1906," $7. Can of Pot Mend made by Pot Mend Co., New York, $6. 1920 Mendets, $7. Mendets, $7. Box of Pecks Rivets for mending pots, $5. *Row 2:* Fancy Knobs set, wooden knobs, bolts, nuts, wrench, $3. Boxes of Mendets, some dated 1906, $3-7. Heintz Pot'n Pan cleaning pad (like steel wool), $2. Rustless E-Z-MEND-RS, $4. *Row 3:* Display box of Mendets. 10¢ package, $3-5. 25¢ triple card package, $3-7. Framed Mendets card with wrench, $6.

The Problems

It soon became obvious that graniteware, literally, was not all it was cracked up to be. For crack it did! And the exposed metal rusted and deteriorated, leaving holes.

This, of course, was more likely to happen to the single coated items than the heavier double or triple coated pieces. Some graniteware was even quadruple coated. The seamless utensils, put together without rivets or solder, had fewer exposed or raised areas to wear through.

Repair kits were marketed to fill the chips and holes.

A friend remembers taking a water bucket to the creek when he was a boy. "When the bucket got a hole in it, my mother patched it with a metal disc and a screw to save the dime it cost to buy a new pail."

He was probably referring to a Mendet which was composed of a nut and a screw, a tin washer and a cork washer and a wrench. Directions on the back of the box indicate that one should push the screw and the cork washer through the leak and as the screw comes through on the opposite side, one should replace the tin washer and nut and tighten the nut with the wrench. Cards and boxes of assorted sizes sold for ten, fifteen and thirty-five cents. They could be used on graniteware, tin, copper, brass, sheet iron and even on rubber hot water bags.

Mending materials were made for over thirty years. Pecks Rivets and E-Z-MEND-RS were similar to Mendets. A product sold in a tube by The Magic Solderine Supply Company of Chicago allegedly repaired one hundred articles and thereby saved the customer ten dollars a year.

One of the authors of this book recalls stuffing a rag in the hole of a water bucket—"A very effective remedy."

People often used the repaired cookware for feeding chickens or picking berries. They were afraid that the rusty metal would contaminate the food if it were used for cooking.

How the poison scare originated is not known but it became a problem soon after graniteware was on the market.

In 1877, Lalance and Grosjean sent samples of Agate Iron Ware to chemists to determine its safety. Chemistry professors from Yale, Harvard and the Massachusetts Institute of Technology were among those who replied. Four German chemists also responded. Their letters stated that they had carefully examined Agate Iron Ware and found that it was free from lead, arsenic or any injurious or poisonous substance and perfectly safe for cooking or preserving food.

In April, 1899, about twenty cases of severe poisoning were reported by physicians from several towns near Boston. The United States Health Reports' investigation found that all of the victims had eaten cream cakes purchased from a certain baker in a town near Boston. The baker had cooked the cream in an enameled kettle and the kettle contained antimony.

The Health Reports said that they had fully explained the whole mystery but could do nothing to stop the production of articles of unscrupulous manufacturers and dealers until laws were passed to prevent their manufacture.

The Health Reports continued, "In the meantime the people must look out for themselves and carefully scrutinize before purchasing all such articles.

"Our investigations of the high grade goods called the 'L & G' Agate Nickel-Steel Ware have been very rigid, and the conclusions of our experts, as unanimously approved by our medical staff, show conclusively their superior excellence, and we are pleased to extend to them the official recognition of the U. S. Health Reports."

Lalance and Grosjean continued to advertise the purity of their products. They began using a Blue Label, showing a chemist's certificate. When other manufacturers copied them, Lalance and Grosjean cautioned that there was only one safeguard against poison. It was their trademark, Agate Nickel-Steel Ware in a band encircling L & G Mfg. Co., which appeared on every piece.

"Of the seventeen other manufacturers of Enameled Ware, an analysis made of the coating revealed in every instance either ARSENIC, LEAD, or ANTIMONY, and, in a few cases, all three of these insidious poisons." In addition, they offered to send a free booklet explaining why those poisons were not necessary in the manufacture of Agate Nickel-Steel Ware.

And the same affirmation, which was written in their 1894 catalog, was repeated in the 1922 catalog:

"It will not rust, break or solve like 'ordinary enamels,' and is absolutely pure and safe to use, as certified to by the most eminent chemists here and abroad.

"It is sold by all first-class dealers throughout the world, and gives universal satisfaction."

Lalance and Grosjean were not the only ones who fought the slander. The St. Louis Stamping Company published testimonials by chemists in 1877, and the Republic Stamping and Enameling Company stressed that the enamel on their Old English Gray Ware would safeguard one's health since there was no metal to touch the contents.

The poison scare subsided when another problem arose. It was aluminum. It began edging in and the Belknap Hardware and Manufacturing Company Catalog of 1930 contained more pages advertising aluminum ware than graniteware.

What Happened to Graniteware

The glory of graniteware lasted almost sixty years.

The outcome of the three original companies is typical of other manufacturers.

The Vollrath Company is still in business. It became a leader in kitchen colors in 1927, working with Macys, and began making stainless steel. Porcelain enameling was discontinued in 1962.

Lalance and Grosjean, the largest company, went out of business in 1955. Multiple factors contributed. They did not want to compromise their excellence by cutting costs in order to compete. They produced superior ware and their standards were so high that there were occasions when they auctioned ten thousand cases of seconds. Even their 1922 catalog is a work of art. The illustrations are drawn by artists and they are hand painted.

Stainless steel, aluminum and the foreign market were difficult competitors.

Suddenly, Grosjean's grandson, August Cordier, who had shown promising leadership, died of a heart attack. Unable to sustain these setbacks, the company closed.

The St. Louis Stamping Company became the National Enameling and Stamping Company (NESCO) in 1899, when they merged with five other companies. In 1955, Knapp-Monarch Company of Belleville, Illinois, bought Nesco, and in 1969, Hoover bought Knapp-Monarch.

The Nesco trade name is still being used on enameled roasters. Hoover sold the trade name to Crown Industries of Binghamton, New York, in 1979. The enameling is being done by General Housewares in Terre Haute, Indiana, once the Columbian Enameling and Stamping Company.

Thus, graniteware is being made and used, although its name has been changed to porcelain enamelware. American and foreign firms offer a large selection and variety of colors. Inexpensive wares may be found in the discount stores; finer ones, such as Asta, in exclusive gourmet departments.

There are good cooks who believe it is best for making sauces, and pie makers who are convinced it's superior for baking the bottom crust of their pies. And for some people, milk is colder and tastes better in a graniteware mug.

There is much discussion as to the best material for cooking utensils. The truth is that no material is best for all, and the work is most easily and satisfactorily done if different kinds are chosen for different needs.—Helen W. Atwater, Yearbook, Department of Agriculture, 1914.

Rare, old graniteware may still be found. It is worthy of collecting and preserving as an historical treasure. It is enjoyable to look at and gratifying to use.

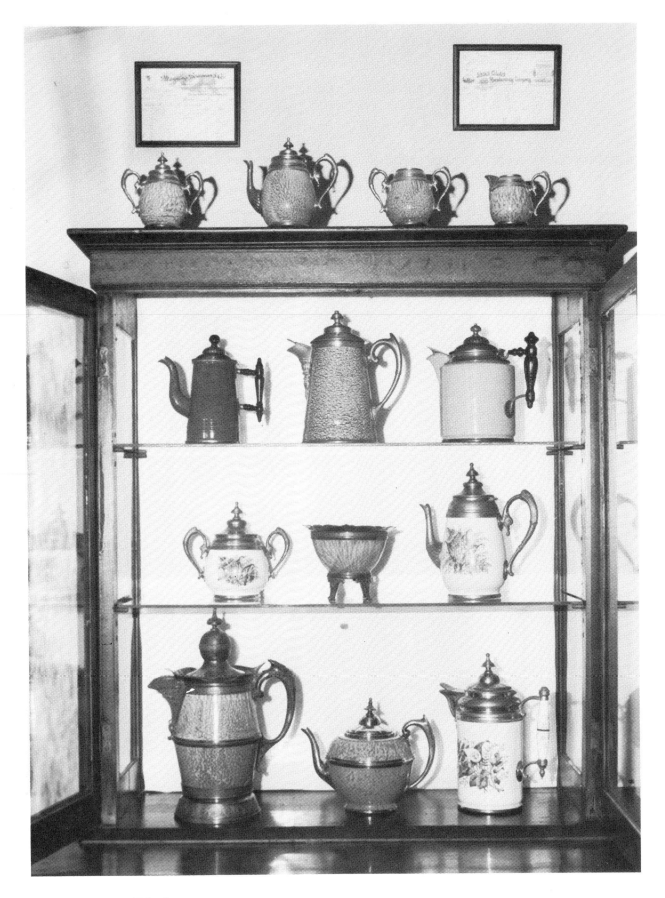

Home Display

Manning-Bowman and Company store cabinet. "Perfection Granite," "Pearl Agateware" and "Manning-Bowman & Co." painted on front. Displayed pieces signed "Manning-Bowman & Co." Framed invoice, upper left, dated December 7, 1901. In the home of Evelyn J. Welch.

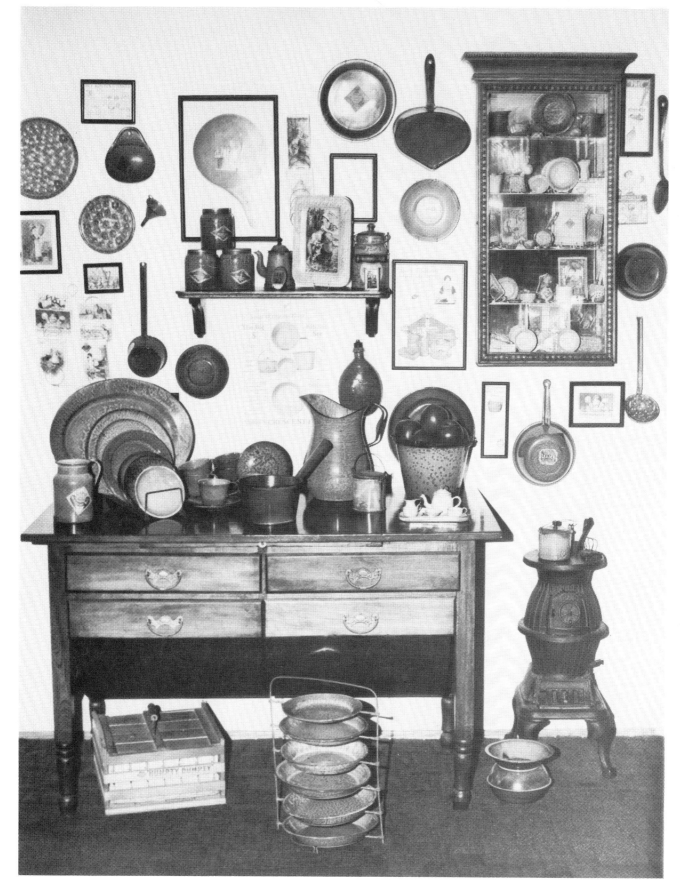

Home Display

Graniteware display in the home of Elaine and Larry Erwin. Note toys in clock case, upper right, and toy tea set on table.

Care and Repair

Burned-on deposits and difficult grease coatings can be removed by soaking graniteware overnight in a lye solution. Oven cleaning products can also be used.

A ten-minute application of naval jelly will remove rust. Salad oil will prevent further corrosion.

Graniteware may be easily maintained with hot soapy water and thorough drying. If it is to be displayed only, it may be protected with a lacquer spray.

Old cleaning methods are not only interesting to read, some are still effective. The Dutch enamelware rack, pictured in this book, has containers which held salt, sand, and soda for cleaning. A teaspoon of soda added to a pan of boiling water will remove stains, and it is said that boiling peeled potatoes will too.

A clever idea was presented in 1908 in *Household Discoveries and Mrs. Curtis's Cook Book:* "Utensils of this ware placed directly over the flame of a coal range should be protected by rubbing the bottoms thickly with soap. Any soot which burns on may then be removed by soap and water."

Illustrated Price Guide

Price Guide Notes

Pieces are gray unless otherwise indicated.

Quotation marks signify the labels or marks on the items.

Other identification indicates that the manufacturer or trade name has been determined but the articles are not marked.

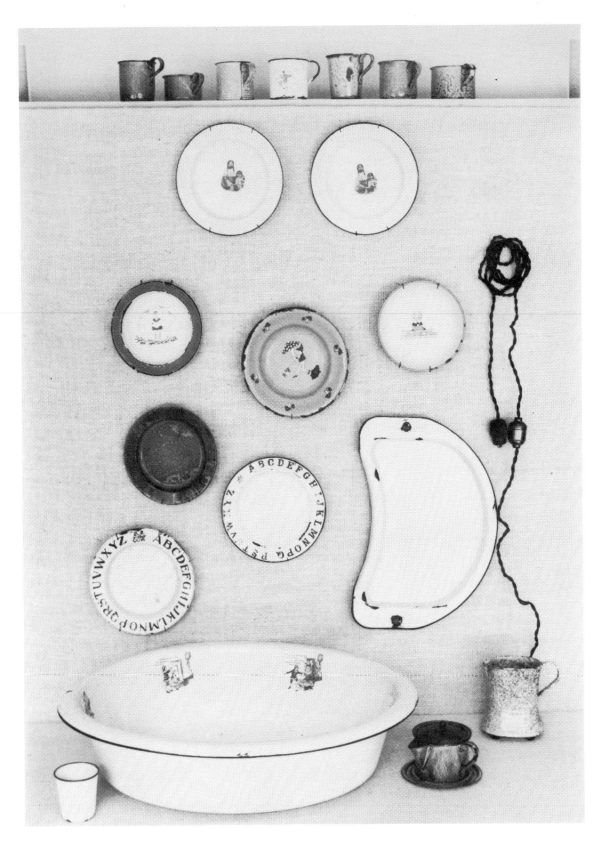

Baby Accessories

Row 1: Children's mugs, $15 each. *Row 2:* Plates, Indians pictured, $15 each. *Row 3:* Orange and white child's plate picturing child reading book, Germany, $12.50. Gray plate with elf and mushrooms, Germany, $10. Blue and white Humpty Dumpty dish, $15. *Row 4:* Black and white A B C plate, faded clock picture, signed "Made in England, OjE Co," $37.50. Plate, $8. Brown and white A B C plate, $35. High chair tray, $35. *Row 5:* White tumbler, navy trim, $8. Baby bathtub with nursery rhymes, $75. Baby food cup, tray and tin lid, $37.50. Electric bottle warmer, dated Nov. 26, 1907, $22-65.

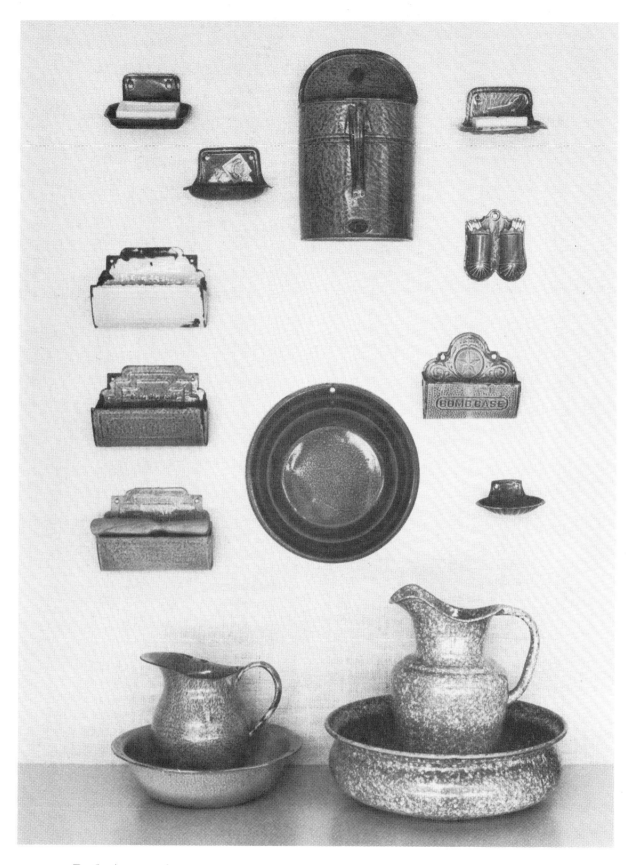

Bath Accessories

Row 1: *Soap dish, $12.50. Soap dish, signed "L & G Mfg Co," "El-an-ge" paper label also, Rare, $22.50. Flat back douche pan or irrigator, strap handle, $45. Soap dish, Mint, $12.50. Match safe, Rare, Mint, $18-100.* **Row 2:** *Three comb cases in vertical row, $10-35 each. Wash basin, $12.50. Comb case with embossed star, Nesco, $35. Soap dish, shell-shaped, Mint, $25.* **Row 3:** *Pitcher and wash basin, $35. Deluxe pitcher and bowl set, $145.*

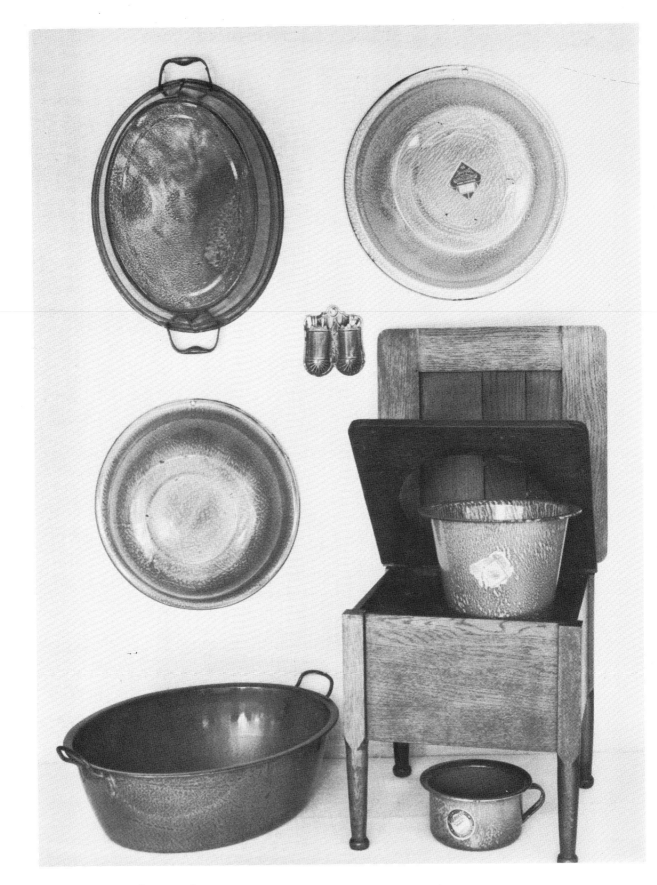

Bath Accessories

Row 1: *Foot tub, embossed "Patented Dec. 3, 1912," Mint, $25. Wash basin, labeled "French Gray,"
15"×6", $22.50.* **Row 2:** *Wash basin, $12.50. Double match safe, Rare, $18-100.* **Row 3:** *Dish-
pan, wire handles, $22.50. Oak commode chair, lift-top toilet seat, commode labeled "Nesco," $95.
Child's potty, "Lafayette" label, Mint, $15.*

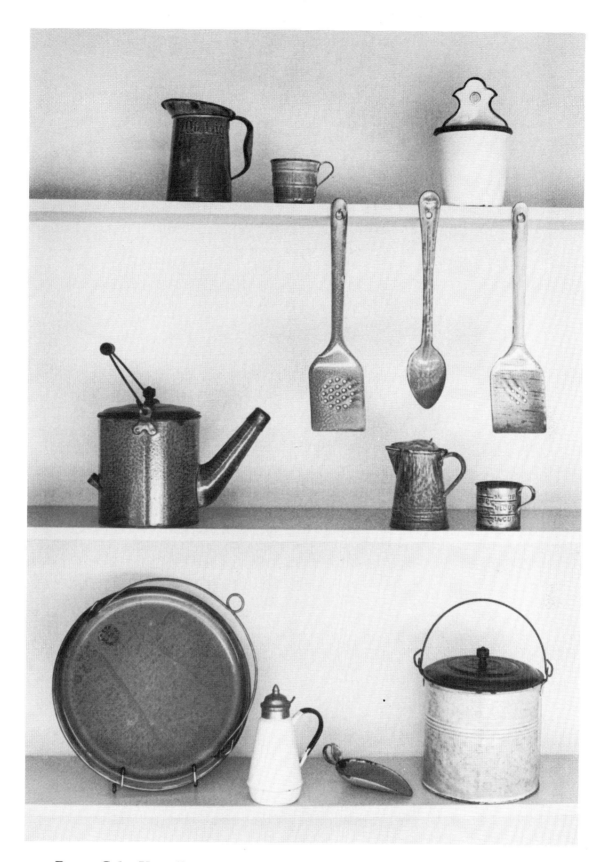

Batter Cake Utensils

Row 1: 1-quart measure, $22.50. 1-cup measure, thirds marked, $15. White covered salt box, $37.50.
Row 2: Turner, $28. Mixing spoon, Mint, $10. Turner, $28. *Row 3:* Covered batter bucket, bail and side handles, tin cap covers spout, $47.50. Syrup pitcher, $12.50. Measuring cup, thirds and quarters marked, $15. *Row 4:* 13" griddle, signed "L & G Extra Agate," Patent Climax steel bottom, $32.50. White syrup pitcher, pewter lid and spout, black handle, $35. Thumb scoop, $25. 1½-gallon covered bucket, for flour or sugar, $25.

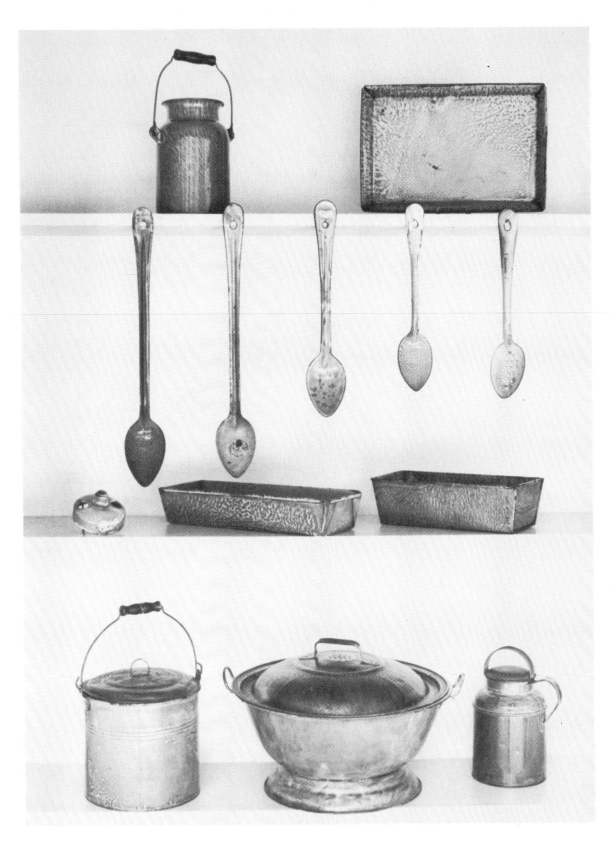

Breadmaking Utensils

Row 1: Milk can, signed "L & G," bail handle, Excellent, $28. Biscuit pan, 8"×12"×1½", $7.50.
Row 2: Four mixing spoons, from 8" to 16", $7.50-18 each. Pierced strainer spoon, $15. *Row 3:* Biscuit cutter, one piece, hollow knob and two air holes, Republic Stamping & Enameling Co., Rare, $25-55. Bread pan, one piece, crimped corners, 2"×5"×13½", $12. Bread pan, $8. *Row 4:* Bucket with tin lid, signed "Opal," used for flour canister, $27.50. 14½"-diameter bread raiser, small size, polished tin lid pierced to allow gas to escape, Excellent, $55. ¼-gallon milk container, tin lid and strap handle, $22.50.

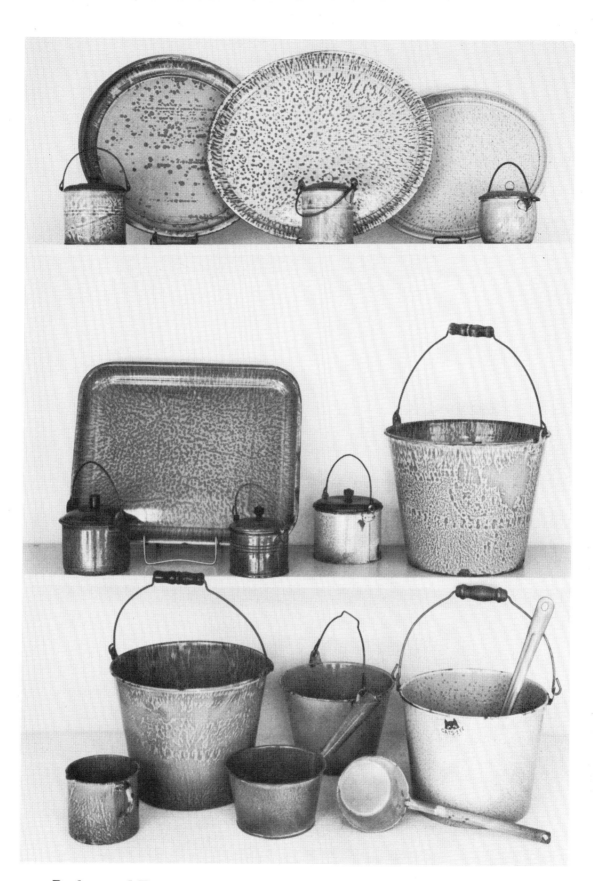

Buckets and Trays

Row 1: Covered bucket, $6-20. Tray, 13¾", $17.50. Oval tray, $15. Bucket, $6-20. Oval tray, $15. Bucket, $6-20. Row 2: Covered bucket, $6-20. Tray, $50. Bucket, $6-20. Bucket, $6-20. Enameled steel bucket, wood bail, $12.50. Row 3: Cup with pouring spout on side, $12.50. Milk bucket, wood bail, Mint, $17.50. Suds dipper, hollow handle, $15. Bucket, $10. Windsor dipper, hollow handle, $8. Bucket labeled "Cats-Eye," $17.50.

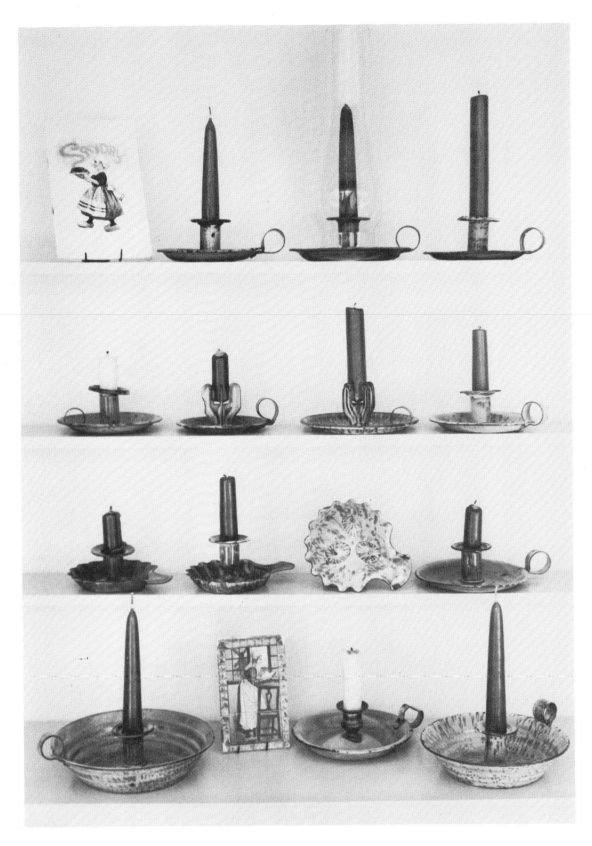

Candlesticks

Row 1: *Savory cookbook, $17.50. Candlestick, $22.50. Candlestick, brass center holder not original, $17.50. Candlestick, labeled "Nesco," $25.* **Row 2:** *Candlestick with inside finger ring, $25. "Save-all" candlestick, $35. "Save-all" candlestick, inside finger ring, $37.50. Candlestick, $25.* **Row 3:** *Candlestick, signed "Extra Agate L & G Mfg Co," Mint, $47.50. Candlestick, $45. "Agate" oyster patty, back view, barnacle feet, $30. Candlestick, $22.50.* **Row 4:** *Beehive candlestick, 2"×7¼", Mint, $65. Savory cookbook, $15. "L & G Agate" cottage candlestick, $27.50. Beehive candlestick, Mint, $45.*

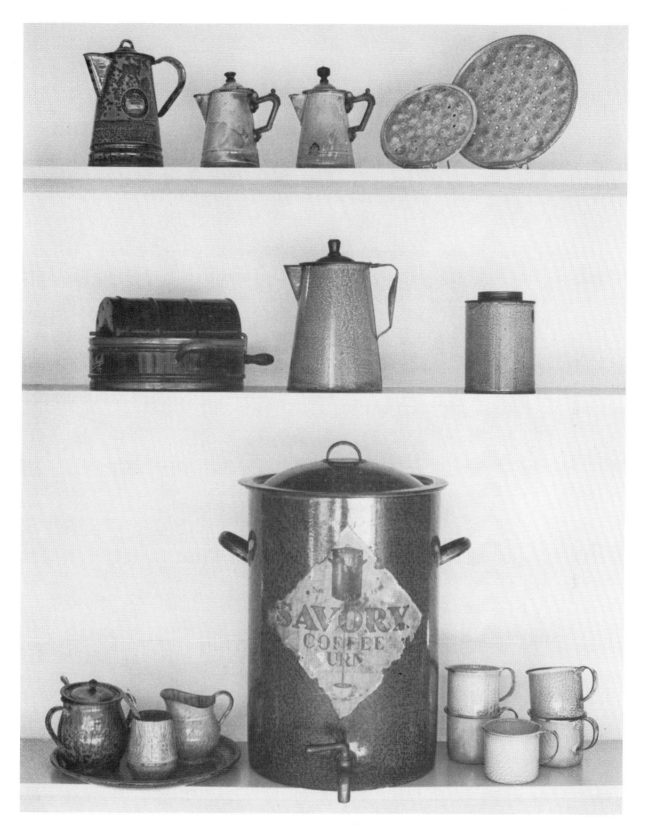

Coffeepots

Row 1: *1-quart coffeepot, "Lafayette" label, strap handle on lid, Mint, $34. 1-pint pot, iron handle, $27.50. Pot with tin lid and iron handle, $32.50. 6½" and 9½" footed pierced trivets, "Pat. Sept. 16, 1902," $10 each. **Row 2:** Stove top coffee roaster in shades of blue, printed "Kifkifkafe Modele Depose," $90. Pot with tin lid and "Crown Cool Cover Knob," $22.50. Coffee canister, 6"×4½", cork lined screw-on lid, $45. **Row 3:** 13¾" tray, sugar bowl with tin lid, spooner and creamer, $95. Savory coffee urn, cloth filter bag, Rare, Mint, $95. Coffee mugs, warehouse find, Mint, $10 each.*

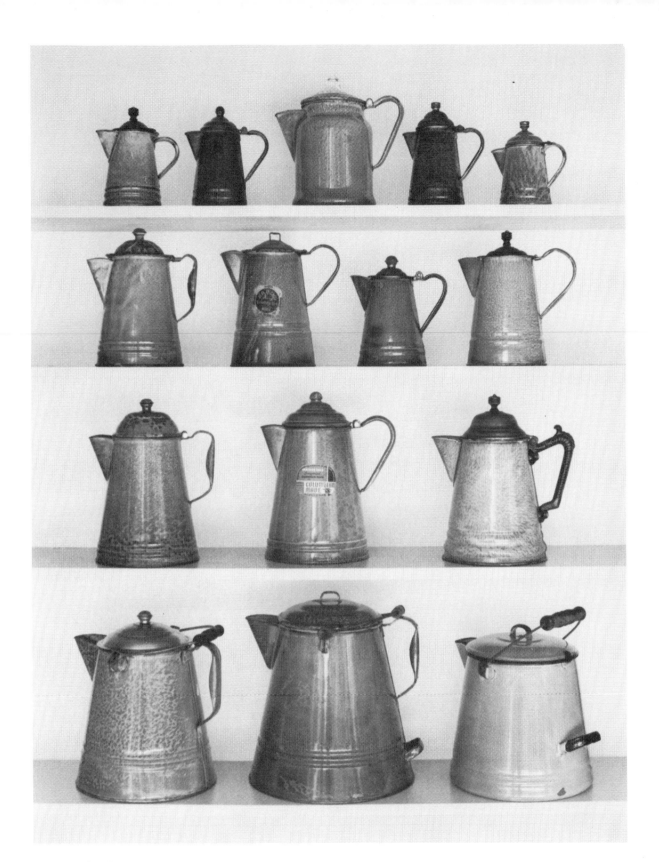

Coffeepots

Row 1: *1-pint, tin lid, "Crown Cool Cover Knob," $17.50. 1-pint, Mint, $25. Percolator, $35. 1-pint, tin lid, $25. ½-pint, smallest made for household use, $25.* *Row 2:* *Pot with fluted lid, hollow knob, $17.50. "Arrow Enameled Ware" label, strap handle on lid, $35. Tin lid, hollow knob, $20. Tin lid, "Crown Cool Cover Knob," $17.50.* *Row 3:* *Coffeepot, $25. "Hoosier Gray Columbian Made" label, Mint, $37.50. 3-quart pot with iron handle, tin lid, wood knob, marked "Patented 1889," $38.* *Row 4:* *2-gallon coffee boiler, tin lid, wood bail and hollow side handle, Mint, $35. 3-gallon pot, four handles, $37.50. Navy blue trim, wood bail, two strap handles, no side handle, $42.50.*

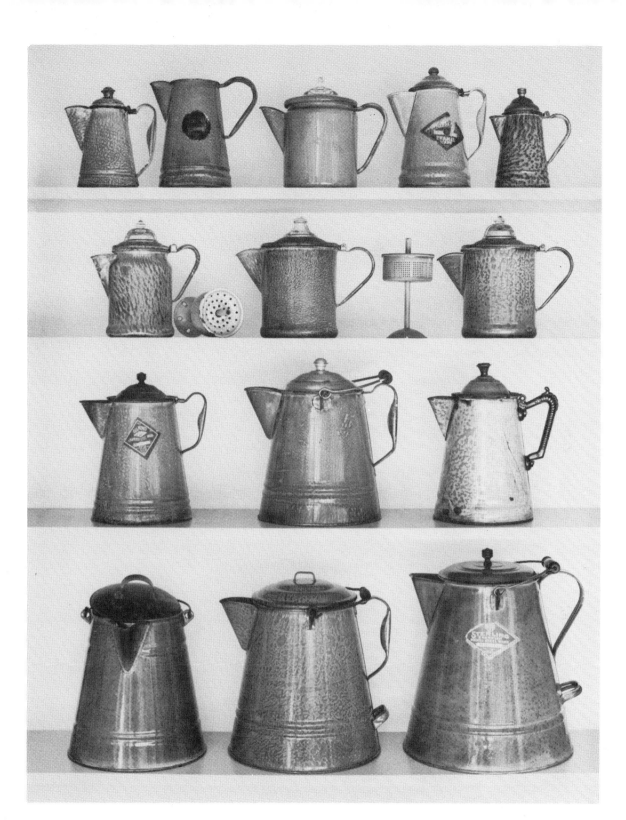

Coffeepots

Row 1: Pot with oversized spout and handle, tin lid, spun knob, $20. 6-cup pot, lid missing, "Lafayette Quality Ware" label, $18. Percolator with sharp upturned spout, $25. Coffeepot, tin lid, hollow handle, "Keystone Enamel Ware" label, Mint, $35. 2-cup pot, dome lid, spun hollow knob, $22.50. **Row 2:** Percolator, enameled basket and stand, metal safety guard securing glass lid, $22.50. Percolator, enameled basket, Mint, $27.50. Percolator, green depression glass knob, metal safety guard, $35. **Row 3:** 3-quart pot, tin lid, black wood knob, labeled "Diamond Enameled Steel Ware #45, Pat. dates Oct. 9, 1894 . . . Sept. 12, 1899," Mint, $37.50. 5-quart pot, tin lid, spun hollow knob, $25. 3-quart pot, iron handle marked "Pat. Oct. 1889," $35. **Row 4:** Coffee boiler, tin lid, soldered strap handle, applied spout, signed "L & G Mfg. Co.," Mint, $37.50. Coffee boiler, strap handle at bottom for pouring, Excellent, $32.50. Unused coffee boiler, "Sterling Enameled Nickel Steel Ware" label, $45.

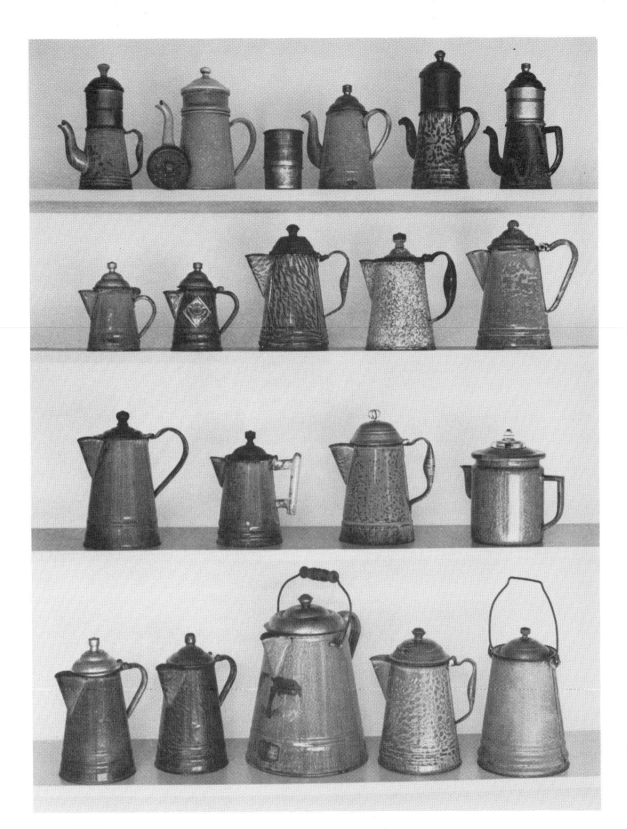

Coffeepots

Row 1: *1-cup biggin, tin dripper and cover, $37.50. 3-cup biggin, dripper cover, $35. 1-pint biggin, tin dripper, $37.50. 1-pint with tin dripper and lid, $37.50. Biggin, tin dripper and lid, $35.* ***Row 2:*** *1-cup coffeepot, signed "L & G," $27.50. Coffeepot, labeled "El-an-ge," $27.50. 1-quart tiger-striped, tin-domed lid, $17.50. Gray pot, dark handle and trim, $17.50. Hollow handle pot, Mint, $22.50.* ***Row 3:*** *Pot with tin lid, wood knob, $17.50. Pot with unusual hollow handle, tin lid, wood knob, Mint, $42.50. "Cat's Eye" pattern, tin lid, "Crown Cover Knob," $25. Percolator, enamel inset, Mint, $27.50.* ***Row 4:*** *Pot, signed "L & G," hollow handle, tin lid, spun knob, Mint, $35. Coffeepot, $22.50. Coffee boiler, labeled "Nash's Coffee Co. Minneapolis, USA, Copyrighted 1921," $45. Coffeepot, Mint, $25. Coffee carrier, wire bail, tin lid, Rare, $45.*

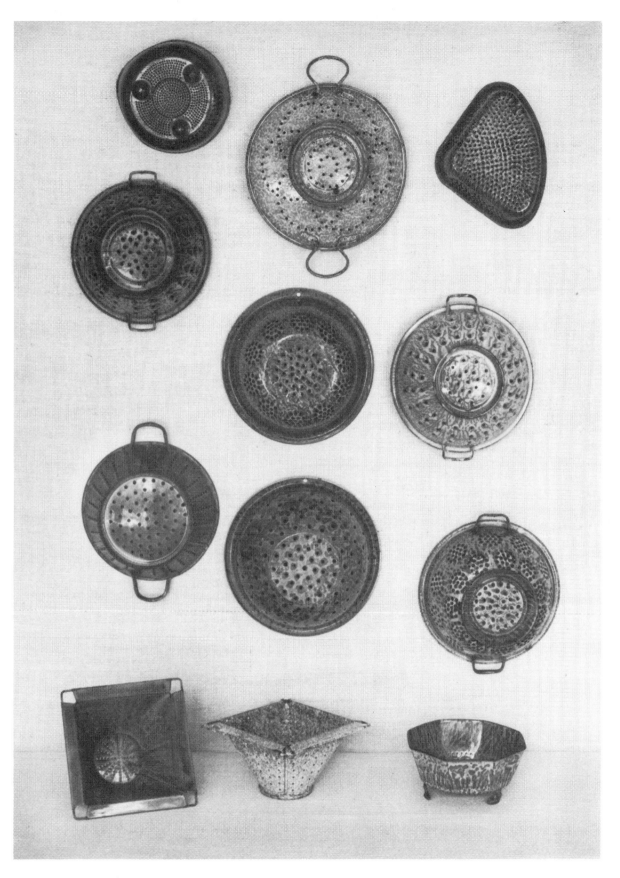

Colanders

Row 1: *Sink strainer with pouring lip, $15. Strainer, 11"×2½", $25. Sink strainer, $10.* **Row 2:** *Colander, $10. Colander, $10. Colander, $17.50.* **Row 3:** *Colander, $12.50. Bowl-shaped strainer, $15. Colander, $17.50.* **Row 4:** *Square sink strainer, top and upright views, Rare, $20-35. Colander, three legs, octagonal-shaped, $17.50.*

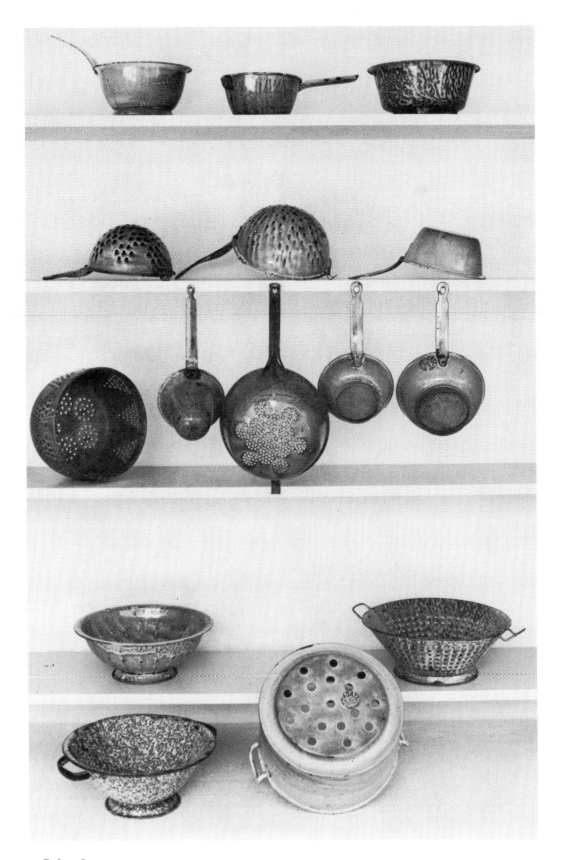

Colanders

Row 1: *Soup strainer, pierced bottom, $22.50. Soup strainer, hollow handle, $10. Three-footed sink strainer, $12.50.* *Row 2:* *Strainer, $15. Strainer, rim hook, $17.50. Strainer, pierced bottom, $10.* *Row 3:* *Strainer, bail handle, $17.50. Funnel-shaped strainer, $15. Strainer, rim hook, $22.50. Soup or gravy strainer, perforated tin, $15. Soup or gravy strainer, signed "Extra Agate," $22.50.* *Row 4:* *Colander, $12.50. Colander, $9.* *Row 5:* *Brown colander, $15. Steamer inset, signed "Extra Agate,"* *$12.50.*

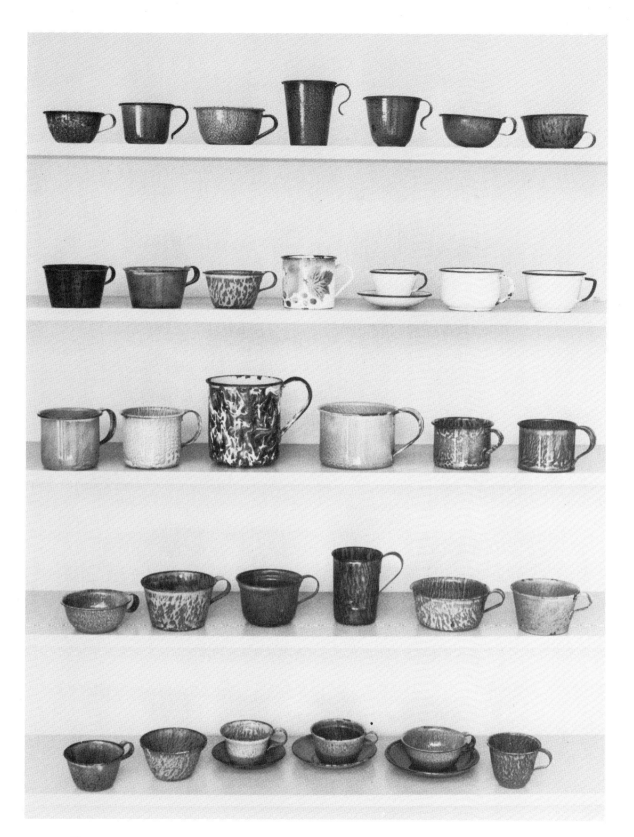

Cups

Row 1: *Teacup, $8. Cup, open handle, $6. Coffee cup, $10. Mug, $3-9. Cup, $6. Cup, $12. Cup with dropped handle, $12.50.* **Row 2:** *Two coffee cups, signed "L & G," $10 each. Teacup, $8.50. Cup from Mexico, 10 years old, $3. Demitasse and saucer, $8.50. White cups, $2 each.* **Row 3:** *Two cups, Mint, $10 each. Miner's cup, 3-pint, green and white Chrysolite, $15. 1½-pint farmer's cup, $12.50. Seamless cup, Mint, $10. "Agate" cup, strap handle, $8.* **Row 4:** *Drinking cup, $6.50. Cup, Windsor shape, $6. Cup, "L & G," $7.50. Child's mug or ice cream measure, 1-pint, $12.50. Teamster's cup, 5" diameter, $6.50. Windsor cup, $7.50.* **Row 5:** *Teacup, $6.50. Coffee cup, $4. Teacup and saucer, $8. Cup and saucer, $6.50. Cup and saucer, $8. Cup, $35, set of 6.*

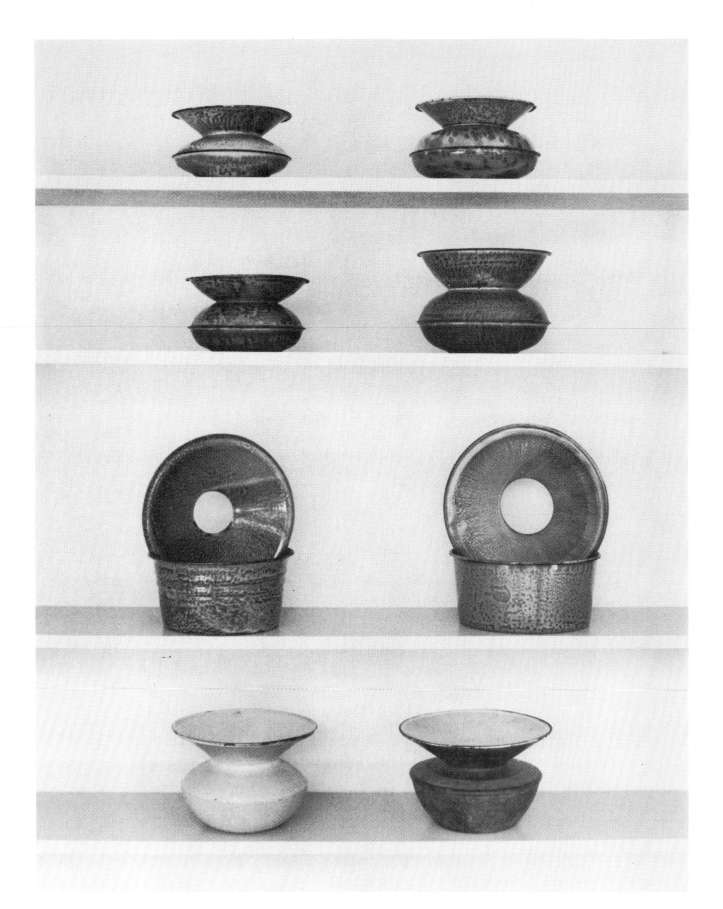

Cuspidors

Row 1: *Cuspidor, Mint, $25. Cuspidor, Mint, $25.* **Row 2:** *Cuspidor, $25. Cuspidor, $27.50.* **Row 3:** *Two-piece cuspidor, $22.50. Two-piece cuspidor, $17.50.* **Row 4:** *Enameled iron cuspidor, light gray, $18.50. Cuspidor, dark brown lined in gray, $25.*

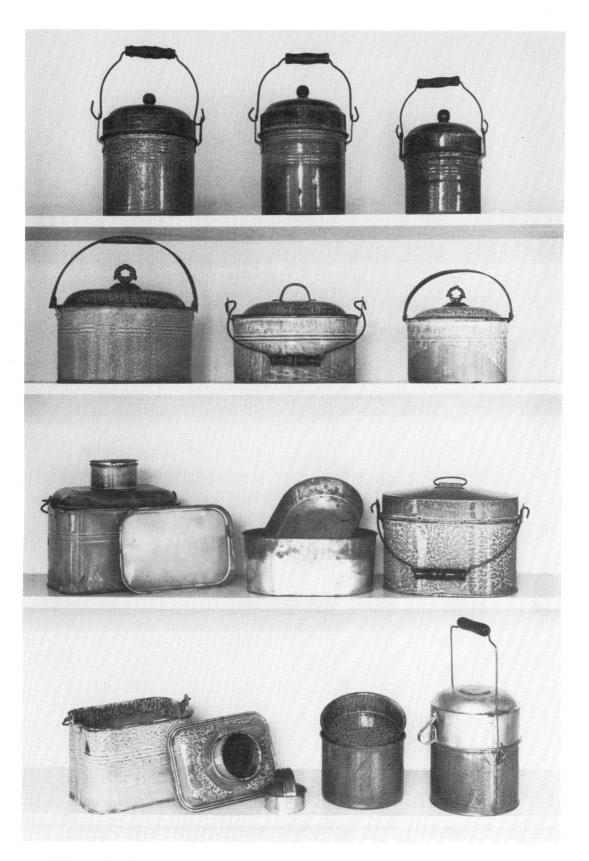

Dinner Buckets

Row 1: Dinner buckets, seamless covers, signed "L & G Mfg Co," contain dessert and beverage inserts, $35.50 each. *Row 2:* Dinner bucket or butter kettle, $37.50. Dinner bucket, $30. Bucket, signed "L & G Extra Agate," $35. *Row 3:* Dinner bucket, coffee carrier and dessert tray, $32.50. Tin compartments and bucket, Excellent, $35. *Row 4:* Dinner bucket with coffee carrier, pie tray and cup not shown, lid not original, $35. Pie tray and soup pail inserts, and miner's dinner bucket with tin cup cover, patented self-locking bail, $37.50.

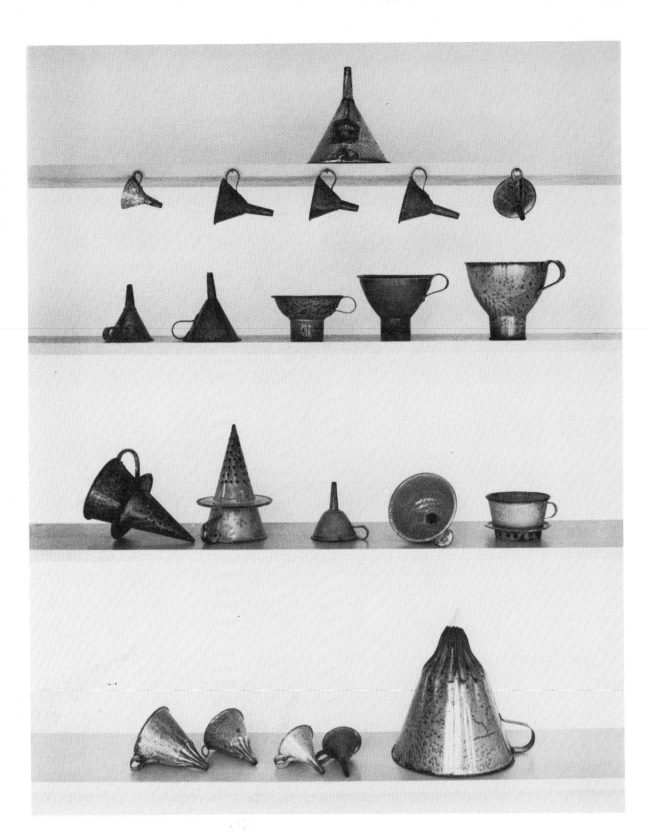

Funnels

Row 1: *"Aetna" labeled funnel, 5¾"×6½", Mint, $22.50.* **Row 2:** *Toy funnel, 2"×2½", Rare, Mint, $35. Funnel with strap handle, $12.50. M.B. etched into funnel before firing, probably by factory worker, $35. Signed "Agate Ware" funnel, $15. Funnel with pierced ear, $20.* **Row 3:** *Strap-handled funnel, Mint, $12.50. Signed "L & G," Mint, $17.50. Fruit jar funnel, Mint, $15. Fruit jar funnel, Mint, $15. Utility jar filler, Mint, $27.50.* **Row 4:** *Percolator for druggist and family use, $27.50. Percolator, signed "L & G Agate Ware," $27.50. Funnel, $12.50. Funnel with pierced ear, $20. Funnel found with original linen cone-shaped strainer (not shown), $27.50.* **Row 5:** *Elliptical funnel, $12.50. Elliptical funnel, $20.50. Elliptical funnel, $17.50. Elliptical funnel, Mint, $20. Elliptical utility funnel, $15.*

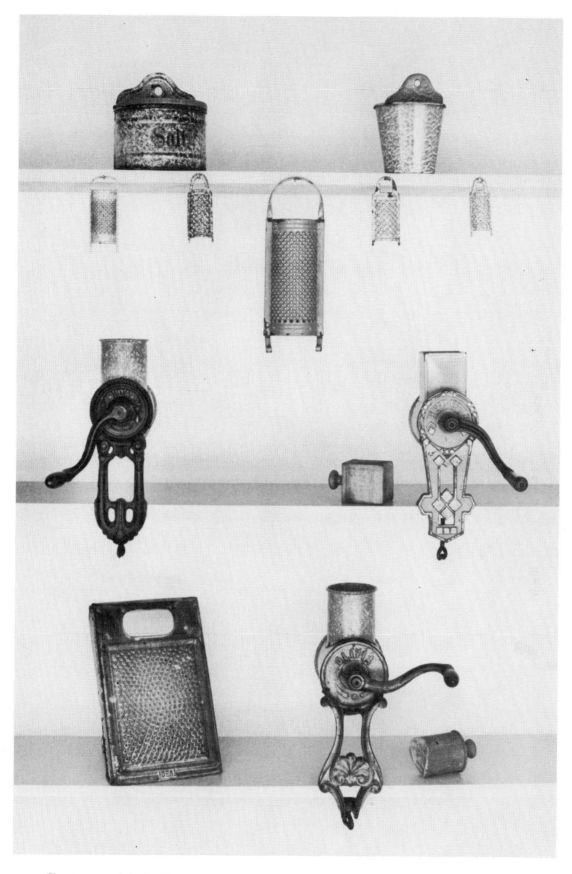

Graters and Salt Boxes

Row 1: Salt box, wood lid, $65. Salt box, lid missing, $37.50. **Row 2:** Toy grater, $10-25. Toy grater, $15-25. Blue grater, $27.50. Toy grater, $15-25. Toy grater, $25. **Row 3:** Grater, marked "Ida Original," $42.50. Grater, marked "Helvetia," blue, square food channel and wood pusher, $45. **Row 4:** "Ideal" grater, $35. "Olivia" vegetable and cheese grater, wood pusher, $45.

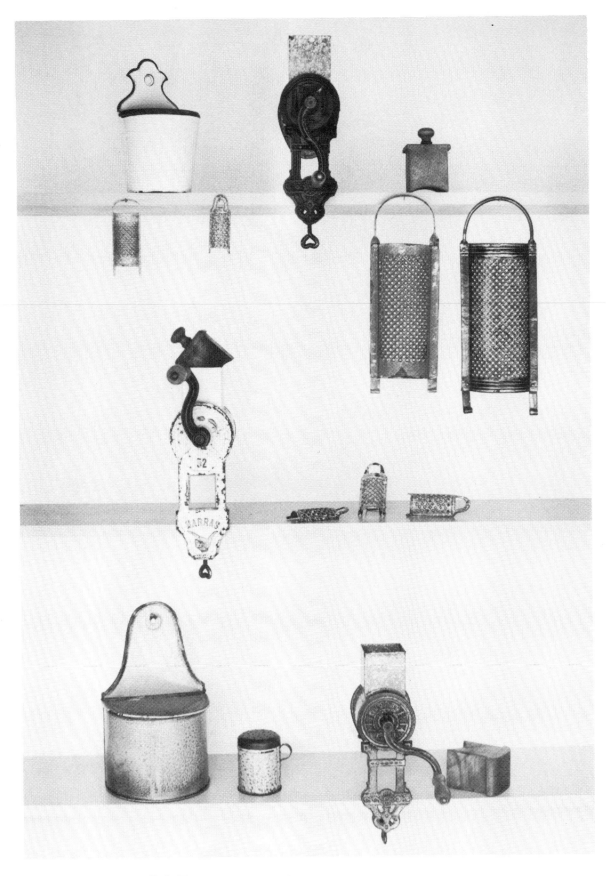

Graters and Salt Boxes

Row 1: White salt box, wood lid, signed "Germany," $37.50. Grater, signed "Noris," wood pusher, $45. Row 2: Two toy graters, $10-25 each. Two graters, $35 each. Row 3: White enamel grater, signed "Harras," $35. Three toy graters, $10-25 each. Row 4: Salt box with hang hole, $38-120. Salt box or shaker, $45-85. Rotary grater, signed "Germany, GMT Co," wood pusher, $37.50.

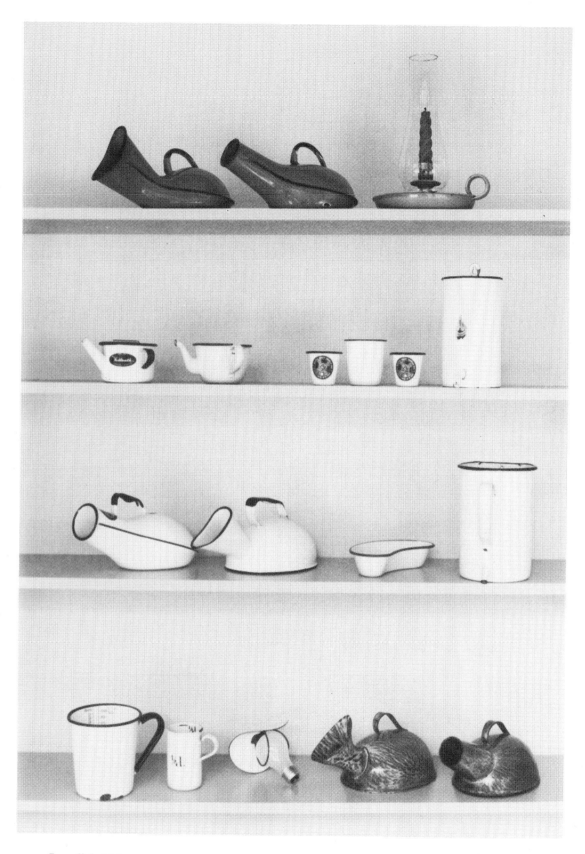

Invalid Aids

Row 1: *Pair of urinals, female and male, navy trim, $12.50 pair. 8" blue candlestick, $25.* **Row 2:** *Invalid feeder, labeled "Volrath," Mint, $10. Invalid feeder, $12.50. Pair of medicine cups, labeled "Asception Co. and N. Y. Hospital Supplies," Mint, $5 each. Tumbler between medicine cups, $8. Douche or irrigator, $22.* **Row 3:** *Pair of urinals, navy trim, $5 each. Pus basin, navy trim, $6. Douche or irrigator, $12.50.* **Row 4:** *Measure, centimeters and ounces, dark trim, $3.50. ¼-liter measure, $7.50. Clamp-on light shade, $7. Pair of urinals, Mint, $45 pair.*

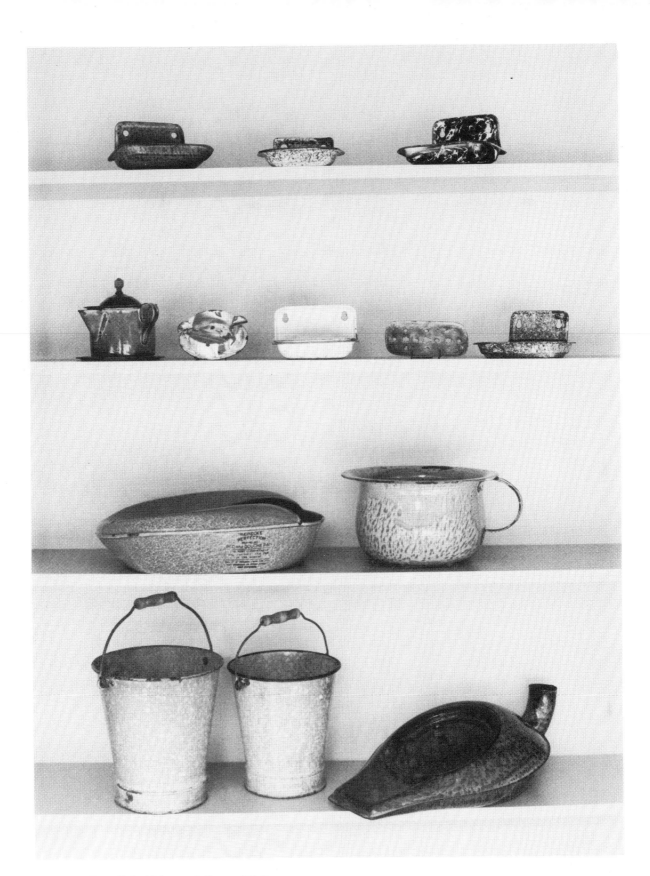

Invalid Aids and Soap Dishes

Row 1: Soap dish, wall type, $13.50. Soap dish, black and gray, Mint, $12.50. Soap dish, blue-green "Chrysolite," Mint, $17.50. **Row 2:** Invalid feeder, drip tray, labeled "L & G Mfg Co," $25. Ashtray, orange and white, $8. Soap dish, labeled "Elite Austria," Mint, $12.50. Drainer, star design, and soap dish, $17.50. **Row 3:** Pan, labeled "Meinecke Perfection Douche," $15. Chamber, signed "Granite Iron Ware," $8. **Row 4:** Two utility buckets, wood bails, $22.50 each. Covered bedpan, signed "L & G Mfg. Co.," Mint, $17.50.

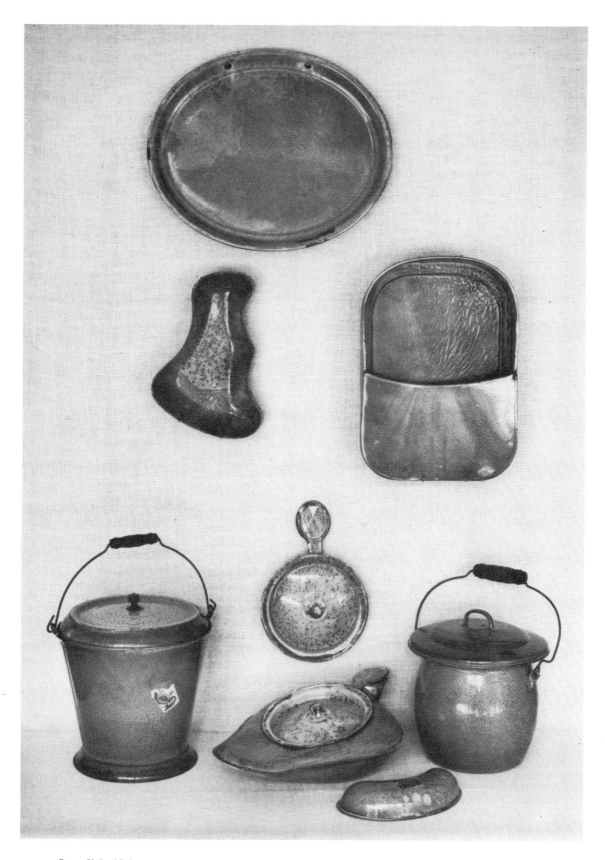

Invalid Aids

Row 1: *Tray, signed "L & G" with brass grommets, $20.* **Row 2:** *Pus basin, $17.50. "Agate" bed or douche pan, seamless, $10.* **Row 3:** *Chamber pail, labeled "El-an-ge" and signed "L & G Mfg Co," $27.50. Bedpan with "odorless" cover, extra lid hangs above pan, $22.50. Pus basin, signed "Granite Iron Ware, Oct. 9, '94 and July 21, '96"; note factory worker's fingerprints, $15. Combinet or chamber pail, $22.50.*

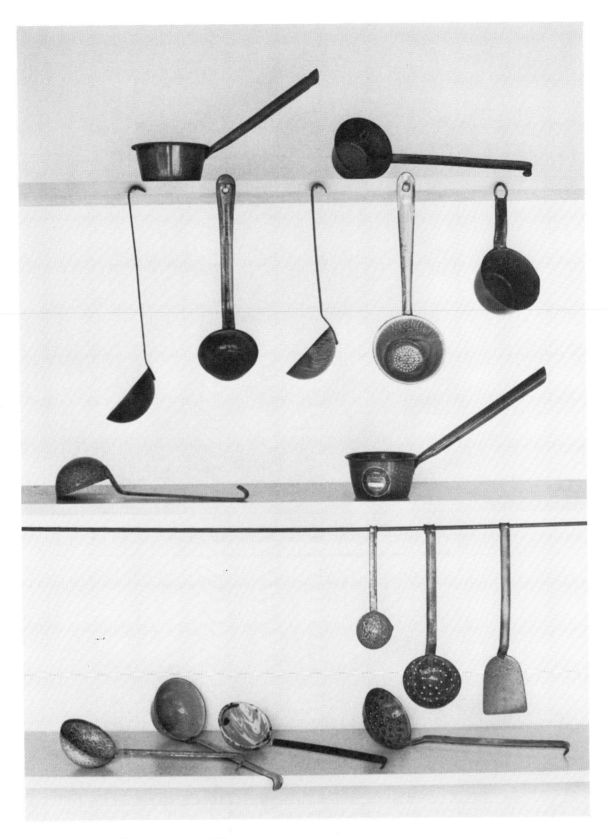

Ladles, Skimmers and Turners

Row 1: *Windsor dipper, hollow handle, $12.50. Windsor dipper, hook handle, $12.50.* **Row 2:** *Dipper, 11½" hook handle, 4" bowl, $10. Oyster ladle, $15. Soup ladle, bent handle, $10. Threaded handle strainer ladle, $14. Dipper with pouring lip, signed "L & G Extra Agate," $12.50.* **Row 3:** *Strainer ladle, arched handle, $12.50. Windsor dipper, hollow steel enameled handle, "Lafayette" label, $20.* **Row 4:** *Sauce ladle, pour spout, $28. Pierced strainer ladle, $9. Cake turner, hook handle, "L & G," $17.50.* **Row 5:** *Ladle, hook handle, $12.50. Ladle, $6.50. Gray and white ladle, black handle, signed "Columbian Ware," Rare, $22.50. Pierced strainer ladle, $12.50.*

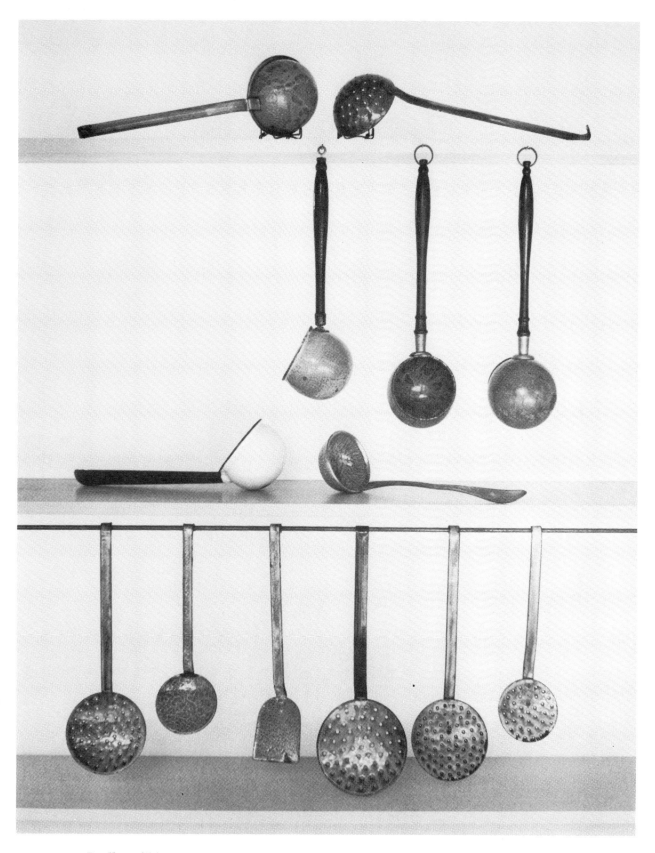

Ladles, Skimmers and Turners

Row 1: Soup ladle with flared rim, $17.50. Strainer ladle, signed "L & G," $15. **Row 2:** Cocoa dipper, wood handle attached by metal and enamel ferrule, $35. "Granite Iron Ware" cocoa dipper, wood handle, metal ferrule, front and back views, $65. **Row 3:** Hollow handle cocoa dipper, white with black trim, $15. Pewter trimmed soup ladle, $45. **Row 4:** Hook handle skimmer, $12.50. Skimmer, hook handle, $25. Cake turner, signed "L & G," hook handle, $17.50. Gray skimmer, dark blue trim, $15. Skimmer, $14. Skimmer, 8" handle, $17.50.

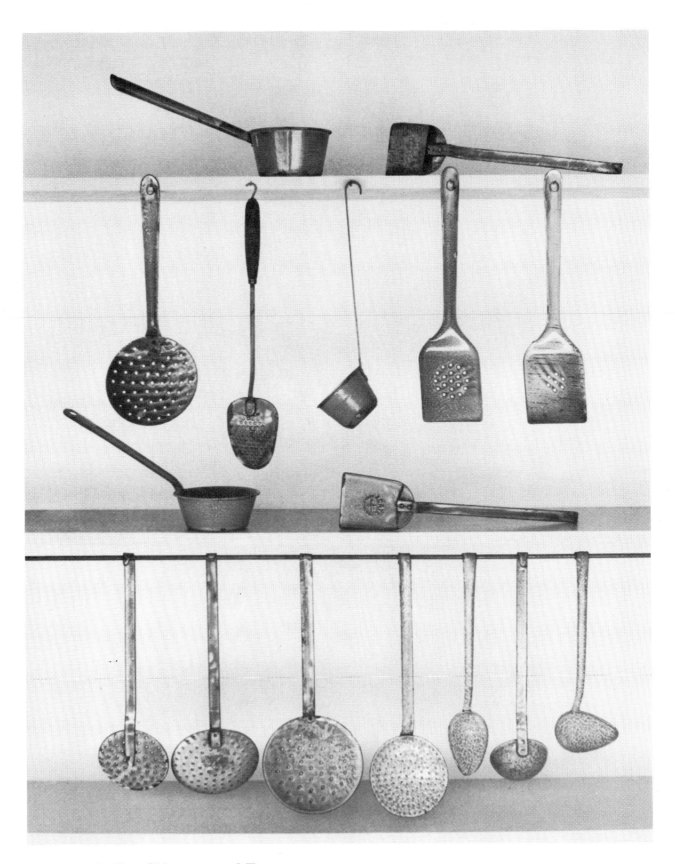

Ladles, Skimmers and Turners

Row 1: *Windsor dipper, hollow handle, $12.50. "Extra Agate" cake turner, $17.50.* *Row 2:* *Flat skimmer, $9.50. "Agate" wood handle preserve skimmer, signed "L & G," $37.50. 1-cup dipper, $22.50. Two "Agate" egg turners or spatulas, $28 each.* *Row 3:* *"Agate" dipper, flaring shape, $13.50. Cake turner, signed "L & G Extra Agate," $20.* *Row 4:* *Flat skimmer, $12.50. Skimmer, signed "Granite Iron Ware, dated 76-77," $17.50. Flat skimmer, 6" diameter, $15. Flat skimmer, $12.50. Tasting spoon, hollow handle, $17.50. Soup ladle, $12.50. Tasting spoon, side handle, $20.*

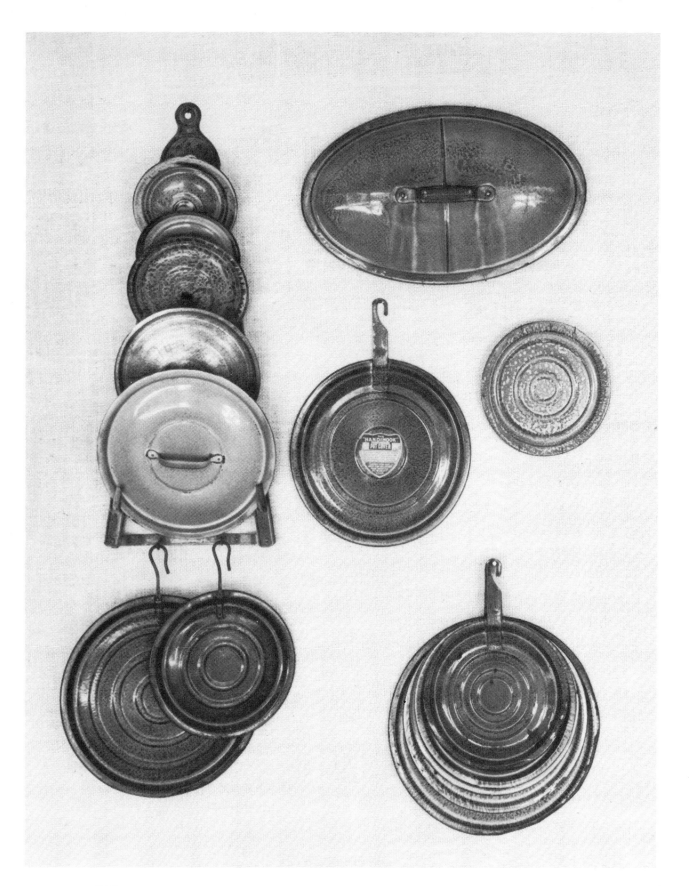

Lids

Row 1: *Lid rack with variety of lids, $2-6 each. Oval ham boiler lid, riveted strap handle, $6.* **Row 2:** *Handihook lid, made by Republic Metalware Company, labeled "The Handihook, Patented Dec. 17, 1912, Pot Cover," Mint, $15. Grooved lid, fits different-sized kettles, $8.* **Row 3:** *Two hook-handle lids hanging from rack, Rare, $12.50 each. Handihook lids, $3-12 each.*

Manufacturers, Labels and Advertising

Row 1: 1-pint pitcher, labeled "Nescoware is everywhere," $24. 1-quart pitcher, early "Royal" Dutch boy label, $22.50. Melon-shaped steamed pudding mold, labeled "Nesco," $45. **Row 2:** 1-quart liquid measure, labeled "Copyrighted 1912," featuring Dutch boy, $22. Pie pan, labeled "Nesco, Pure Greystone Enameled Ware," $12. **Row 3:** Cardboard lady, "Nesco" 1920s advertising help, $37.50. "Nesco" letterheads hang from second and third shelves, $6 each.

Manufacturers, Labels and Advertising

Row 1: *Pie pan, labeled "El-an-ge," Mint, $15. Ladyfinger pan, signed "Agate Nickel Steel Ware,"* *$35. Pudding pan, labeled "Old English," $9. Lid, labeled "Old English, R. S. & E. Co," $8.* ***Row 2:*** *Saucer, labeled "Old Hampshire," Republic S. & E. Co., $22.50. Bowl, labeled "New England," $15. Pudding pan, labeled "Cream City," $15. Graduated measure, labeled "Dresden," $22.50. Chamber pot, labeled "Sterling," $17.50.* ***Row 3:*** *Dipper, labeled "Columbian," Mint, $22. Egg or au gratin pan with trademark (circle enclosing eagle and "Libertas") signed "Germany," $12.50. Pudding pan, labeled "Cats-Eye," $17.50.* ***Row 4:*** *Baking dish, labeled "Granite Iron Ware," burnt into last coat of enamel "May 30, 1876 and July 3, 1877," $25. Chamber pail, "Gray Goose" label, $27.50. Foreground, 1-cup pewter trimmed teapot, labeled "Granite Iron Ware, Pat. May 30, 1876," $120. Trade incentive—Enamelware set given by Lee Manufacturing Co., Chicago, for merchant's $10 order, $16.*

Manufacturers, Labels and Advertising

Row 1: Teapot with two "Sterling Gray" labels, $35. Bucket, labeled "Sterling Grey," $22. Covered bucket, labeled "Sage," $25. Water dipper, labeled "Parrot," $19. *Row 2:* Water bucket, labeled "Samson," $29.50. Covered kettle, labeled "Iron City," $27.50. Kettle, labeled "Oriole," $22.50. "Nesco"-labeled candlestick, $27.50. *Row 3:* Preserve kettle, labeled "Old English," $22.50. "Hoosier"-labeled pitcher, $27.50. "Primo Enameled Ware" label on pan, $22.50. *Row 4:* Reference books, see bibliography.

Manufacturers, Labels and Advertising

Lalance and Grosjean Manufacturing Company: Trade cards, $2-10 each. Cookbooks, $6-15 each. Menu planner, $16-20. Magazine advertisements, 25¢-$4 each. Agate Iron Ware ad picturing factory, souvenir from Bloomingdales, New York, $7.50. L & G bill to G. H. Coonrad, Rome, N.Y., April 8, 1902; factory pictured on letterhead, $6.

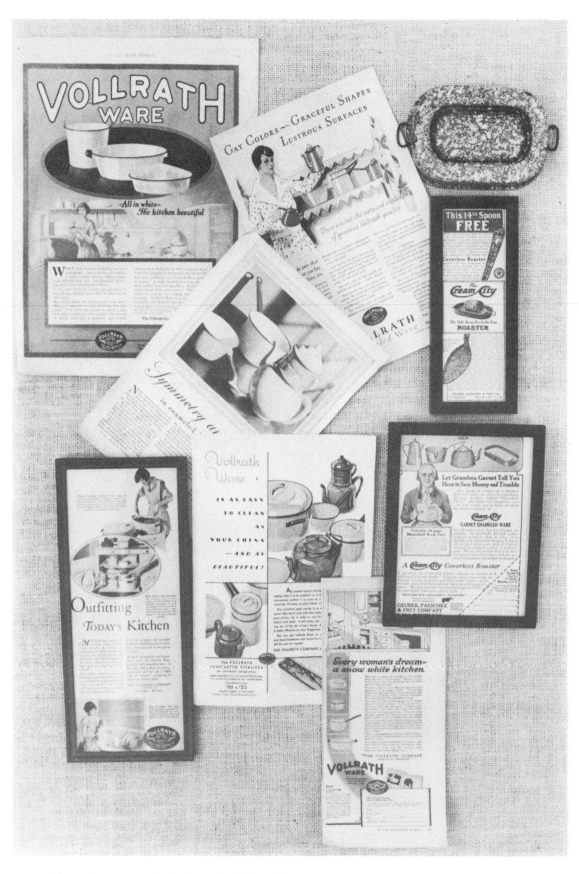

Manufacturers, Labels and Advertising

Vollrath Company advertisements, $2-6 each. Geuder, Paeschke & Frey Company advertisements, Cream City, Garnet Enameled Ware, $2-6 each. Upper right, roaster, Domestic Science size or salesman's sample, well for juices; pictured in ad below, $15.

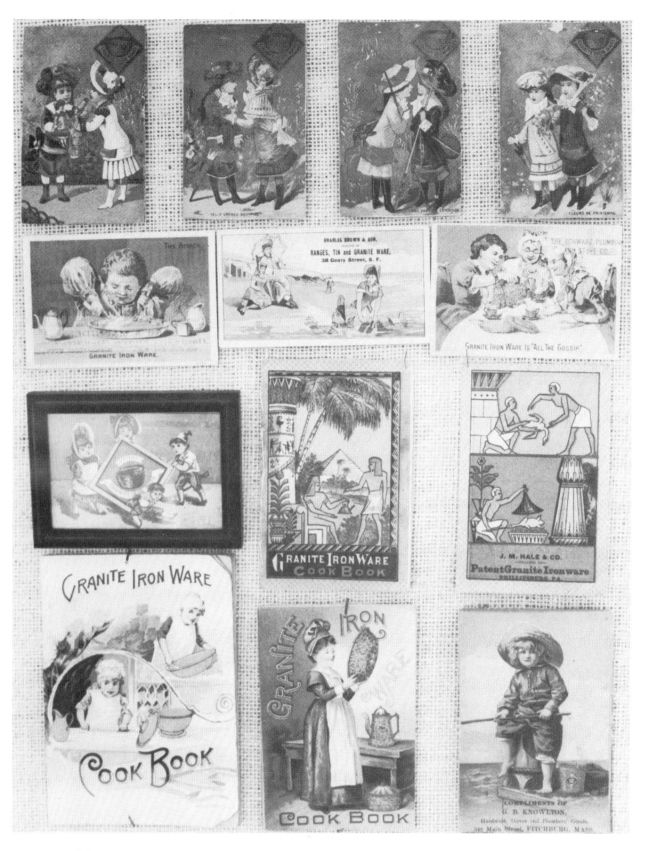

Manufacturers, Labels and Advertising

Row 1: "Granite Iron Ware" *trade cards, French captions, $50.* *Row 2:* *Trade cards, $2-10 each.*
Row 3: "Patent Granite Iron Ware" *trade card, $2-10.* "Granite Iron Ware Cook Book," *$10-25.*
"Patent Granite Ironware" *trade card, $2-10.* *Row 4:* "Granite Iron Ware Cook Book, June 9,*
1874," earliest date available, complete with cover; same as cookbook (cover missing) pictured on
page 63 in frame with other items. $32. "Granite Iron Ware Cook Book," *$10-25. Trade card,*
$2-10.

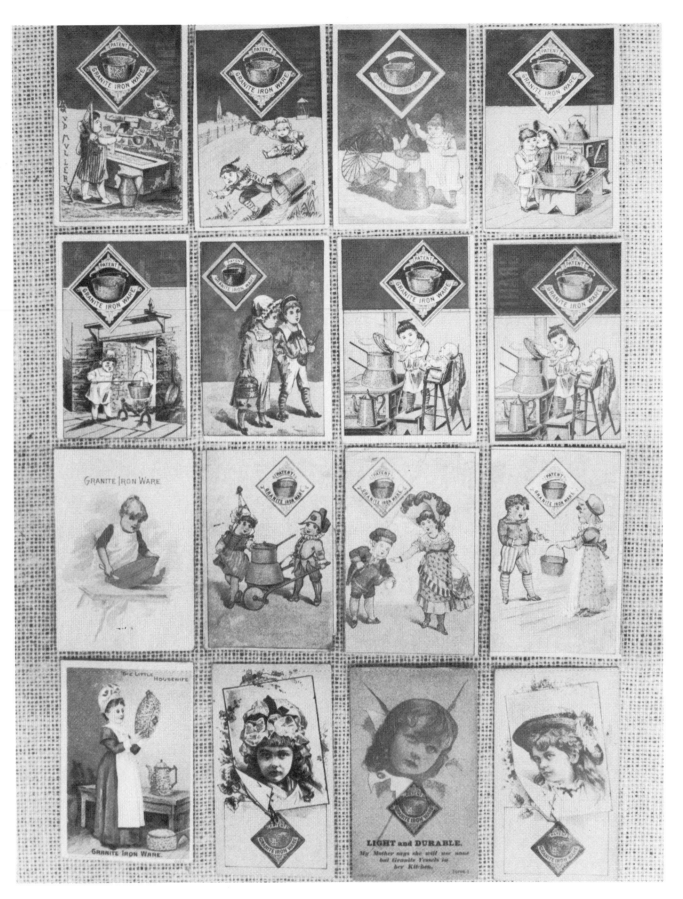

Manufacturers, Labels and Advertising

St. Louis Stamping Company, Granite Iron Ware: Colored trade cards, $2-10 each.

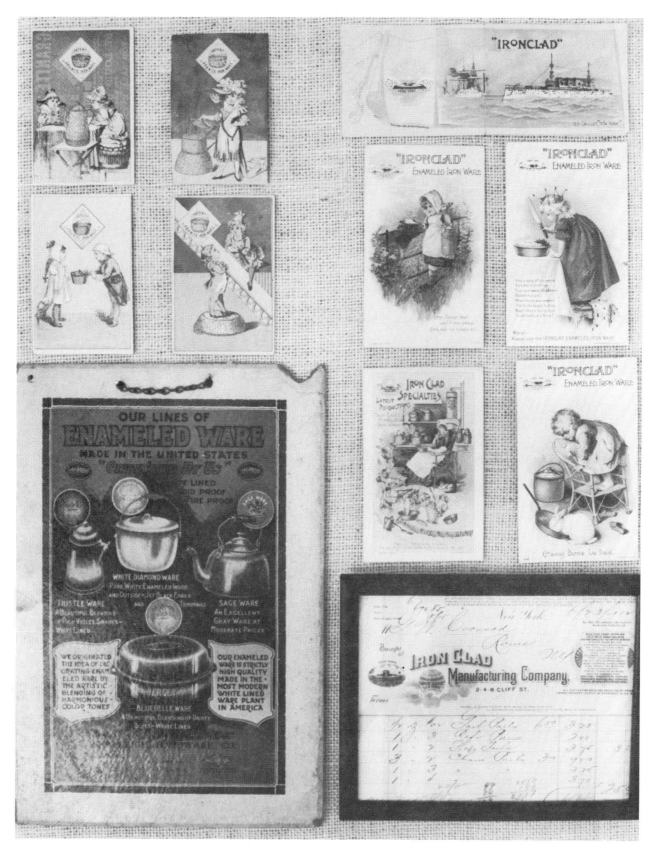

Manufacturers, Labels and Advertising

Clockwise, beginning with upper right: Cookbook, Iron Clad Manufacturing Company, souvenir, World's Fair, St. Louis, 1904, $6. Four "Iron Clad" trade cards, $10 each. "Iron Clad" bill to G. H. Coonrad, Rome, N.Y., June 23, 1902, $6. "Advertising Help" for the Shapleigh Hardware Co., St. Louis, $35. Four "Granite Iron Ware" colored trade cards, $2-10 each.

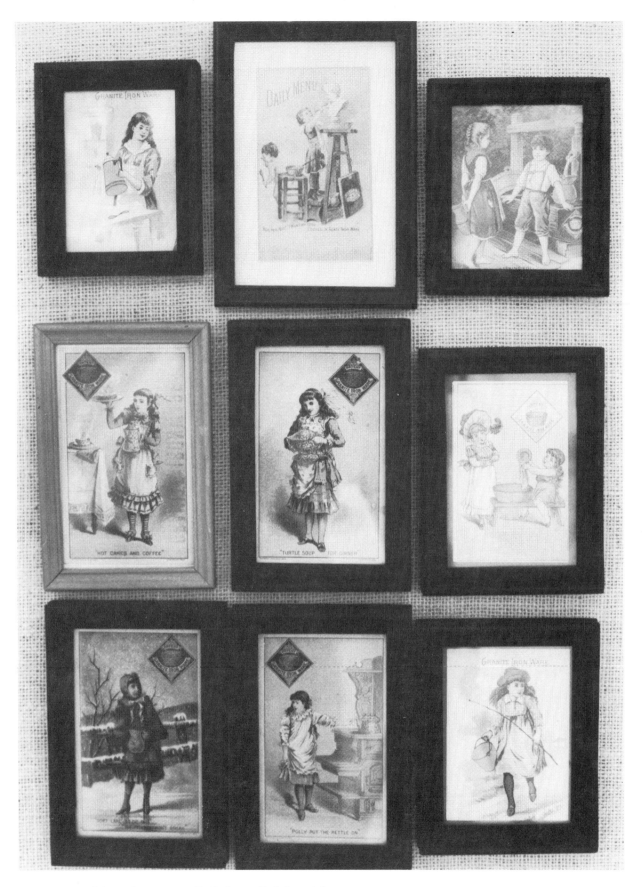

Manufacturers, Labels and Advertising

*Trade cards, Granite Iron Ware and Agate Iron Ware, made by St. Louis Stamping Co. and L & G
Mfg. Co., respectively, $8-15 each.*

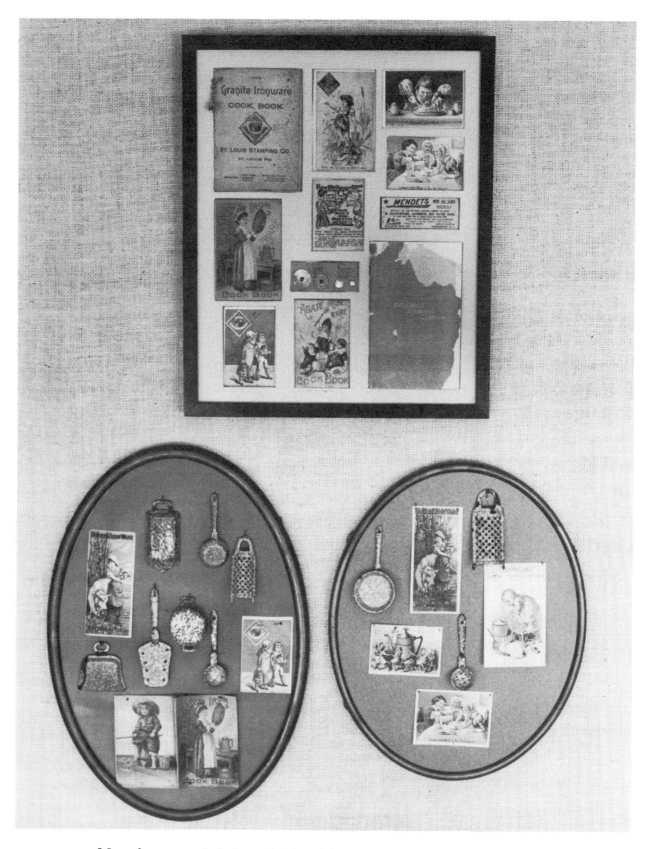

Manufacturers, Labels and Advertising

Row 1: Pictured in rectangular frame, clockwise, beginning upper right—Two trade cards, Mendets, "Bellaire Stamping Company" catalog, "Agate Iron Ware Cook Book," trade card, "Granite Iron Ware Cook Book"; "The Granite Ironware Cook Book, Patent Granite Iron Ware, St. Louis Stamping Co., St. Louis, Mo., June 9, 1874," also shown on page 59 with cover; trade card, Mendets, $125. Row 2: Picture with trade cards, cookbook and toys, $125. Picture, $65.

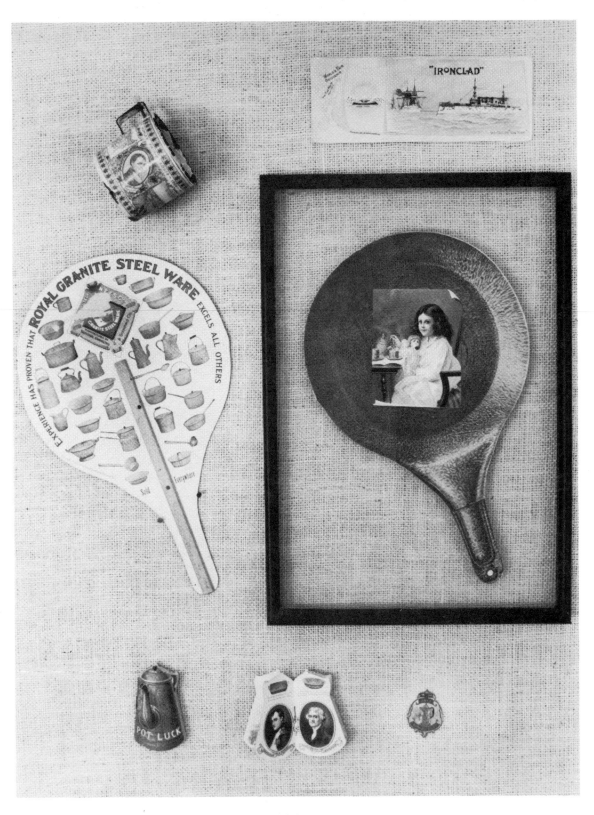

Manufacturers, Labels and Advertising

Row 1: Souvenir cup, World's Fair, St. Louis, 1904, made by Elite Austria for distribution by Norvell Shapleigh Co., 1904, shows history of Louisiana Purchase, $10-30. "Iron Clad" souvenir cookbook, World's Fair, St. Louis, 1904, $6. *Row 2:* National Enameling & Stamping Co. fan, advertising "Royal Granite Steel Ware," copyright 1904, back view, and front view with child pouring from Graniteware teapot, $20-50. *Row 3:* Front of NESCO booklet advertising "Royal Granite Steel Ware," World's Fair souvenir, 1904, St. Louis, and inside pages showing Napoleon who sold and President Jefferson who purchased the Louisiana Territory, $25. Columbian Enameling & Stamping Co. watch fob, souvenir of 1893 Columbian Exposition, Chicago, $35.

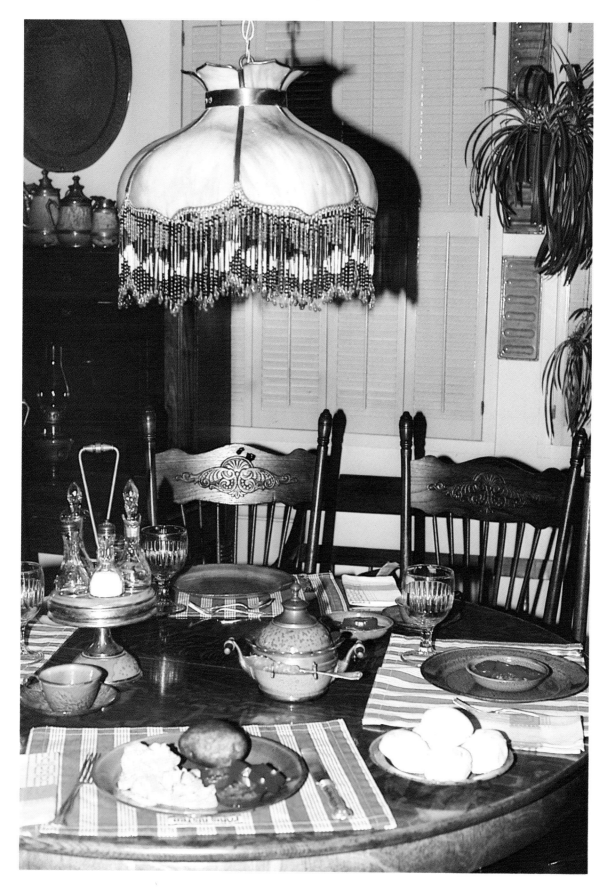

Home Display

Table setting in the home of Evelyn J. Welch.

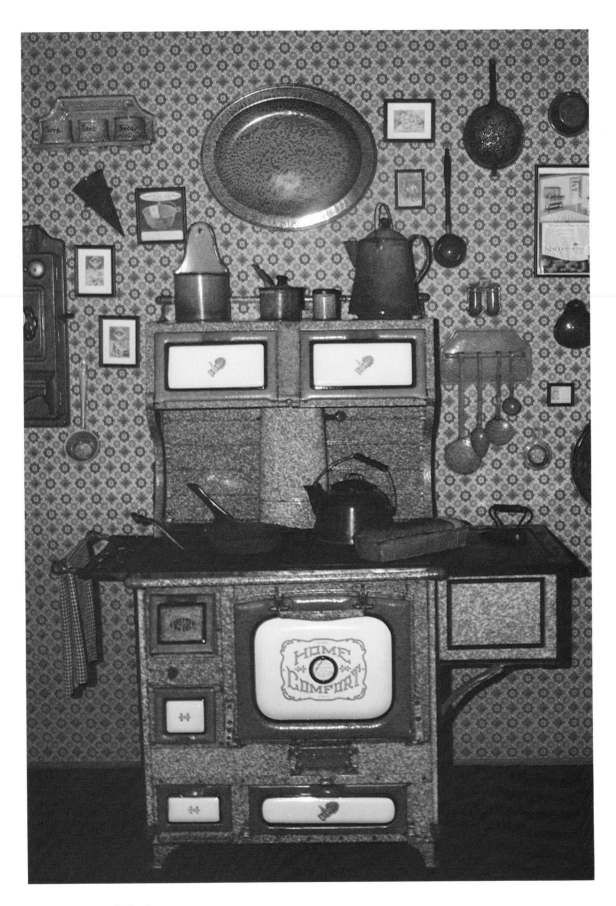

Home Display

"Home Comfort" stove, Mint, $600-1250. Graniteware display in the home of Elaine and Larry Erwin.

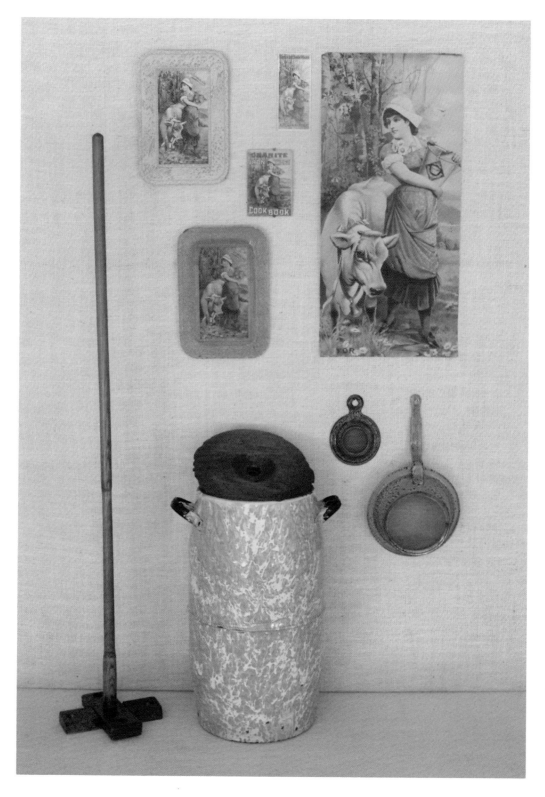

Manufacturers, Labels and Advertising

Clockwise, Upper Right: St. Louis Stamping Company's advertising symbol, "Gran-ie-ta," original cloth-back picture 12"×28", this one trimmed to 11"×22", $85. Milk strainer, $20. Milk strainer, long handle, $33. Blue and white 5-gallon churn, hickory lid and dash, enamel lid missing, black handles, 10"×18", $150. Papier-mâché tray darkened by exposure, labeled "Souvenir to the Patrons of Granite Ironware" on front and "The Best Cooking Utensils Ever Made, Light, Wholesome, Durable and Easily Cleaned" on back, $19.50 "Gran-ie-ta" papier-mâché tray, Mint, offered with purchase of $1's worth of Granite Ironware, $75. "Gran-ie-ta" cookbook, Mint, $12. Trade card, 2½"×5½", $3-15.

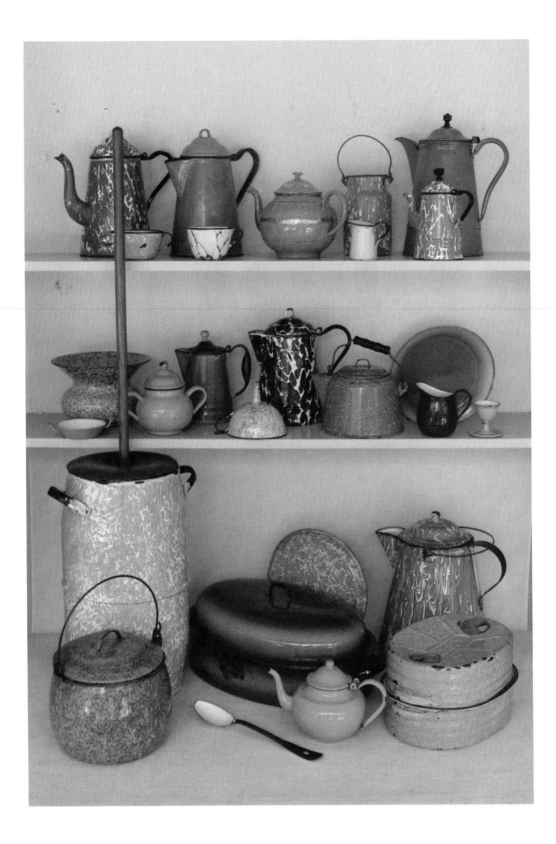

Miscellaneous

Row 1: Teapot, $32.50. Cup, $6. Coffeepot, $22.50. Cup, $4. Pekin teapot, gold trim, $45. Measure, $12.50. Milk kettle, $25. Teapot, $22.50. Coffeepot, $37.50. **Row 2:** Egg pan, $12.50. Cuspidor, $45. Sugar bowl, $35. Coffeepot, $12.50. Funnel, $12.50. Coffeepot, $17.50. Teakettle, $25. Pitcher, dark blue, white lining, $12.50. Pie plate, $6. Egg cup on saucer base, gold trim, $15. *Row 3:* Covered kettle, $25. Churn, $150. Spoon, $6. Pekin teapot, $27.50. Roaster, $25. Pie plate, $9. Coffeepot, $35. "Reed" oval roaster, $16.

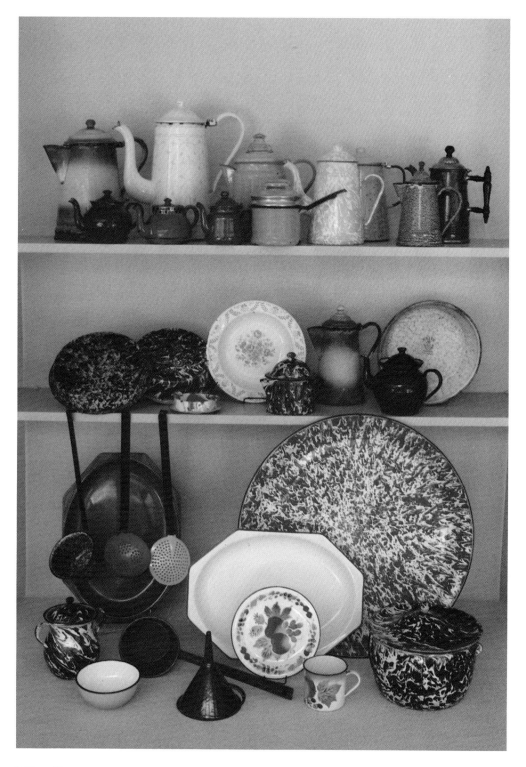

Miscellaneous

*Row 1: Coffeepot, two-toned, $22.50. Brown teapot, $12.50. Pekin teapot, coral with gold trim, "Czechoslovakia," $22.50. White teapot, onion pattern, $45. Green teapot, $6. Green coffee percolator, $25. Green coffee percolator, side handle, $15. Yellow and white teapot, $35. Yellow coffeepot, $10. Brown coffeepot, $15. Brown teapot, nickel lid, wood handle, $37.50. **Row 2:** Black and white cake pan, $6. Brown and white pan, $14. Orange and white ashtray, $12.50. Floral soup plate, $9. Green Chrysolite tea steeper, $37.50. Shaded green coffeepot, $15. Brown teapot, $17.50. Green pie plate, signed "Elite Austria," $9. **Row 3:** Brown dipper, $12. Orange dipper, Poland, $6. Yellow skimmer, Poland, $6. Brown and white sugar bowl, $47.50. Yellow bowl, $6. Dark green dipper, $8. Metallic green platter, $15. Brown funnel, $7.50. "Corona" fruit design plate, $8. Mexican cup, $3. White platter, red trim, $8. Red and white tray, $25. Brown and white covered kettle, $35.*

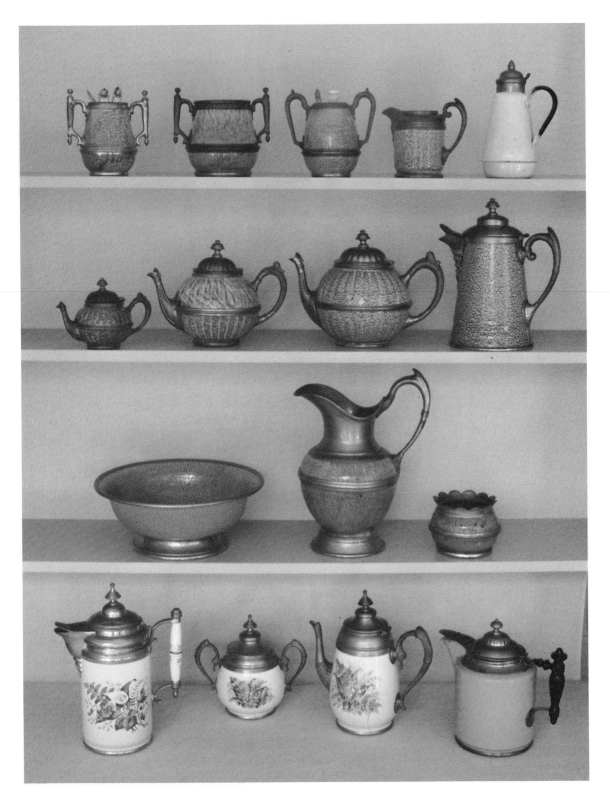

Pewter Trimmed Pieces

Row 1: Syrup pitcher, black enamel handle, Mint, $35. Creamer, copper base rim, Granite Iron Ware, $65. Spooner, $65. Sugar bowl, copper base rim, lid missing, $60. Pearl Agate Ware spooner, $65.
Row 2: Coffeepot, 8-cup, $115. Teapot, 4-pint, $125. Teapot, 3-pint, $125. Teapot, 1-cup, $85.
Row 3: Waste bowl, $50. Bowl and pitcher set, signed "Granite Iron Ware, Pat. May 30, 1876, and July 8, 1877," $400. *Row 4:* Coffeepot, wood handle and nickel-plated cover, signed "Manning-Bowman & Co. Pat. May 21, 1889," Mint, $95. Teapot, Lily of the Valley and Fern pattern, $125. Sugar bowl, Lily of the Valley and Fern pattern, $100. Pearl Agate Ware coffeepot, Calla Lily and Fern pattern, Mint, $150.

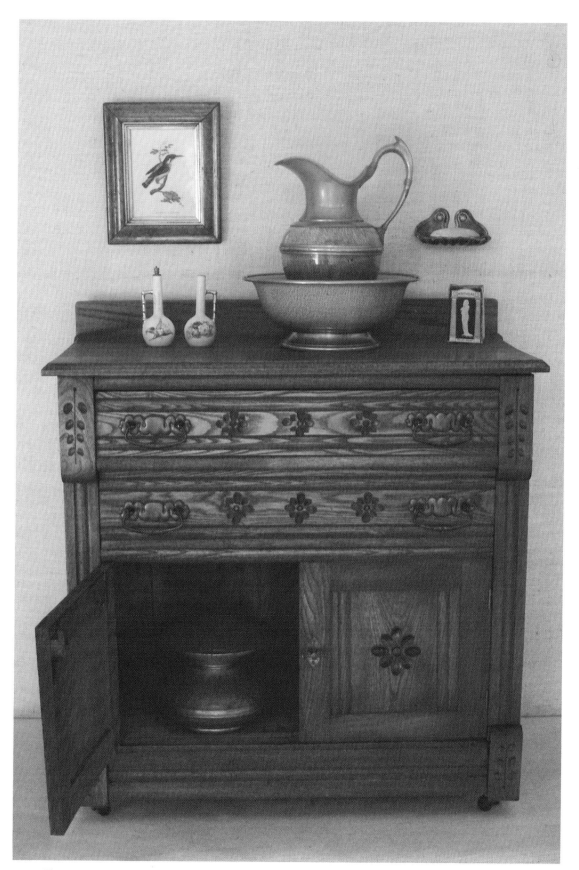

The pewter trimmed bowl and pitcher belonged to the Reverend L. P. Bergstrom, D.D., a Lutheran minister of St. Paul, Minnesota. He was designated "Knight of the Royal Order of Vasa" by King Gustaf V of Sweden, in recognition of Bergstrom's fifty years of international contributions as a church worker. Pewter trimmed bowl and pitcher, signed "Granite Iron Ware, 1876-77," $400. Soap dish, shell shape, Mint, $32.50. Cuspidor, signed "Granite Iron Ware, 1876-77," pewter trimmed, $125.

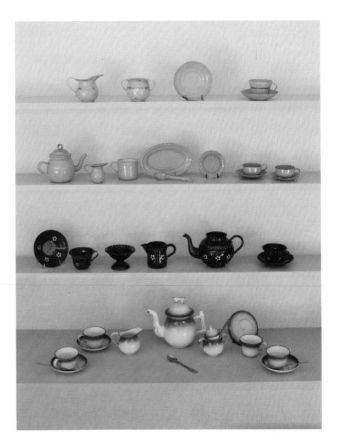

Toys

Row 1: *Pink set with gold trim, $50.* **Row 2:** *Partial set, $75.*
Row 3: *Tea set with raised floral design—two cups and saucers,
teapot (lid missing), creamer and pedestal sugar bowl—German,
$65.* **Row 4:** *Complete tea set, teapot 4¾", $95.*

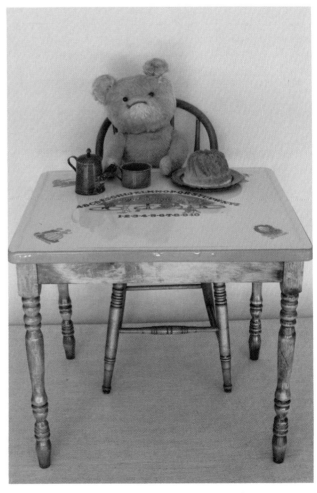

Toys

Child's teapot, $37.50. Mug, $9.50. A B C table, 1920s, $125.

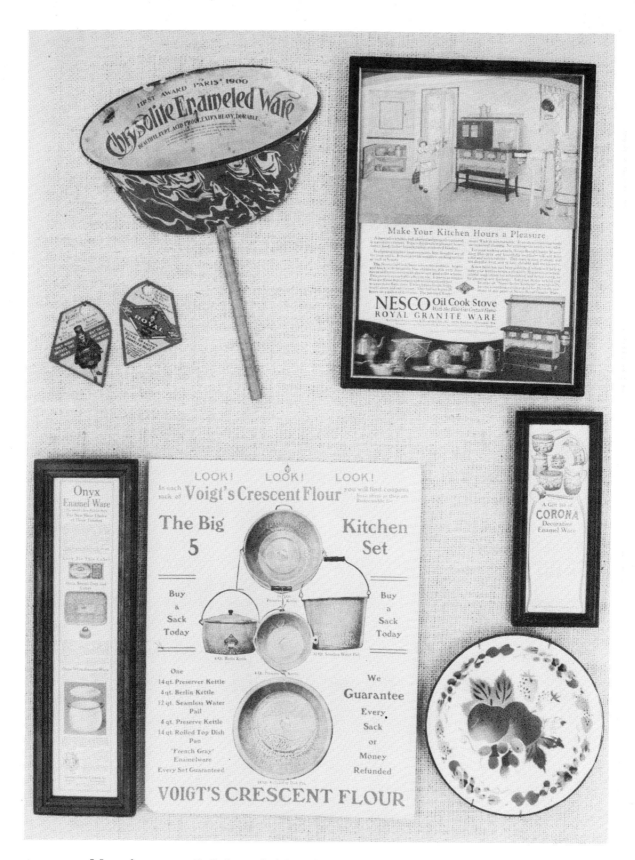

Manufacturers, Labels and Advertising

Row 1: *Pair of NESCO pot and pan scrapers, front and back views, labeled "A curve or point to fit anywhere in the pots or pans," advertised for 10¢ in early 1920s ladies magazines, $15-45 each. "Chrysolite Enameled Ware" fan, "First Award Paris 1900," $22.50. NESCO magazine ad, colored, full page, $8.* *Row 2:* *Columbian Enameling & Stamping Co. advertising "Onyx Enamel Ware," $8. Voigt's Crescent Flour premium offer, reproduction, $2-5. Enterprise Enamel Co. advertising "Corona Enamelware," $6. Dessert plate, one of set by Corona, $8 each.*

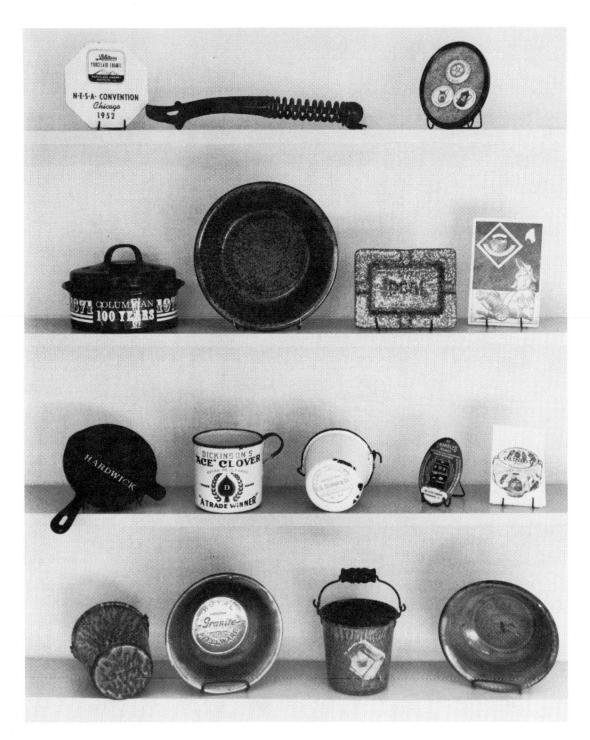

Manufacturers, Labels and Advertising

Row 1: Souvenir coaster, National Enamel Stamping Association Convention, Chicago, 1952, $10. Stove lid lifter, embossed "Use Granite Iron Ware, Pat. Oct. 22, 1895," $25. Advertising pin-back lapel buttons—Green pitcher, "Norvell Shapleigh Hardware Co., Shamrock Ware"; "The Central Stamping Co., Sterling Enameled Ware"; brown coffeepot "Stewart Roswood Enameled Ware Shapleigh Hardware Co., St. Louis," $7.50 each. Row 2: Roaster commemorating 100 years of Columbian Enameling & Stamping Co., $3-10. Pan, "Compliments of Farwell, Ozmun, Kirk & Co., Flint Gray Enameled Ware, L & G Mfg Co," $6.50-25. Green ashtray embossed "Ideal," $15. "Granite Iron Ware" trade card, $2-10. Row 3: Enameled iron ashtray "Hardwick," $12.50. Child's cup "Dickinson's 'Ace' Clover," $15. White pail, "Compliments of U. S. Stamping Co., Moundsville, W. Va.," $15. Pocket mirror advertising enameled kitchen range, $12-18. "Parrot Ware, Cleans Like China," Grunden Martin Manufacturing Company, old label with six parrots, $5. Row 4: Salesman's sample water pail, signed "Royal Granite Steel Ware," $10-25. Salesman's sample wash basin, signed "Royal Granite Steel Ware," $10-25. Salesman's sample water pail, labeled with early 1900s NESCO label, $10-25. Salesman's sample wash basin, signed "Royal Granite Steel Ware," $10-25.

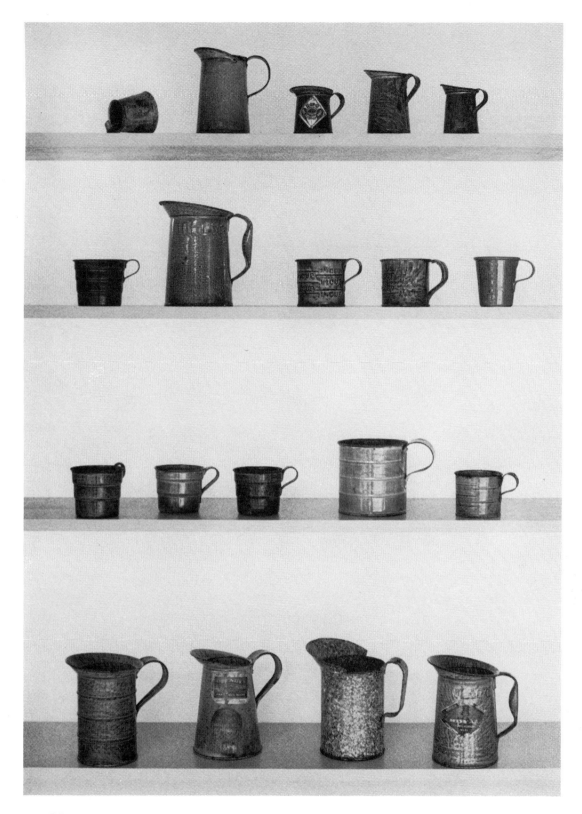

Measures

Row 1: *1-gill, labeled "Iron Clad, Pat. July 10, 1888," no lip, Rare, $35. Heavy iron, applied lip and strap handle, signed "Granite Iron Ware, Pat. May 30, 1876, July 3, 1877, St. Louis Stamping Co.," $35. 1-gill, labeled "El-an-ge," $45. 1-cup, $22.50. 1-gill, $35.* **Row 2:** *Graduated 1-cup measure, wirelike handle, $17.50. 1-quart liquid, $15. 1-cup, $17.50. 1-cup, $17.50. 6-ounce graduated measure, pouring lip, $12.50.* **Row 3:** *Three graduated 1-cup measures, thirds designated, different handles, all Excellent, $17.50 each. 1-quart graduated dry measure, $15. 1-cup, thirds and fourths marked, $15.* **Row 4:** *4-cup graduated measure, $17.50. "Dresden Aluminum Enameled Ware, Central Stamping Co., Pat. Dec 6, 1893," $25. "McClary Mfg Co., London, Ontario" stamped in red, lip does not encircle rim as on U. S. measures, $35. Labeled "Royal," dated July 19, 1898, Mint, $35.*

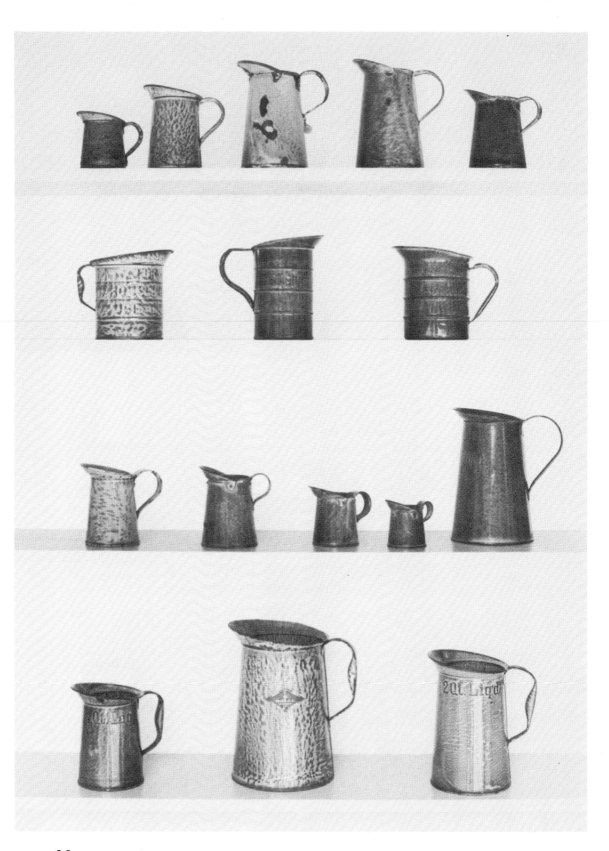

Measures

Row 1: *1-cup, $15. 1-pint, $12.50. 1-quart oil measure certified by U. S. Bureau of Weights and Measures on lead seal attached to handle, $12.50. Two oil measures marked "NYC" (New York Central RR), $10 each.* *Row 2:* *Graduated quart measure, signed "For Household Use Only," Mint, $22.50. Quart measure, $22.50. Quart measure, $22.50.* *Row 3:* *1-pint measure, riveted strap handle, $17.50. 1-pint, $35. ½-pint, handle applied with rivets by hand, $35. 1-gill, lip set into rim with rivets, Mint, $45. ½-gallon, embossed "For Household Use Only," Rare, $27.50.* *Row 4:* *Hollow handled 1-quart liquid measure, "Nesco," $25. 1-gallon, "Nesco," $35. ½-gallon, "Nesco," Rare, $27.50*

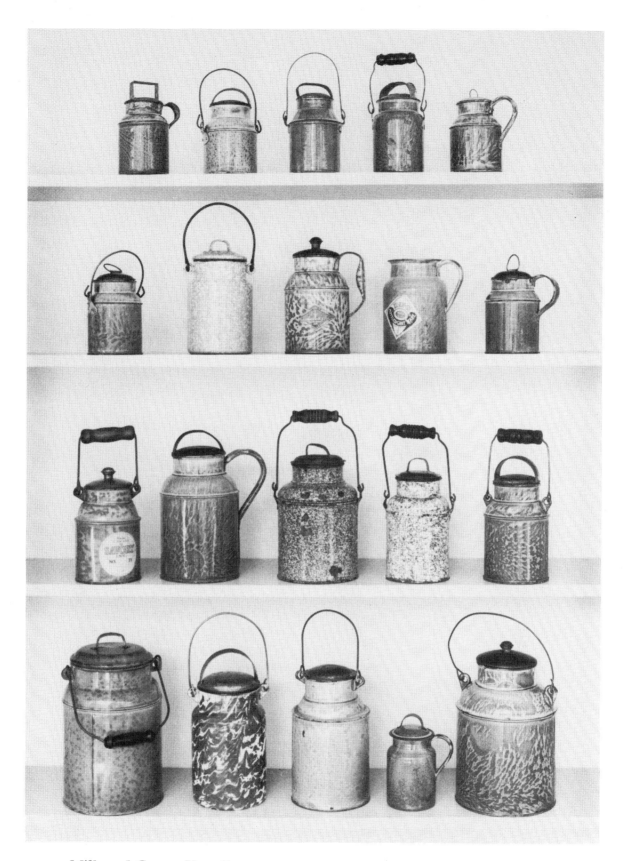

Milk and Cream Utensils

Row 1: *Cream cans, $25 each.* **Row 2:** *1-pint cream can, $25. 1-quart milk can, blue and white, Mint, $22.50. "Royal" Nesco can, side handle, tin lid, Mint, $25. 1-quart can, labeled "El-an-ge Mottled Gray Ware," lid missing, $25. 1-pint cream can, $22.50.* **Row 3:** *Milk or cream can, "Savory" label, $27.50. Can with tin lid, $22.50. Dark brown can, $19.50. 1-quart can, $17.50. 1-quart can, tin lid, Mint, $20.* **Row 4:** *Milk can, wood bail, $27.50. ½-gallon can, tin lid, blue and white, $22.50. ½-gallon can, $17.50. Cream can, tin strap lid, $35. 1-gallon can, tin lid, $20.*

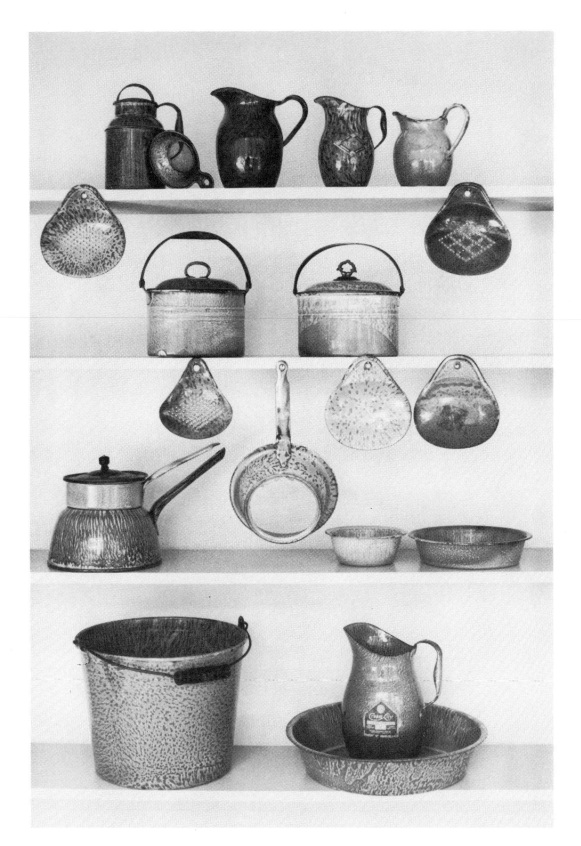

Milk and Cream Utensils

*Row 1: 1-quart milk can, $17.50. Milk strainer, wire screen, $20. Milk pitcher, $17.50. Pitcher with old "Nesco" label, $22.50. Cream pitcher, $16.50. **Row 2:** Cream skimmers, $25 each. **Row 3:** Butter kettle, wide tin bail, $35. Butter kettle, wide strap bail, $37.50. **Row 4:** Cream skimmer, "L & G," $16-25. Milk strainer, fine wire screen, Mint, $10-33. Cream skimmer, $17.50-25. Skimmer, signed "Granite Iron Ware," brass grommet, $25. **Row 5:** Double boiler, Mint, $22.50. Pudding or clabber pan, $5. Clabber pan, $5. **Row 6:** Milk bucket, $15.50. Milk pitcher, labeled "Cream City," Mint, $17.50. Milk pan, $10.*

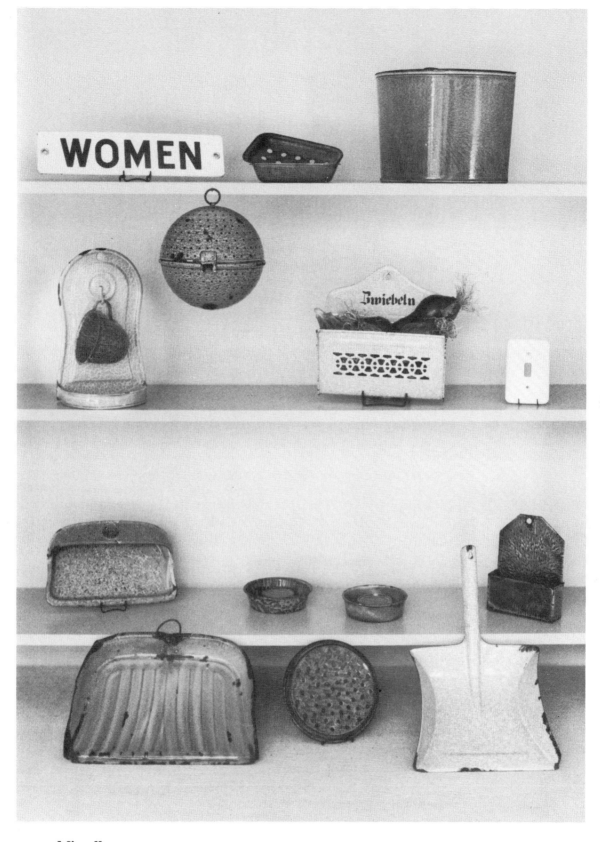

Miscellaneous

Row 1: Rest room sign, $5. Soap dish and drainer, "Agate," $17.50. Fireless cooker pot, tin lid, flat back, $10. *Row 2:* Wall rack for cup and soap, $35. Pierced rice ball (hanging), $45. "Zwiebeln" (Dutch for onions) rack, $47.50. Electric switch cover, $2.50. *Row 3:* Crumb pan, $28. Two ant cups, water moat keeps ants off table, $10-25 each. Match safe, $17.50. *Row 4:* Dustpan, missing round handle replaced by wire ring, L & G Manufacturing Co., $16.50. Pierced drainer for "Agate" ice bowl, $6. Dustpan, $52.50.

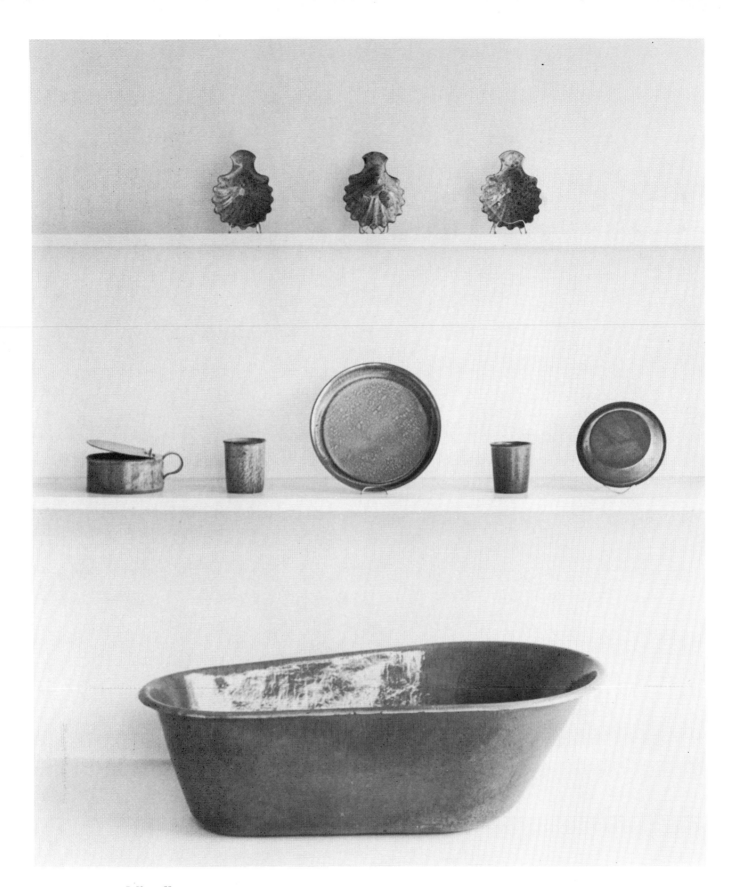

Miscellaneous

Row 1: *Oyster patties, $30 each.* **Row 2:** *Covered spit cup, $45. Tumbler, $18. Enamel-lined tin pie pan, $12.50. Tumbler, $15. Enamel-lined tin tart pan, $12.50.* **Row 3:** *Child's bathtub, $75.*

Photograph by Glen R. Moore

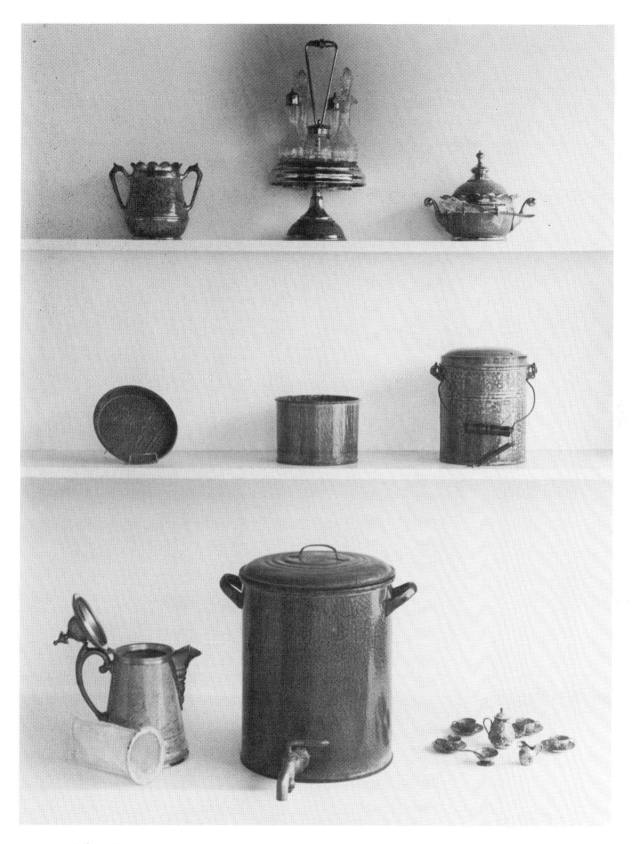

Miscellaneous

Row 1: *Pewter trimmed sugar bowl, lid missing, $60. Pewter trimmed caster set, $375. Pewter trimmed butter dish, Mint, $175.* *Row 2:* *Three-piece lunch bucket, $37.50.* *Row 3:* *Pewter trimmed coffeepot with original net coffee holder, Mint, $150. Coffee urn, $45. Toy tea set—four cups and saucers, pedestal sugar bowl, creamer and teapot, $200.*

Photograph by Glen R. Moore

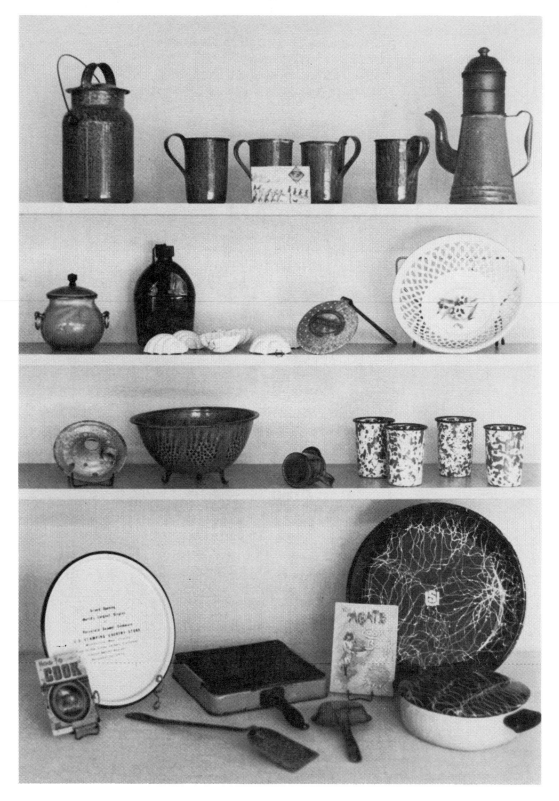

Miscellaneous

Row 1: Milk kettle, $35. Set of four mugs, signed "Extra Agate L & G," $102. "Granite Iron Ware" cartoon trade card, $4. Biggin, $37.50. *Row 2:* Sugar bowl, metal ring handles, signed "Nesco," $60. Black flask, marked "U.S.S. Co., U.S. 1942," $12. Six shell-shaped molds with rings, $45. Skimmer with "Blulite" label, $8. Fruit dish with pansies, $18. *Row 3:* Vaporizer insert, $5. Colander, $8. 1-gill measure with "Second" stamped on bottom, $22.50. Blue and white tumblers, $25 each. *Row 4:* Granite Iron Ware cookbook, $12. December 1, 1973, tray commemorating United States Stamping Company, $10. Hotcake turner, $15. Blue comfit or confectioner's pan, $35. Toy fry pan, $15. Agate Iron Ware cookbook, $17.50. Black bowl, signed "U.S.," made by United States Stamping Company, $10. Covered casserole, by United States Stamping Company, $10.

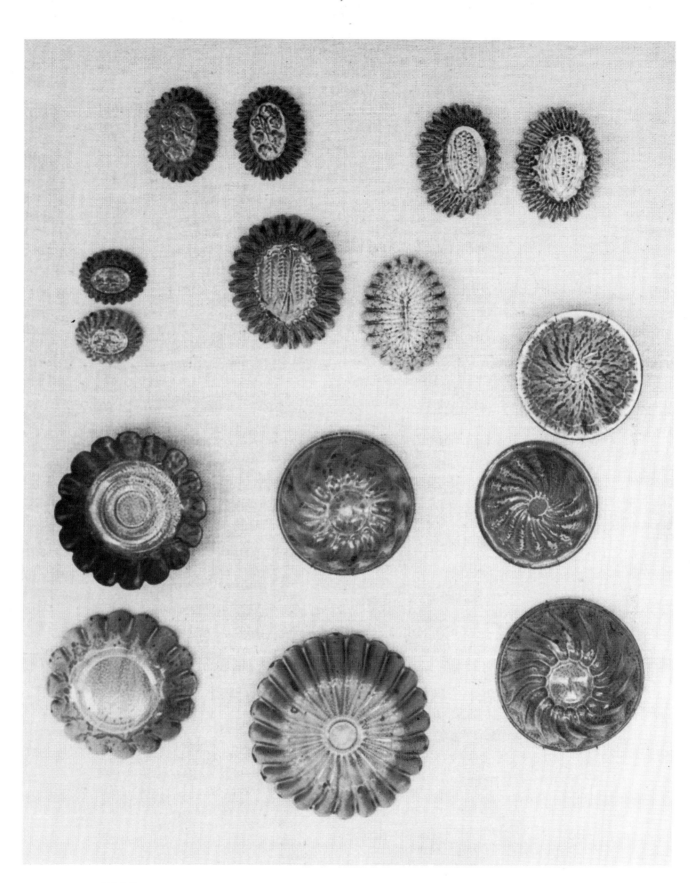

Molds

Row 1: *Pair of fluted molds, strawberry pattern, $35 each. Pair of molds, corn pattern, $22.50 each.*
Row 2: *Pair of 3½"×2¾" molds, rabbit pattern, $35 each. Mold, barley design, $25. Fluted mold, $22.50. Gelatin mold, $15-30.* **Row 3:** *Cake mold, $12.50. Turk's Head mold, $22.50. Gelatin mold, $15-30.* **Row 4:** *Scalloped mold, $12.50. Cake mold, $17.50. "Agate" Turk's Head cake mold, $22.50.*

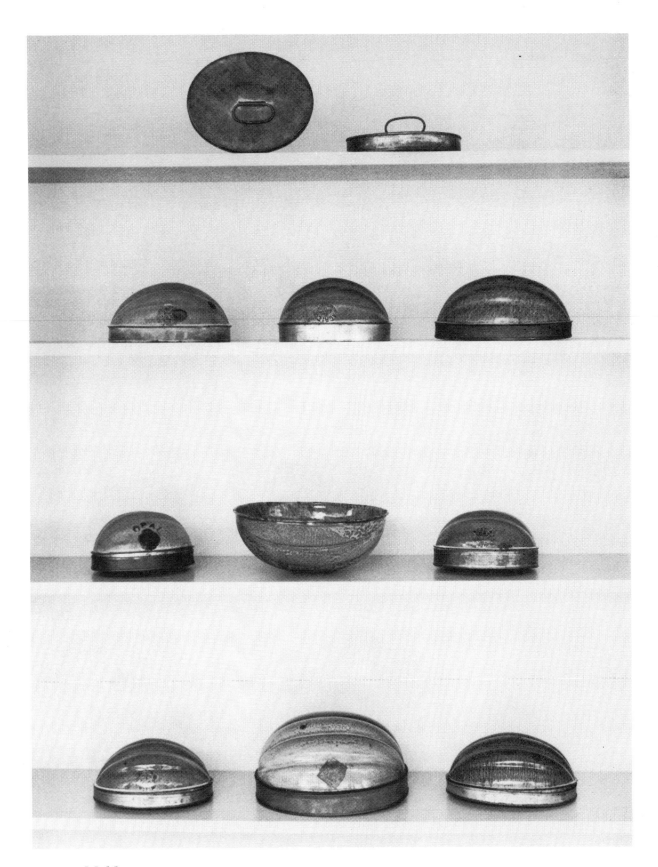

Molds

Row 1: Heavy tin lids, soldered ring handles, $6 each. **Row 2:** *"Extra Agate" oval seamless melon mold, $35. "Extra Agate" mold with tin collar, $37.50. Mold, $25.* **Row 3:** *Mold, signed "OPAL," "L & G" hardly discernable under ink blot, $35. Jelly mold with stand to hold level, $45. "Extra Agate" mold, "30" mark indicates size, $32.50.* **Row 4:** *Mold, signed "L & G Mfg Co. Extra Agate," $27.50. Mold with early "Nesco" label, patent date "Sept. 12, 1899," $55. Mold, signed "L & G Mfg Co," $27.50.*

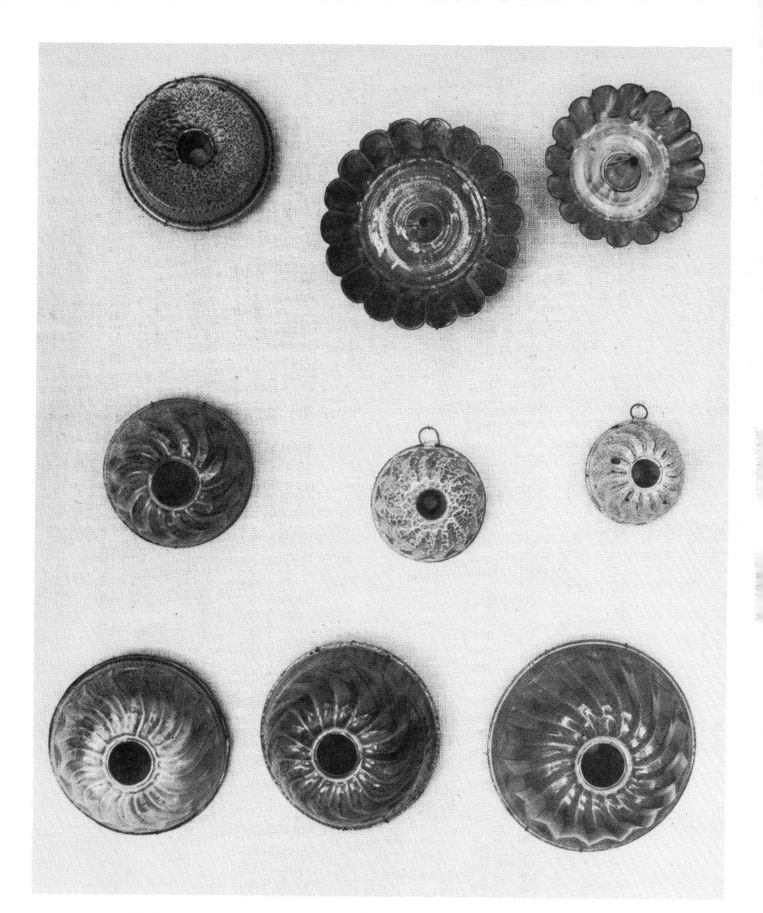

Molds

Row 1: Tube cake mold, $12.50. Mold pan with 18 scallops, Mint, $17.50. Pan with 16 scallops,
$17.50 **Row 2:** 7" Turk's Head mold, $20. 5½" mold, $32. 4½" mold, $32.50. **Row 3:** "Agate"
Turk's Head cake mold, 8", $20. 9" cake mold, $22.50. 11" cake mold, $25.

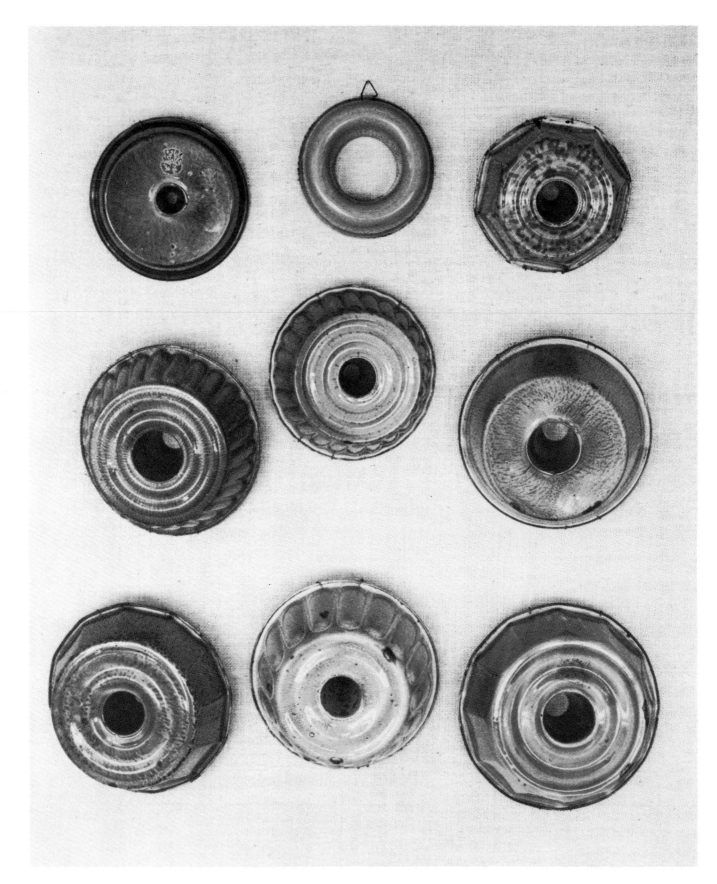

Molds

Row 1: *Shallow mold, signed "Extra Agate L & G," $17.50. Ring mold, blue with white lining, $10. Octagonal 8" mold, $15.* **Row 2:** *10" cake mold, $35. 9" mold, $27.50. 10" mold, $12.50.* **Row 3:** *12-sided cake mold, $15. "Agate" turban mold, $17.50. Mold, rare signature "Nesco Granite Steel Ware" under glaze, $35.*

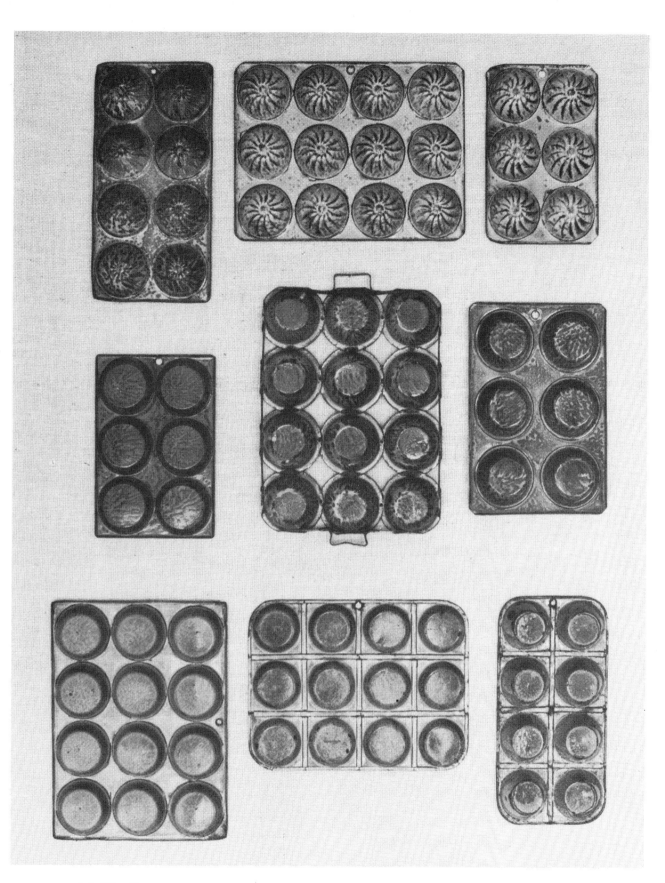

Muffin Pans

Row 1: *"Agate" Turk's Head muffin pan, $35. 12-cup pan, $37.50. 6-cup pan, $30.* **Row 2:** *6 shallow cups, Mint, $12.50. Cups individually riveted together, held by wire frame, strap handles, very old, $45. 6-cup pan, Mint, $15.* **Row 3:** *Shallow cups, signed "Extra Agate L & G," $15. 12 cups and 8 cups, stamped singly and held with straps, $17.50 each.*

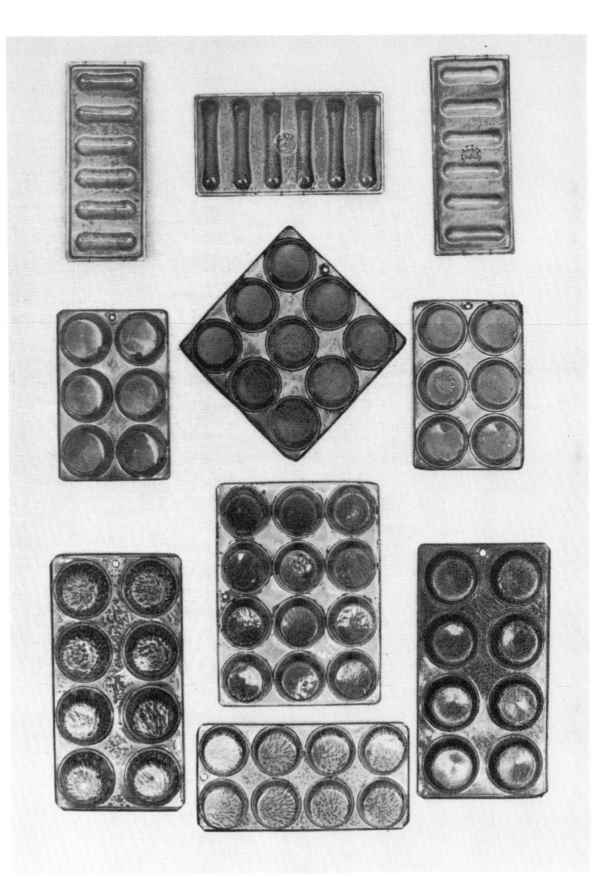

Muffin Pans

*Row 1: Ladyfinger pan, 5"×11½", $35. Pan, signed "Agate L & G," $40. Back view of ladyfinger pan, signed "Agate L & G," $35. **Row 2:** Muffin pan, $12.50. Muffin pan, signed "Agate Ware L & G," $22.50. 6-cup pan, signed "Agate Ware L & G," $18.50. **Row 3:** Pan, deep cups, Mint, $22.50. Shallow pan, ½" deep, 8 cups, $15. Muffin pan, $15. Pan, signed "Extra Agate L & G," $22.50.*

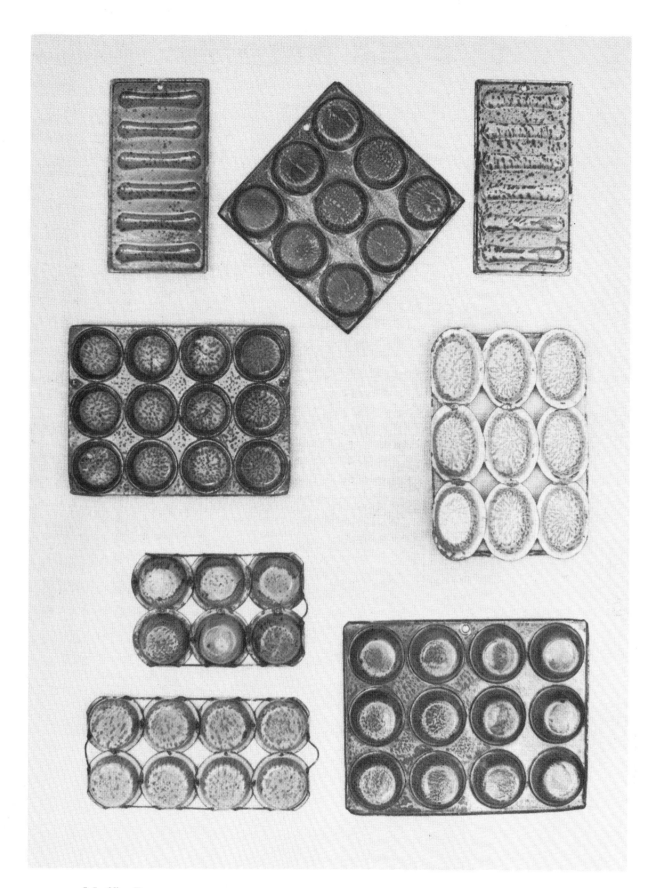

Muffin Pans

Row 1: *Ladyfinger pan, inside view, $35. 9-cup pan with hang hole, $16.50. Ladyfinger pan, back view, $35.* **Row 2:** *12-cup pan with 2 hang holes, $15. "Agate" oval Vienna Baker, "L & G," cups riveted into wire frame, very heavy, $65.* **Row 3:** *6 cups in wire frame, $35. 8 cups crimped over wire frame, very old, $35. 12-cup muffin pan, $15.*

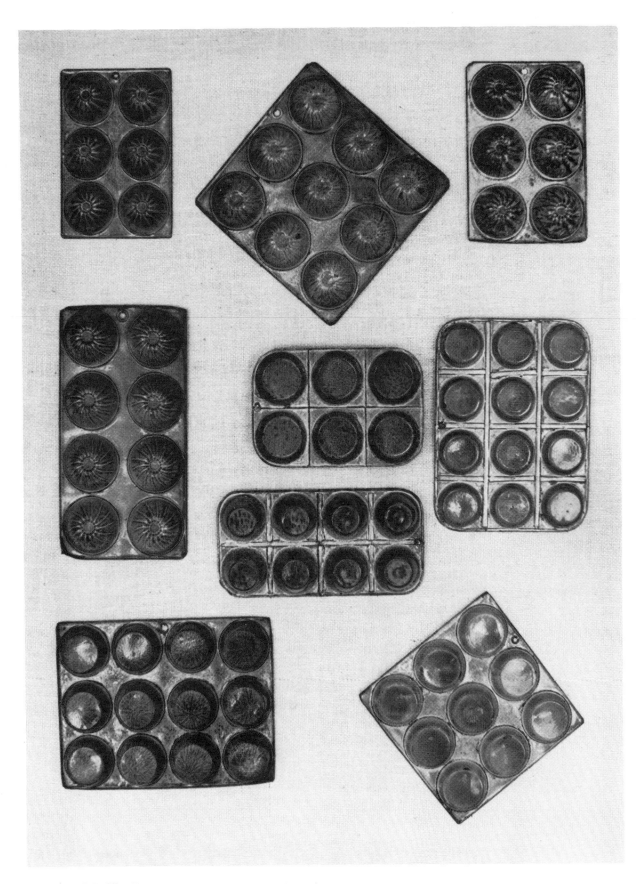

Muffin Pans

Row 1: *Turk's Head pan, signed "Extra Agate L & G," 6-cup, $35. Muffin pan, signed "Granite Steel Ware, St. Louis Stamping Co., Pat July 21, 188–," $37.50. Muffin pan, $35.* *Row 2:* *Turk's Head pan, $37.50. 6 cups attached by metal straps, $27.50. 8-cup muffin pan, $35. Muffin pan, $35.* *Row 3:* *12-cup muffin pan, $15. Pan, signed "Extra Agate L & G," $25.*

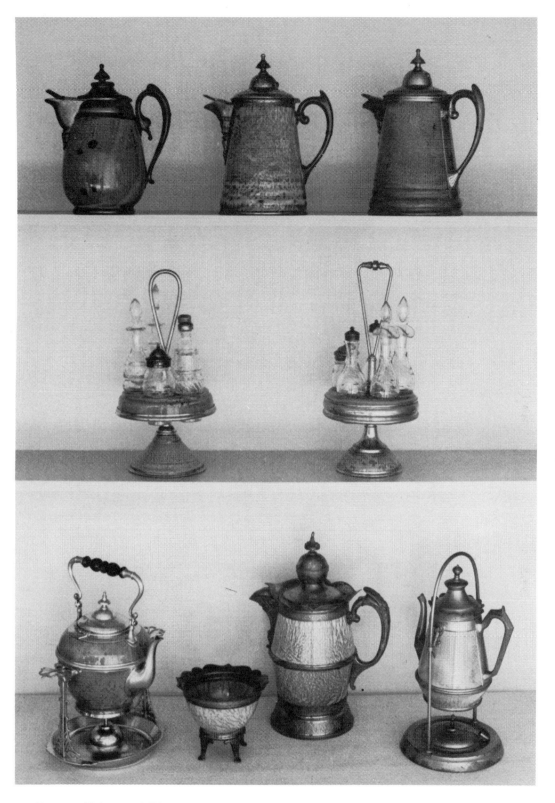

Pewter Trimmed Pieces

Row 1: *Coffeepot with covered spout, "Manning Bowman & Co.," $95. Coffeepot with solid copper base, marked "Patent Pending," 5-pint, "Perfection Granite Iron Ware," $125. Coffeepot, copper rim on base, "Perfection Granite Iron Ware," $135.* *Row 2:* *Caster set for five cruets and shakers, silver trimmed, $300. Caster set, $325.* *Row 3:* *Mikado teakettle, signed "Granite Iron Ware, Patent May 30, 1876," alcohol burner, silver trim, $168 plus $108 restoration, total $276. Sugar bowl marked "5000," three-legged, ivy design on pewter, $45. Server, double graniteware walls, opening on base for water for temperature control, signed "Manning Bowman & Co., 300," $175. Teapot with pewter stand and alcohol burner, scalloped collar and snuffer on chain, $135.*

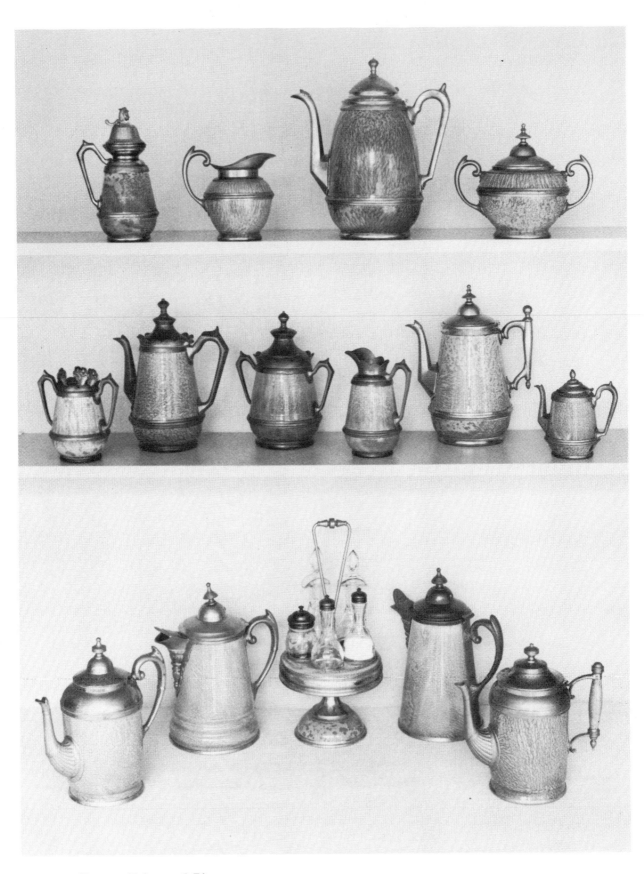

Pewter Trimmed Pieces

Row 1: Syrup pitcher with lady's head finial, $125. Creamer, $100. Teapot, $135. Sugar bowl, $100.
Row 2: "Granite Iron Ware" tea set—spooner, teapot, sugar bowl, creamer, $400. "Perfection Granite Iron Ware" teapot, $115. Teapot, 1-cup, $100. *Row 3:* Teapot, "Perfection Granite Iron Ware," $110. Coffeepot with copper rim on base, $100. Five-bottle caster set, $325. Coffeepot, $125. Teapot with pewter and porcelain handle, $135.

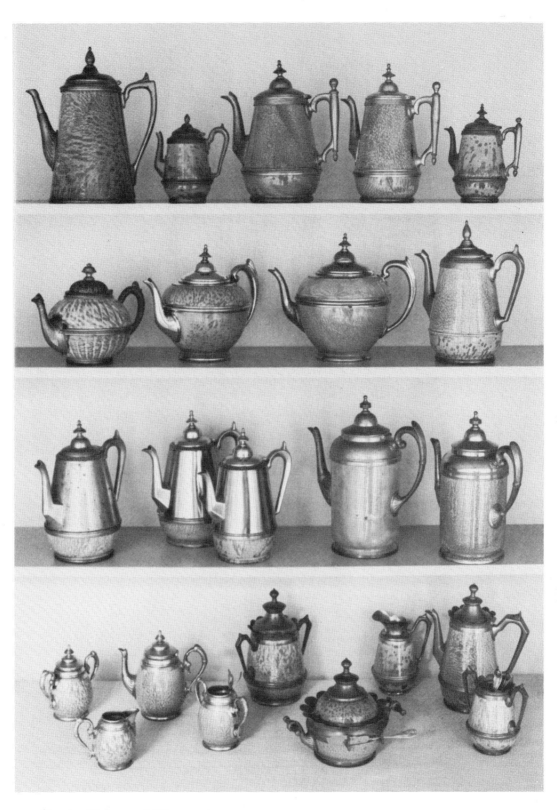

Pewter Trimmed Pieces

Row 1: *Teapot, signed "Granite Iron Ware, May 30, 1876, July 3, 1877," handle attached to metal strap running from lid to copper rim on base, $125. 1-cup teapot, signed "Granite Iron Ware, Pat. May 30, 1876," copper rim on base, $120. 8-cup teapot, $110. 6-cup teapot, $90. 2-cup teapot, $75.* ***Row 2:*** *Melon shaped teapot, spout repaired, $125. Pekin teapot, $125-150. Pekin teapot, $125-150. 8-cup teapot, copper rim on base. $85.* ***Row 3:*** *Teapot, metal body, pewter lid, spout and handle, granite base, spout repaired, $75. Two teapots, metal bodies, pewter lids, spouts and handles, granite bases, highly polished, $100 each. Two teapots, straight sides, "Perfection Granite Ware," $110 each.* ***Row 4:*** *Four-piece tea set, stamped "Manning Bowman & Co." on plated copper base, Rare, Mint, $500. "Granite Iron Ware" tea set, scalloped collars, $500. Butter dish with ice compartment, $150.*

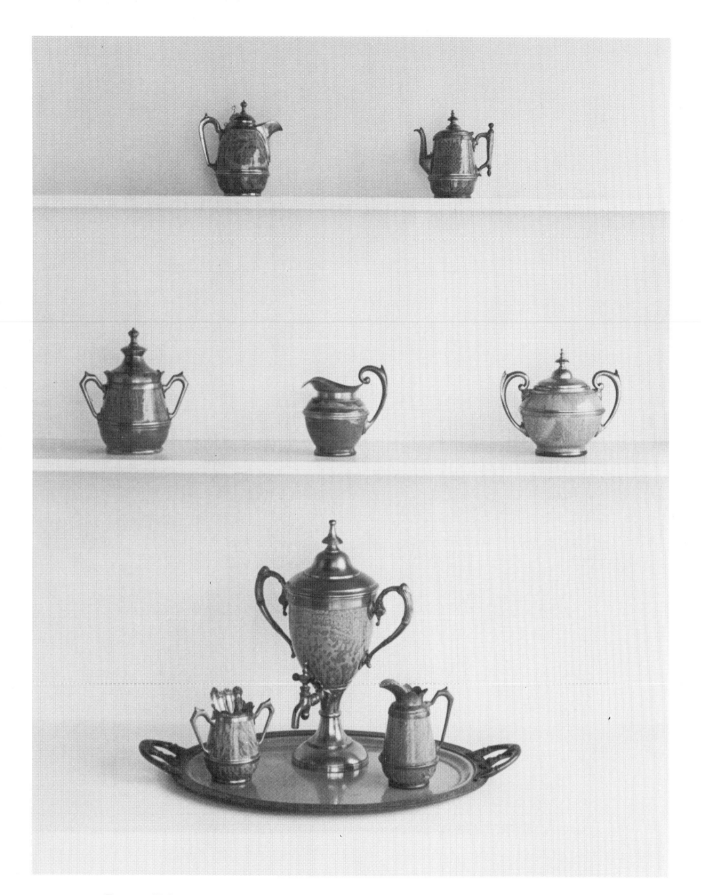

Pewter Trimmed Pieces

*Row 1: Syrup pitcher, $125. Teapot, $125. **Row 2:** Sugar bowl, $100. Cream pitcher, $100. Sugar bowl, $100. **Row 3:** Spooner, $100. Urn, $300. Cream pitcher, $100. Tray, $250.*

Photograph by Glen R. Moore

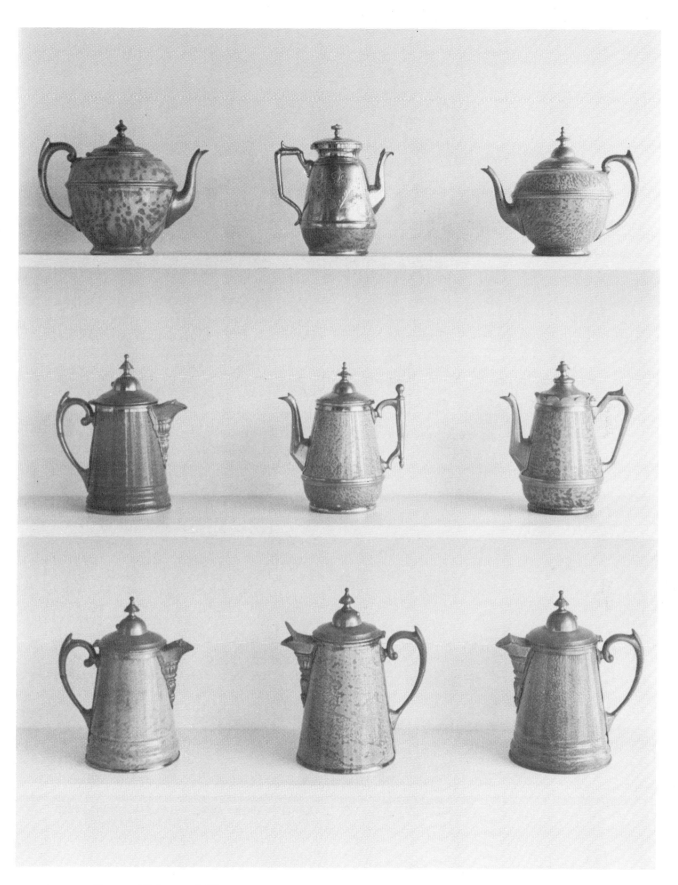

Pewter Trimmed Pieces

Row 1: *Teapot, $150. Teapot with planished tin, $125. Teapot, $150.* **Row 2:** *Coffeepot, $175. Teapot, $150. Teapot, $165.* **Row 3:** *Three coffeepots, $175 each.*

Photograph by Glen R. Moore

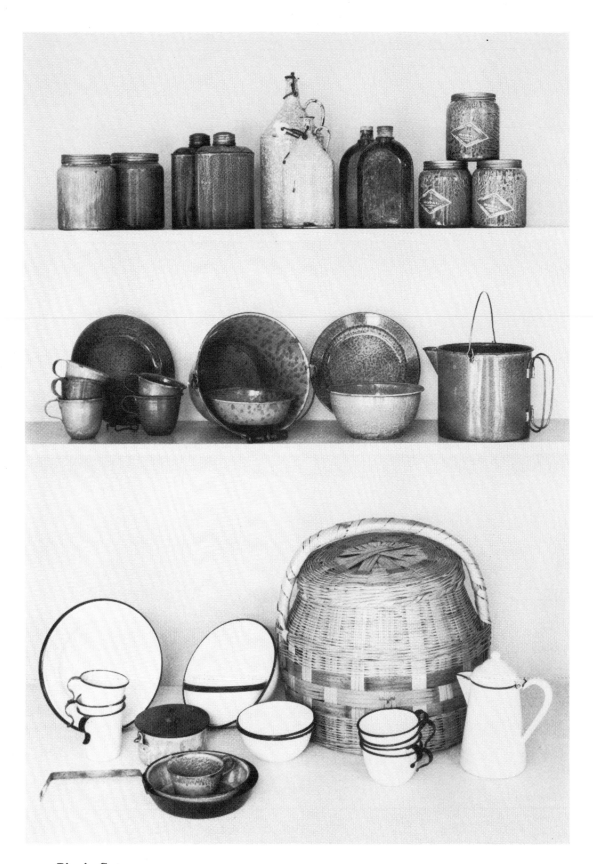

Picnic Sets

Row 1: *Pair of coffee flasks, tin cork-lined screw-on lids, $35 each. Pair of 1-pint coffee flasks, tin screw-on caps, $28-45 each. Liter and ½-liter flasks, clamp-on porcelain lids, $25 each. Pair of "L & G" flasks, $40 each. Three flasks, labeled "Royal Nesco," tin screw-on lids, Mint, $45 each.* *Row 2:* *Picnic set, cups, plates and bowls fit into bucket, $75. Water carrier, handles fold flat, $35.* *Row 3:* *White picnic set includes original basket, coffeepot, cups, plates, bowls, mugs, $52.50. Complete mess kit—bowl, cup, tin-covered cook pot and iron skillet fit into khaki shoulder strap carrier, $47.50.*

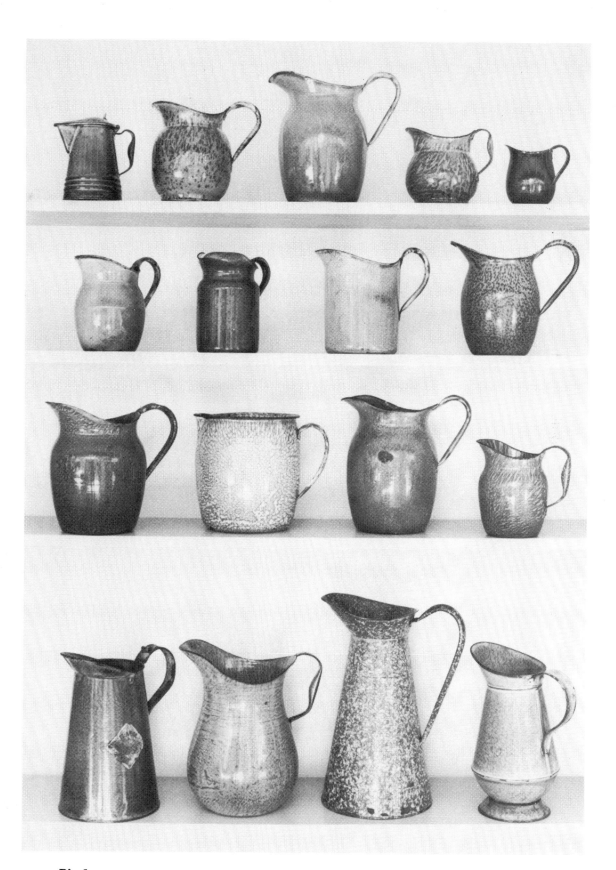

Pitchers

Row 1: Molasses pitcher, Mint, $22.50. Convex milk pitcher, $17.50. Water pitcher, $22.50. Cream pitcher, $28. Dark blue cream pitcher, $14. *Row 2:* Milk pitcher, "Extra Agate," $25. Water pitcher with ice lip, $27.50. Water pitcher, $22.50. Water pitcher, $25. *Row 3:* Convex water pitcher, seamless, "L & G Mfg Co," $25. Pitcher with ice lip and dark blue rim, $17.50. Water pitcher, $15. Milk pitcher, $22.50. *Row 4:* Ale measure, labeled "El-an-ge," lid missing, $28. Water pitcher, "Nesco," Mint, $35. Pitcher, $18. Pitcher, part of set, footed basin missing, $22.50.

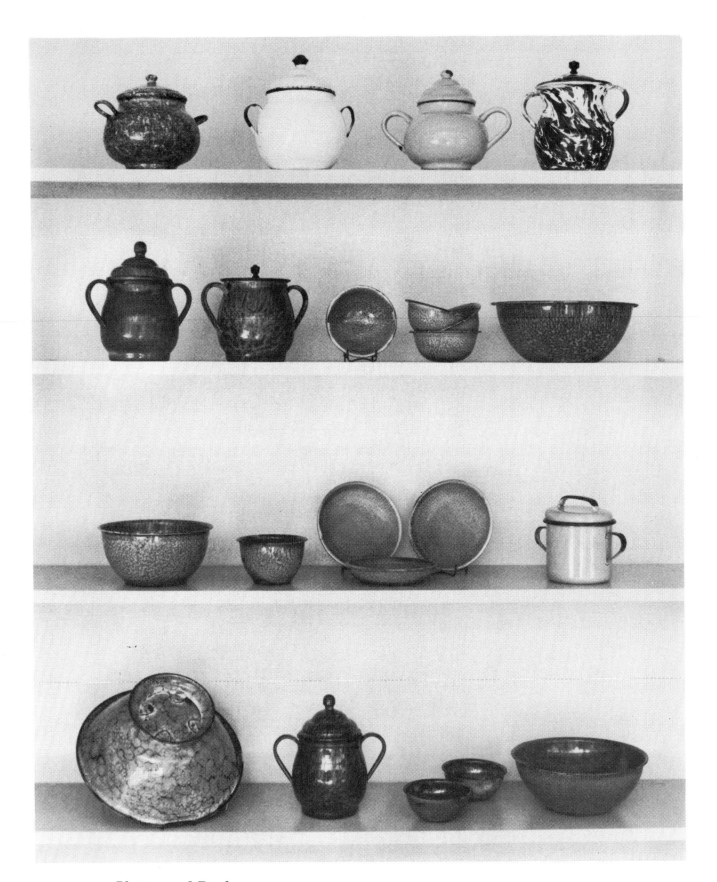

Platters and Bowls

Row 1: Sugar bowl, wire handles, $18.50. Sugar bowl, white with navy trim, $17.50. Bright blue sugar bowl, $22.50. Brown and white sugar bowl, very old, $35. *Row 2:* Sugar bowl, $30. Sugar bowl, tin lid, $27.50. Set of four serving bowls, $13.50. Mixing bowl, $12.50. *Row 3:* Two bowls from graduated set of ten, $10 each. Set of three shallow bowls, $8 each. Gray sugar bowl, blue trim, military (U.S.N.), $10. *Row 4:* Bowl, $27.50. Sugar bowl, $28. Fruit bowl and set of serving bowls, $35.

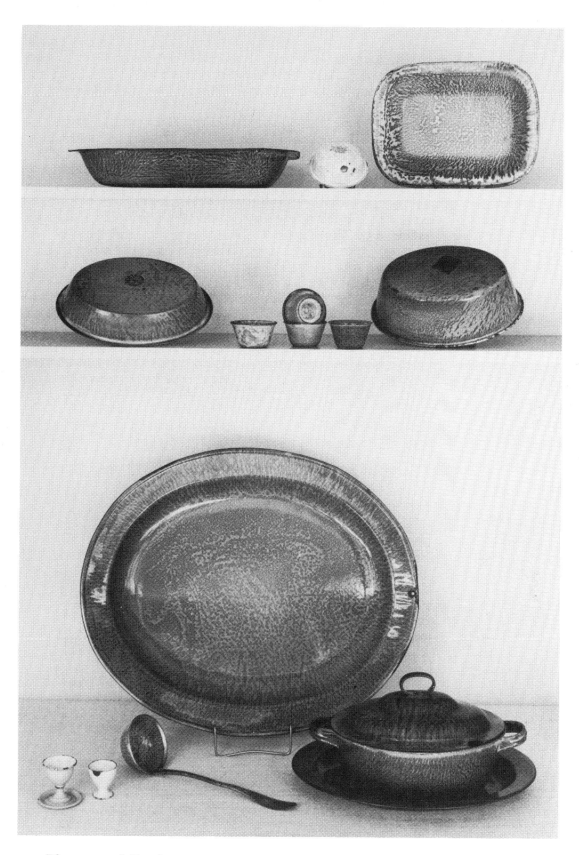

Platters and Bowls

Row 1: *Vegetable serving dish, $10. Pan with Eagle trademark, labeled "Columbian Ware," $12.50. Vegetable serving dish, $12.50.* *Row 2:* *Pie plate, labeled "Extra Agate L & G," 11"×2", $15. Set of four muffin pans, one signed "L & G Mfg Co," $25 set. Oval cake pan, signed "Granite Iron Ware '76-'77," $17.50.* *Row 3:* *Blue egg cup with gold trim, saucer attached, $12.50. White egg cup, $3. Pewter trimmed soup ladle, $45. Turkey platter, hole drilled in rim after manufacture, $50. Soup tureen, slot in lid for ladle handle, $37.50.*

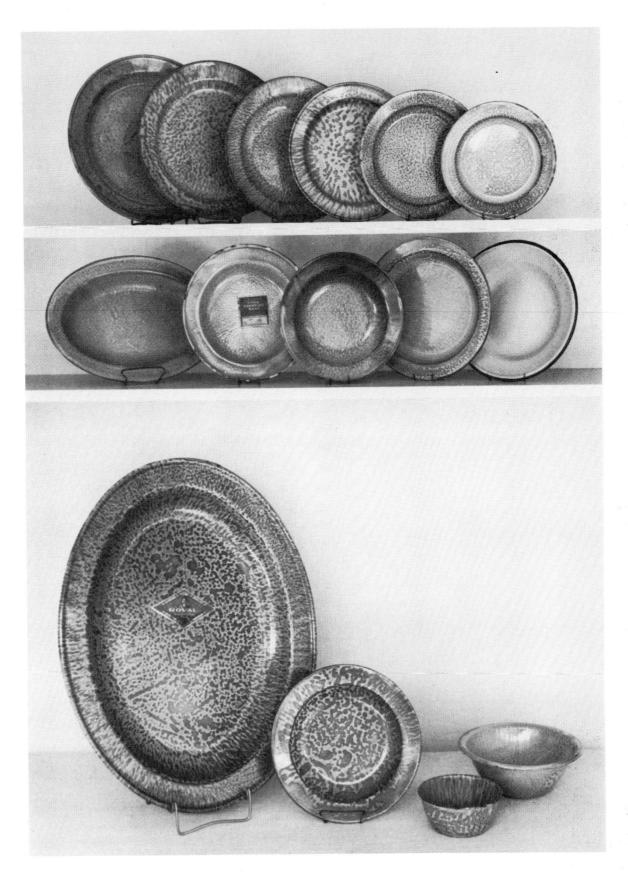

Platters and Bowls

Row 1: Dinner plate, 11", $10. Dinner plate, $7.50. Luncheon plate, $6. Breakfast plate, $6. Dessert plate, $5. Salad plate, $12. *Row 2:* Serving platter, signed "Granite Iron Ware, Pat. May 30, 76 and May 8, 77," Rare, $13.50. Plate, labeled "Titan, Banner Stamping Works," $10. Soup bowl, $8. 9" plate, $7.50. Soup bowl, navy trim, $3. *Row 3:* Platter, labeled "Royal," $45. Soup bowl, $9.50. Serving bowl, $8. Mixing bowl, $6.

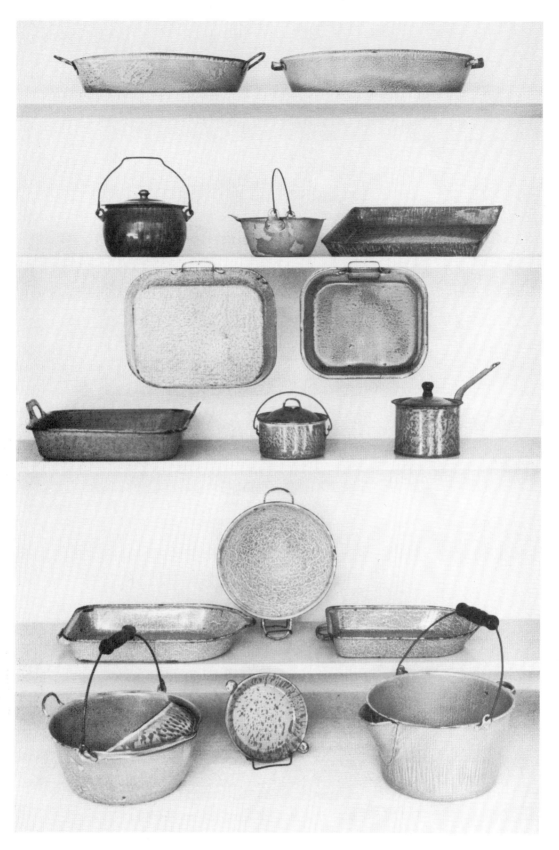

Pots and Pans

Row 1: *Pudding pan, signed "Granite Iron Ware," $17.50. Baking pan, signed "Granite Iron Ware,"*
$17.50. **Row 2:** *Saucepan, convex type, $12.50. Lipped saucepan with pierced ear, $15. Oblong pie*
plate or biscuit pan, 8"×12", $12.50. **Row 3:** *Two baking pans, $10 each.* **Row 4:** *Baking pan,*
signed "Extra Agate," $10. 1-pint covered kettle, $15. 1-quart covered saucepan, wood knob, $17.50.
Row 5: *Baking pan with pouring spout, $14. Wok-shaped pan, $29.50. Baking pan, $14.* **Row 6:**
Saucepan with strainer, $25. Egg plate, $17.50. Saucepan with strainer spout, $17.50.

Pots and Pans

Row 1: Tart pan, $6. Tart pan, 6", signed "Granite Iron Ware," $12. Tart pan, $6. *Row 2:* Green and white "Chrysolite" pan, $12. Green and white, signed "Elite Austria," $9.50. "Agate" pan, $7.50. *Row 3:* Pan, signed "Extra Agate L & G," $7.50. Labeled "El-an-ge," $12.50. Signed "Agate, L & G," $8. *Row 4:* Signed "Agate Nickel Steel L & G," $9. Signed "Extra Agate L & G," $7.50. Signed "Granite Iron Ware," $9.

Pots and Pans

Row 1: Blue and white cake pan, 11", $7.50. Black and white cake pan, $9. Square pan for jelly cake or fudge, $10. **Row 2:** Cake pan, signed "Granite Iron Ware," $7. Cake pan, $4. Cake pan, signed "Granite Iron Ware," $6. **Row 3:** 8" square cake pan, $9. Cake pan, $4. Pan, signed "Extra Agate L & G," $5. **Row 4:** Three jelly cake pans, $8 each.

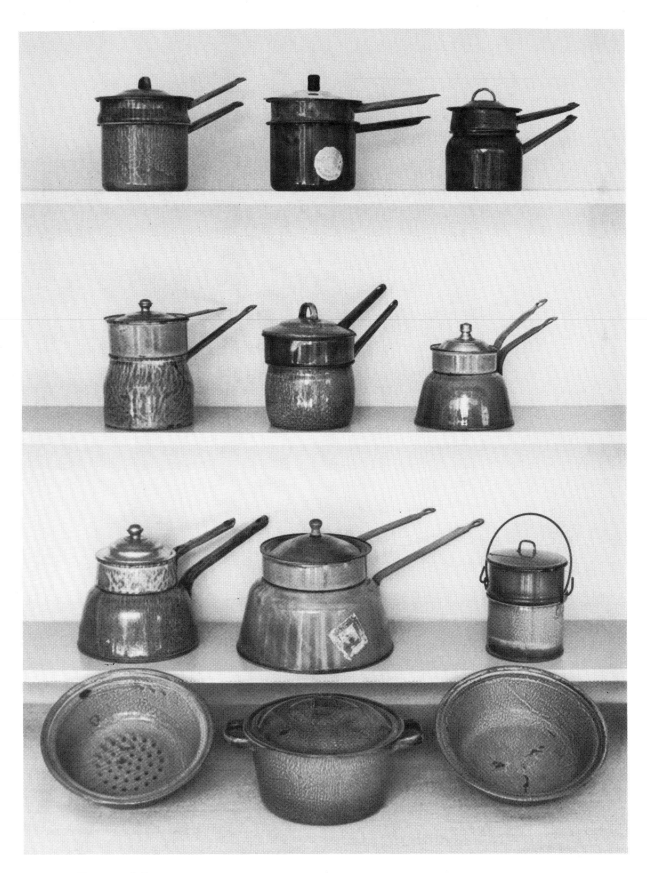

Pots and Pans

*Row 1: Double boiler, $15. Double boiler, labeled "French Gray," tin lid, Mint, $22.50. Double boiler with brass grommets in handles, $22.50. **Row 2:** Double boiler, $12.50. Double boiler, $15. Milk or rice boiler, signed "L & G Extra Agate," $25. **Row 3:** Double boiler with tin lid, $22.50. Double boiler, labeled "Nesco," $29. Lunch bucket type boiler, $22.50. **Row 4:** Four-piece steamer includes double boiler top and steamer insert, $10.*

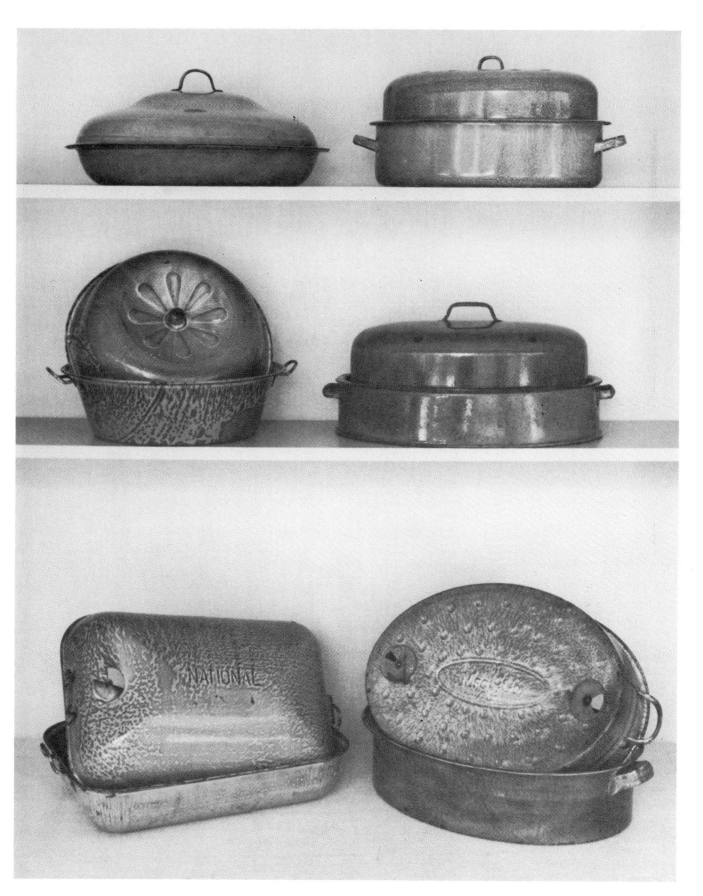

Pots and Pans

Row 1: *Oval vegetable dish with matching cover, $17.50. Roaster, self-basting, $17.50.* **Row 2:** *Round roaster, $17.50. Oval roaster, $15.* **Row 3:** *Roaster, embossed "National," $22.50. Roaster, self-basting, two vents, embossed "L & G Mfg Co," $35.*

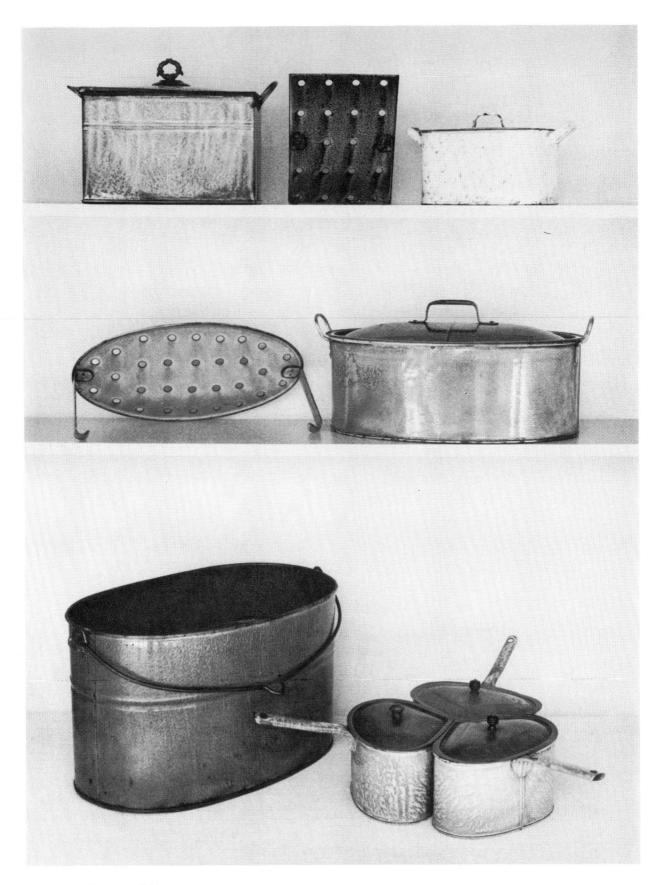

Pots and Pans

Row 1: Asparagus or corn boiler and drainer, $125. Green and white asparagus or corn boiler, signed "Elite Austria," $35. *Row 2:* Ham boiler and drainer, 10"×17", $22.50. *Row 3:* Boiler, lid missing, $35. Combination triple saucepans with tin covers, Mint, $75.

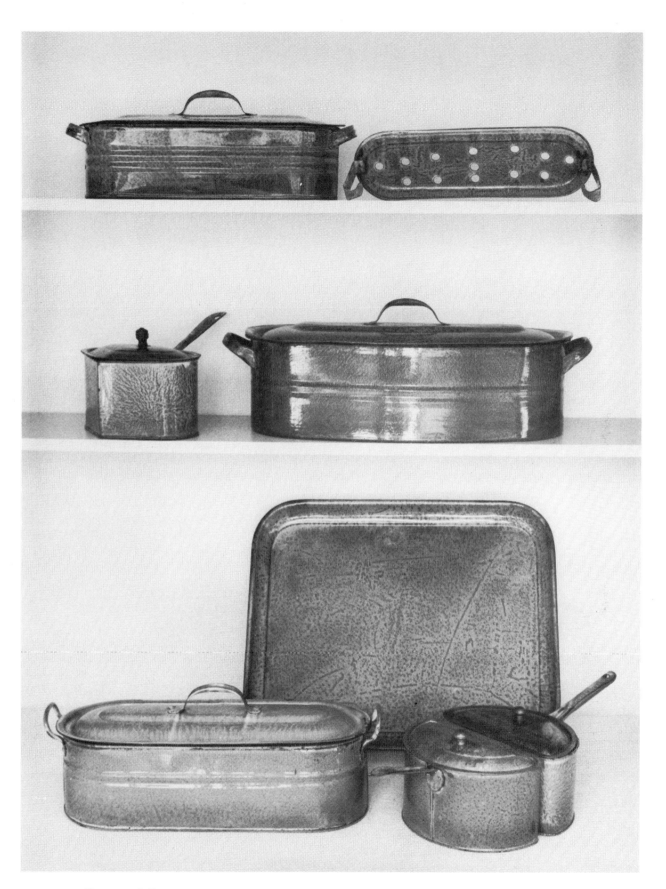

Pots and Pans

Row 1: Fish kettle with rack, signed "L & G," 15"×4½", $55. *Row 2: One pan from triple saucepan set, enameled lid, $25. Fish boiler, $65.* *Row 3: Fish kettle with enameled drainer, signed "L & G," $55. Tray, 16½"×20", $50. Combination double saucepans with tin covers, $55.*

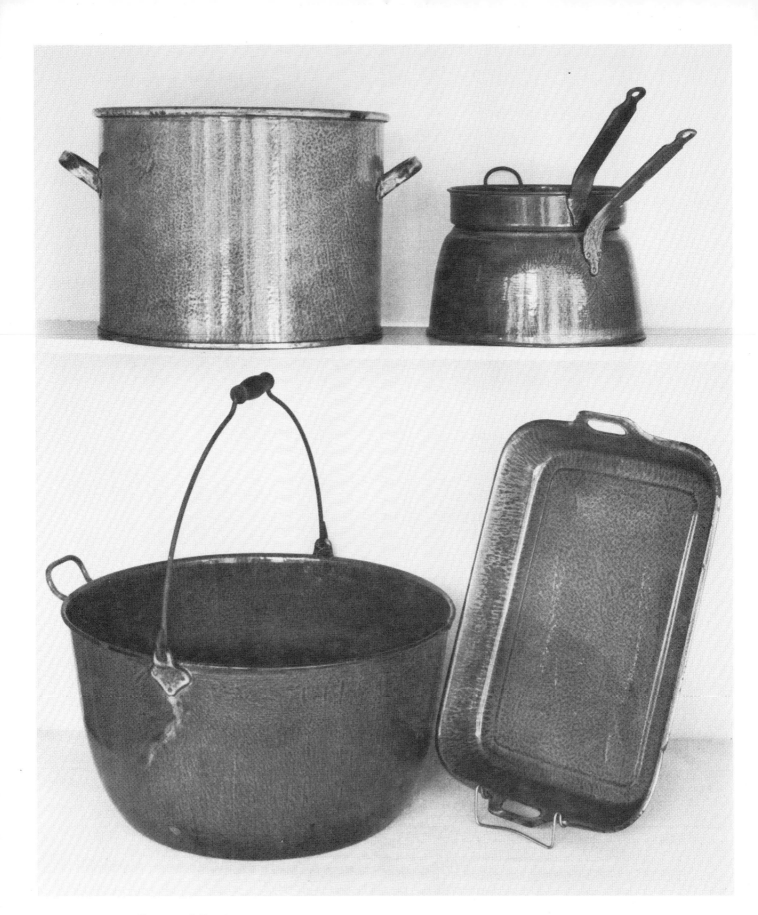

Pots and Pans

Row 1: Boiler, "Climax," copper bottom, signed "L & G," 16½" diameter, $65. Double boiler, signed "L & G," lid missing, $45. *Row 2:* Preserve kettle, signed "L & G," wood bail, 22" diameter, Excellent, $28-65. Baking pan, signed "Agate L & G," $17.50.

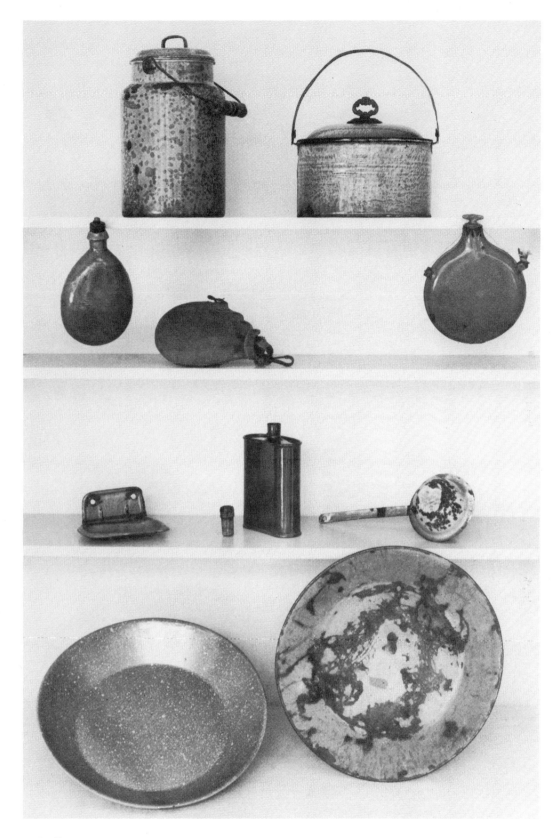

Relics

Row 1: Wide-mouth milk kettle, wood bail, from Texas, $8.50. Miner's lunch bucket, pie tray, signed "Granite Iron Ware '76, '77," metal knob, $17.50. *Row 2:* Flask, khaki cover, military item, two views, $35. Early flask, screw-in lid, $15. *Row 3:* Old soap dish found on cabin wall, $2. Dark blue curved flask, carved wood cork, $8. Whimsey, noisemaker—two cups riveted together, attached handle, metal pieces inside cups; said to belong to employee of Canton Stamping Company, Canton, Ohio, $5. *Row 4:* Miner's gold pan, 16½"×2⅜", Mint, $32. Gold pan found by Evelyn Welch in Mother Lode Gold Country, California, at abandoned dump; used as a target, signed "L & G Extra Agate," $3.

Scoops

Row 1: *"Agate Iron Ware" cookbook, $15. Druggist's scoop, labeled "40 years L & G Mfg Co," and "Agate L & G Mfg Co," Mint, $47.50. Thumb scoop, $25.* *Row 2:* *Ice or candy scoop, "L & G," hollow handle, $32.50. Confectioner's or family scoop, "L & G Agate," wood handle attached by metal ferrule, $45. Enameled pieced ring handle scoop, Rare, $35.* *Row 3:* *Signed "L & G" thumb scoop, Mint, $35. Scoop with strap handle, Mint, $45. "Granite Iron Ware" cookbook, $15. Scoop with thumb rest, Mint, $35.* *Row 4:* *"Granite Iron Ware" cookbook, $15. Thumb scoop, $17.50. Druggist's scoop, signed "Extra Agate L & G," $42.50. ½-cup druggist's scoop, $35. Thumb scoop, $15.*

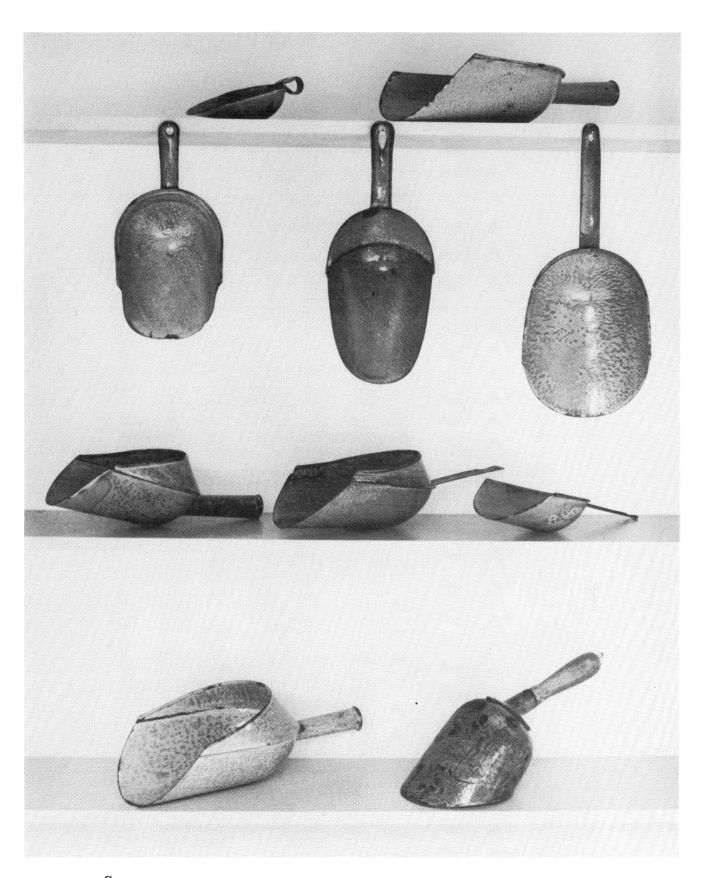

Scoops

Row 1: *"Agate" thumb scoop, $25. "L & G Agate" grocer's scoop, hollow handle, $22.50.* **Row 2:** *Heavy covered scoop, applied handle, $32.50. Extra heavy iron scoop, $32.50. "Nesco" scoop, $25.* **Row 3:** *Covered grocer's scoop, $22.50. Grocer's scoop, strap handle, $25. "Nesco Royal Granite" grocer's scoop, $25.* **Row 4:** *"Agate" grocer's scoop, $27.50. Enameled iron utility scoop, seamless, wood handle firmly in place, ferrule riveted on, shows hard use, $25.*

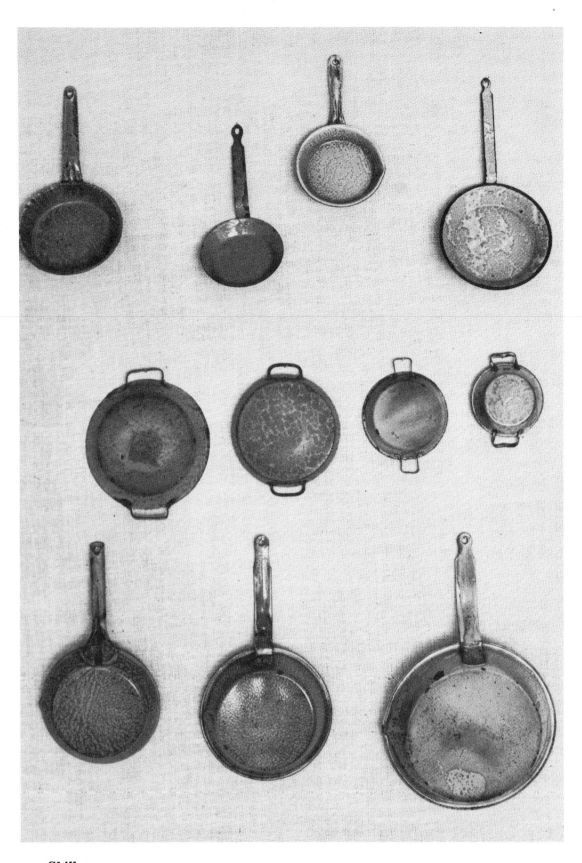

Skillets

Row 1: Skillet, hollow handle, signed "Extra Agate," $9.50. Bright blue egg pan, 4" diameter, $9. Fry pan from child's Domestic Science cookset, $10-25. Heavy dark blue trimmed skillet, Mint, $17.50.
Row 2: Fry pan, signed "Granite Iron Ware, May 30, '76, July 8, '77," $20. Egg plate, seamless, "L & G," $7.50. Egg plate, $9.50. Egg plate, $12.50. **Row 3:** Heavy iron fry pan, "Cold Handle, L & G," $17.50. Stew pan, lightweight, "L & G," $8.50. Stew pan, $10.

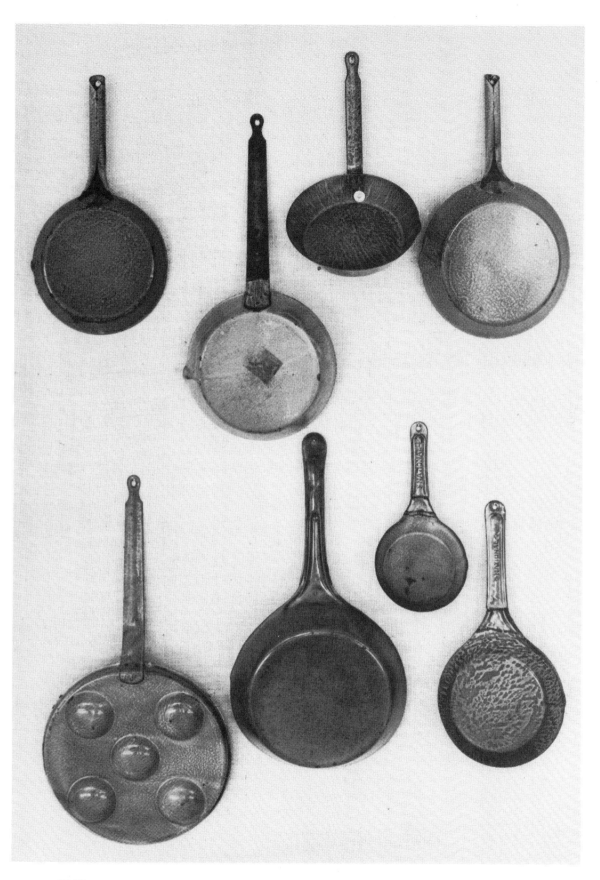

Skillets

*Row 1: Heavy iron pan, $15. Skillet with unfinished handle, signed "Granite Iron Ware, Pat. May 30, 1876, July 8, 1877," $22.50. Skillet with Mendet repair, $2. Heavy iron skillet, $25. **Row 2:** "Agate" egg fry pan with five eyes, $25-45. 10½" skillet, "Cold Handle," brass grommet hang hole, Mint, $25. 5½" and 8" skillets, "Cold Handle" and "National" embossed on handles, $17.50 each.*

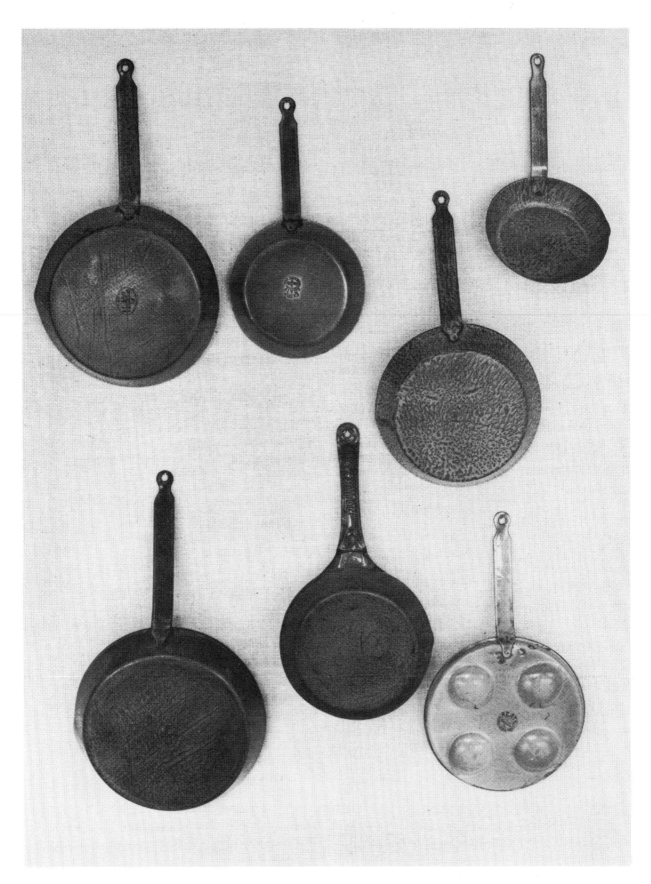

Skillets

Row 1: *Heavy iron pan, signed "L & G Mfg Co," $17.50. Skillet, signed "Extra Agate L & G Mfg Co," Mint, $22.50. Very old skillet, "L & G," $17.50. Skillet, "L & G," $10.* **Row 2:** *Heavy 12" skillet, signed "L & G Mfg Co," $27.50. Skillet, handle embossed "Cold Handle, L & G," $27.50. Egg fry pan, four eyes, signed "L & G Extra Agate," $25-45.*

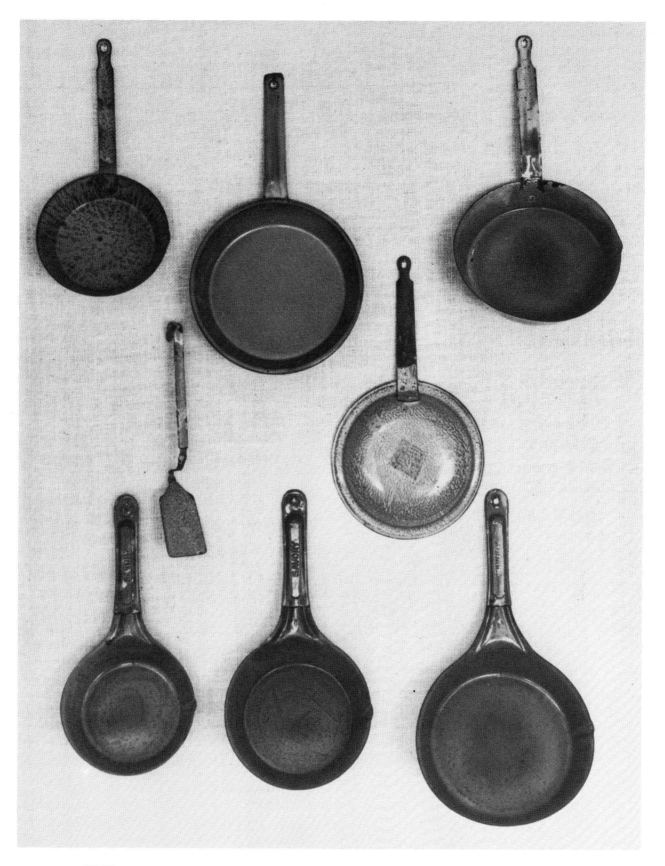

Skillets

Row 1: *Iron fry pan, $12.50. Stew pan, $9. Iron fry pan, $15.* *Row 2:* *Cake turner with French handle, $10. Upper part of chafing dish set, signed "Granite Iron Ware '76 & 77," unfinished "Cold Handle," very old, $27.50.* *Row 3:* *Two "Savory Cold Handle" lipped fry pans, Mint, $17.50 each.* *"Savory Cold Handle" lipped fry pan, Mint, $22.50.*

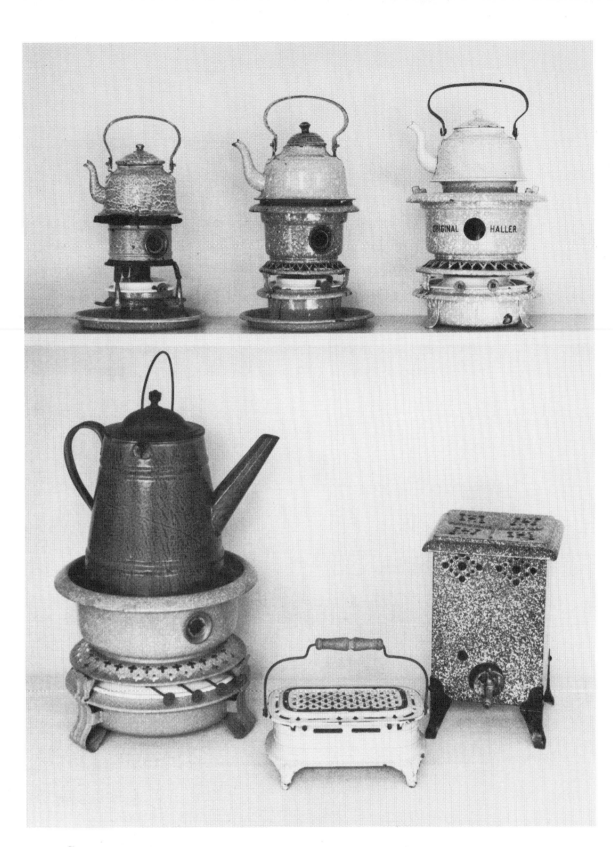

Stoves

Row 1: 13" one-burner kerosene stove, Rare, complete unit of six parts—26-ounce teakettle, pit bottom; three-legged kettle holder, brass-rimmed glass hole, signed "George Haller Original Germany 259"; wick holder and stem, serves as fuel container cover; fuel container; three-legged stand embossed "259"; base tray, embossed ring fits fuel container, $200. One burner kerosene stove, teakettle lid not original, $175. "Original Haller" two-burner model, tray and brass-rimmed glass cover missing, teakettle not original, $160. Row 2: Four-burner portable kerosene stove, tray and teakettle missing, $75. Water carrier on stove, $45. Foot warmer, hinged lid, signed "Godin & Cie AGUISE AISNE Bte S.G.D.G. No 5," Gray, $100. Natural gas heater, brass fitting, $25.

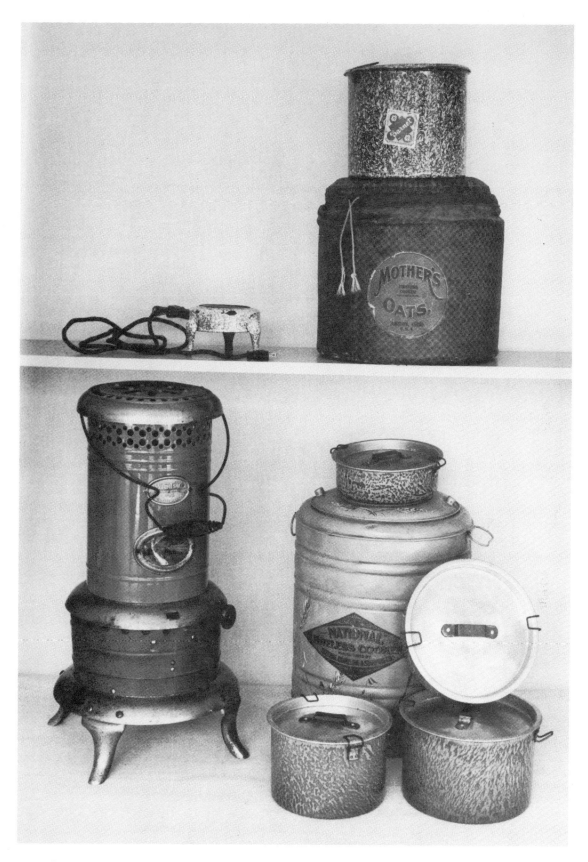

Stoves

Row 1: *Electric burner, 4½″ diameter, $35. "Mother's Oats Fireless Cooker, Pat. Oct. 23, 1908,"* *canvas cover, food pot labeled "Garnet, Cream City Ware, Milwaukee, Wisc.," $65.* ***Row 2:*** *Blue kerosene room heater, labeled "Montgomery Ward, Windsor," Mint, $47.50. Fireless cooker, labeled "National Peerless Cooker Manufactured by Nesco," food pots with clamp-on lids, soapstone discs for heating, $75.*

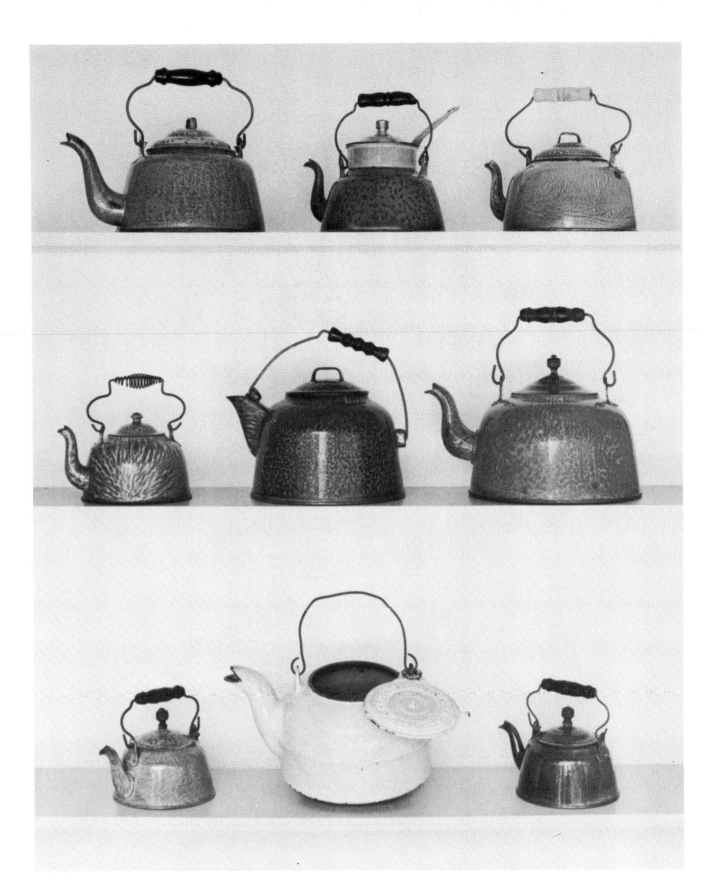

Teakettles

Row 1: *1-gallon teakettle, $22.50. 2-quart kettle, double boiler inset, tin lid, $42.50. 3-quart kettle, $17.50.* *Row 2:* *1½-quart kettle, "Alaska" handle, $37.50. Teakettle, unusual shape, $45. 2-gallon kettle, wood bail handle, $25.* *Row 3:* *1-quart, wood bail and knob, Mint, $35. Heavy enameled iron teakettle, pit bottom, premium given for purchase of kitchen stove from Wrought Iron Range Co., St. Louis, Mo., as signed on cover, $47.50-95. 1-quart, signed "L & G Mfg Co," Mint, $65.*

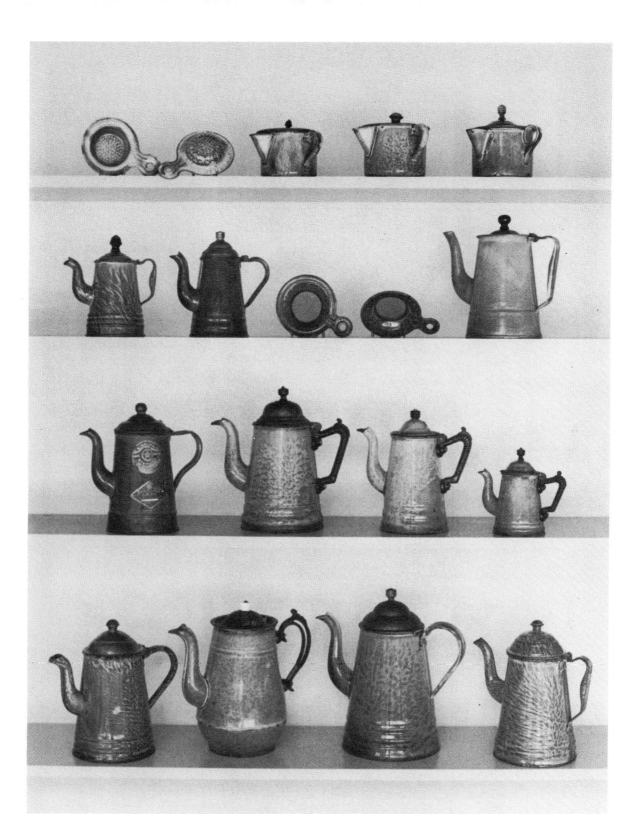

Teapots

Row 1: Tea strainer, inside and back views, $20. Tea steeper, tin lid with wood knob, identical to invalid feeder or baby food cup, $25. Tea steeper, tin lid and spun hollow knob, $25. Tea steeper, early "L & G Extra Agate Ware" trademark inside lid, Rare, $32. *Row 2:* 3-cup teapot, replaced lid, $15. Quart teapot, dark gray with tin lid, Mint, $22.50. Tea strainer with wire inset, inside and back views, $22.50. Hollow handle teapot, tin lid, wood knob, Mint. $22. *Row 3:* Labeled "Sterling Gray, Pat. Sept. 6, 1902," Mint, $35. Iron handled teapot, 6-cup, tin lid, $45. 4-cup, signed "L & G Mfg. Co.," $45. 1-cup, wood knob, $42.50. *Row 4:* 6-cup, tin lid, spun knob, $22.50. Teapot with slit iron handle, signed "L & G," tin lid, knob replaced, $57.50. Teapot with tin lid, Mint, $27.50. 6-cup teapot, Excellent, $25.

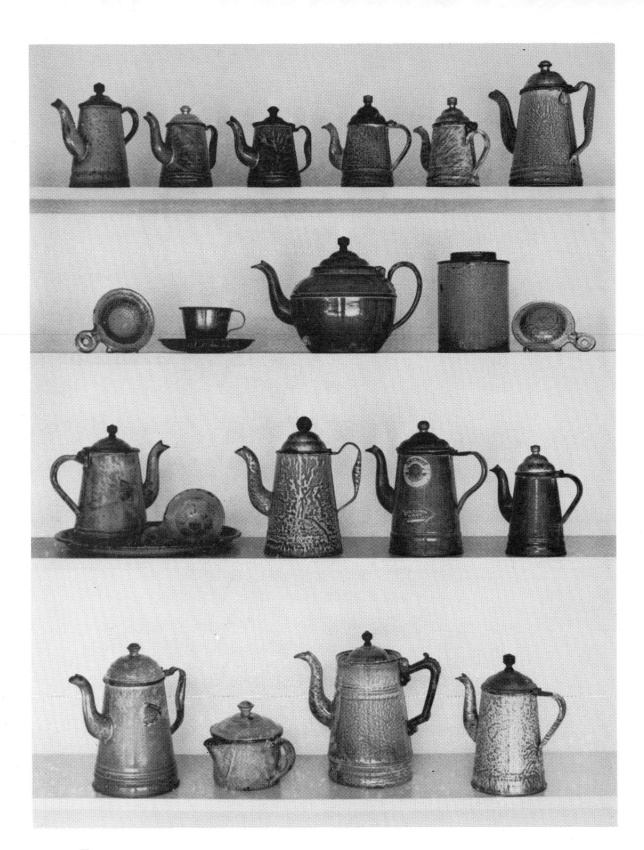

Teapots

Row 1: "Cat's Eye" pattern, tin lid, $22.50. Four 1-cup teapots, different mottling patterns, $27.50 each. Hollow handled teapot, tin lid, $20. *Row 2:* Tea strainer, inside view, $20. Tea cup and saucer, Mint, $12.50. "Pekin" pot, wood knob on domed lid, $45. Tea canister, 1-pound capacity, tin screw-on lid, $45. Tea strainer, back view, $20. *Row 3:* 12" round tray, $24. Tea strainer, holes pierced in clusters, $15. Teapot, labeled "Royal Steel Ware, Pat. Oct 9, 1894," $32.50. Teapot, domed lid and wood knob, $25. Teapot with two "Sterling" labels, Mint, $35. 3-cup with domed tin lid, $20. *Row 4:* Labeled "Royal," Mint, $27.50. Tea steeper, strap handle and applied spout, $25.50. Teapot with L & G Mfg. Co. handle, $47.50. High contrast in mottling, tin lid, wood knob, $22.50.

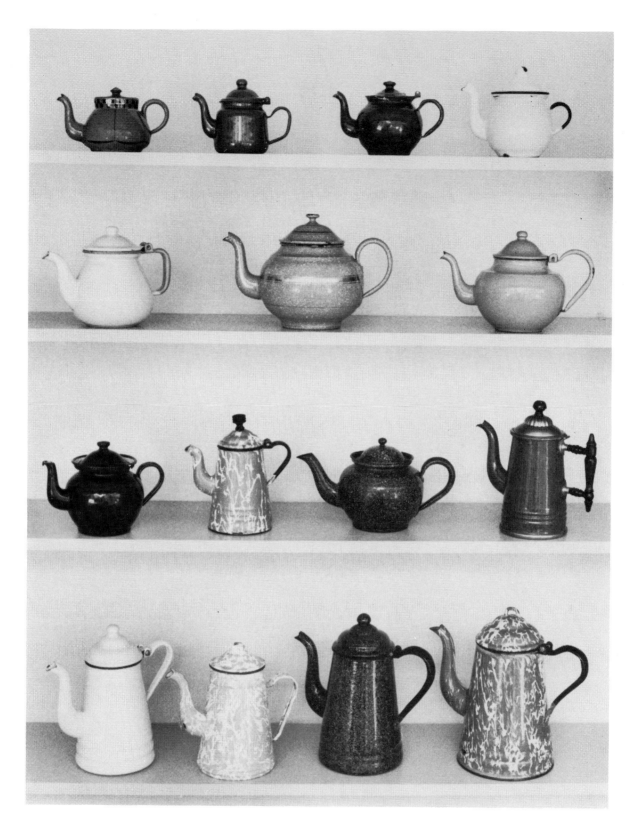

Teapots

Row 1: *Teapot, signed "Made in Czechoslovakia," coral colored, individual size, $22.50. Restaurant-type individual pot, dark green with hinged lid, $2-6. Pekin teapot, garnet color, $7.50. Teapot, navy trim, $6.50.* **Row 2:** *Cream colored teapot, light blue trim, $15. Bright blue teapot, gold trim, $45. Pekin teapot, bright blue, $27.50.* **Row 3:** *Brown Pekin teapot, $12.50. Blue and white teapot, dark trim and wood knob, $15. Dark blue Pekin teapot, $12.50. Garnet teapot, signed "Manning Bowman," copper rim, metal lid, wood handle, $37.50.* **Row 4:** *Teapot, Polar Ware Company, $17.50. Bright yellow and white teapot, $35. Brown teapot, $17.50. Green and white Chrysolite teapot, dark handle, $32.50.*

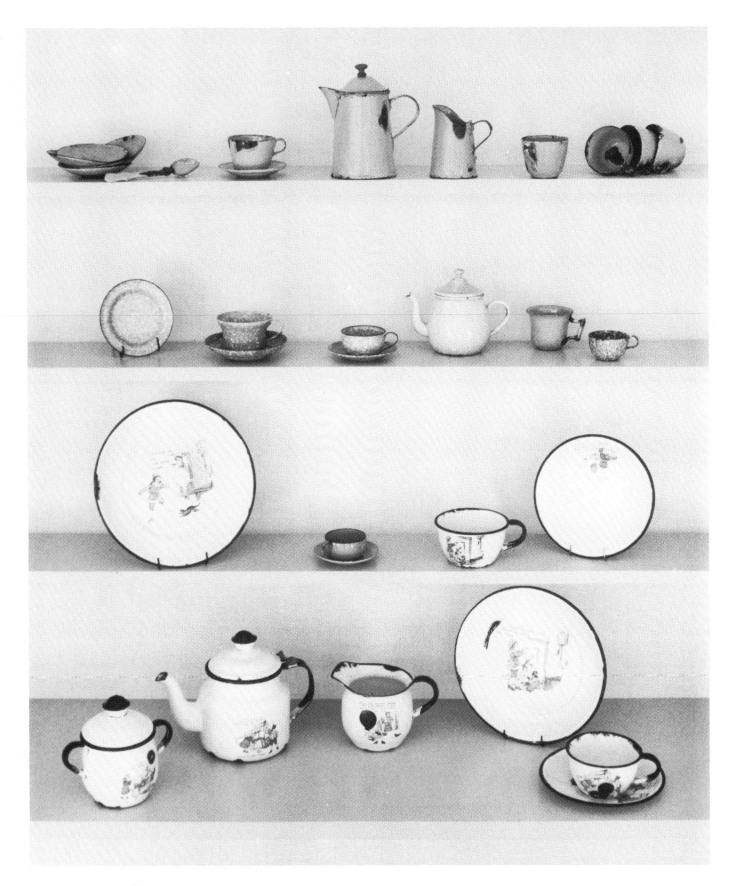

Toys

Row 1: *Blue coffee set—coffeepot, creamer, six cups and saucers, sugar bowl missing, $35.* **Row 2:** *3"
plate, cup and saucer, Mint, $40. Small gray cup and saucer, $8. Gray Pekin teapot, lid with hollow
knob, $35. Blue coffee cup with iron handle, $15. Small gray cup, $6.* **Row 3:** *Small blue cup and
saucer, $8.* **Rows 3 and 4:** *Child's nursery rhyme tea set from the 1920s, $50.*

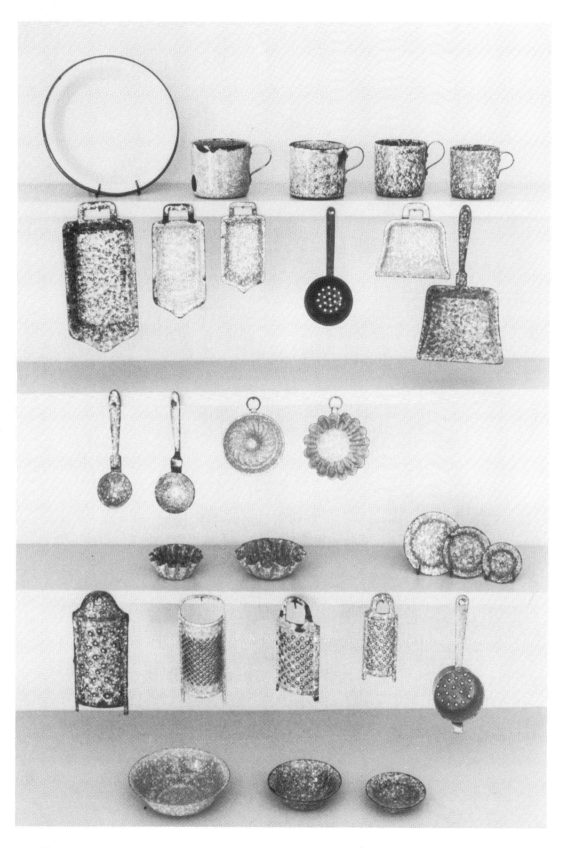

Toys

Row 1: *Pie pan, cream color with green trim, $6. Mug, $12.50. Mug, pieced bottom, seamed cup, very old, $25. Two mugs, $17.50 each.* **Row 2:** *Roast pan, $15. Roast pan, $12.50. Roast pan, $10. Dark blue tea strainer, $8. Dustpan, $15. Dustpan, $17.50.* **Row 3:** *Ladle, $12.50. Ladle, $15. Tube mold, ring handle, $25. Fluted mold, ring handle, $25.* **Row 4:** *Mold, $7.50. Mold, $10. Plate, $12.50. Plate, $10. Plate, $8.* **Row 5:** *Grater, $15. Grater, $12.50. Grater, $9. Grater, $20. Soup strainer, $15.* **Row 6:** *Wash basin, $15. Wash basin, $12.50. Wash basin, $10.*

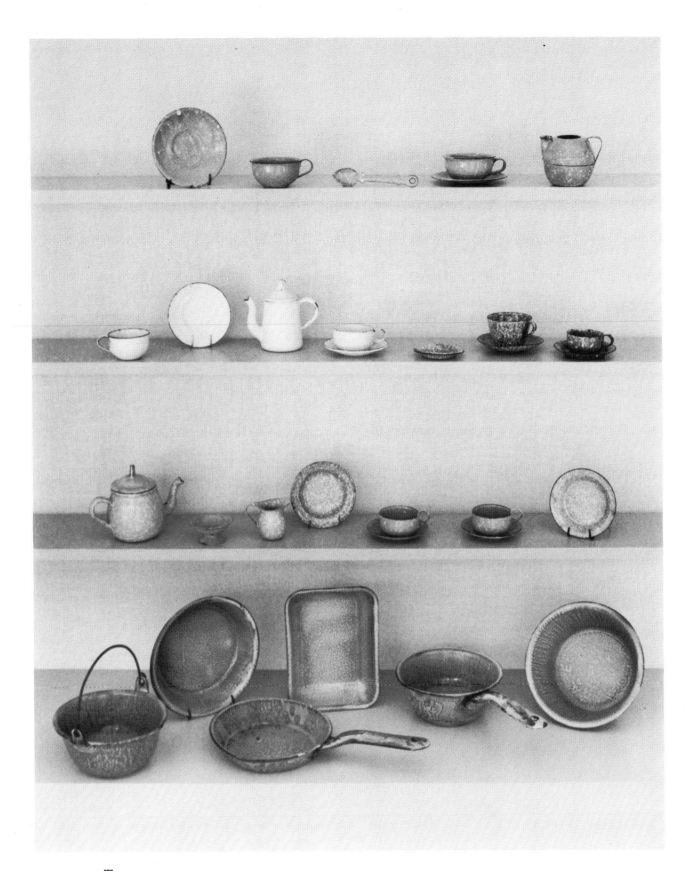

Toys

Row 1: Blue and white tea set, teapot lid missing, $35. **Row 2:** White teapot, 2¾" tall, two cups and saucers, $35. Gray plate, size of 25¢ piece, $8. Cup and saucer, Mint, $28.50. Small gray cup and saucer, $7.50. **Row 3:** Gray tea set—Pekin teapot with strap handle, pedestal sugar bowl, creamer, two plates, two cups and saucers, Mint, $125. **Row 4:** Domestic Science cook set, six pieces, complete —preserve kettle with bail, cake pan, 5" frying pan with 4" handle, baking or roasting pan, long-handled saucepan, pudding pan, Mint, $65.

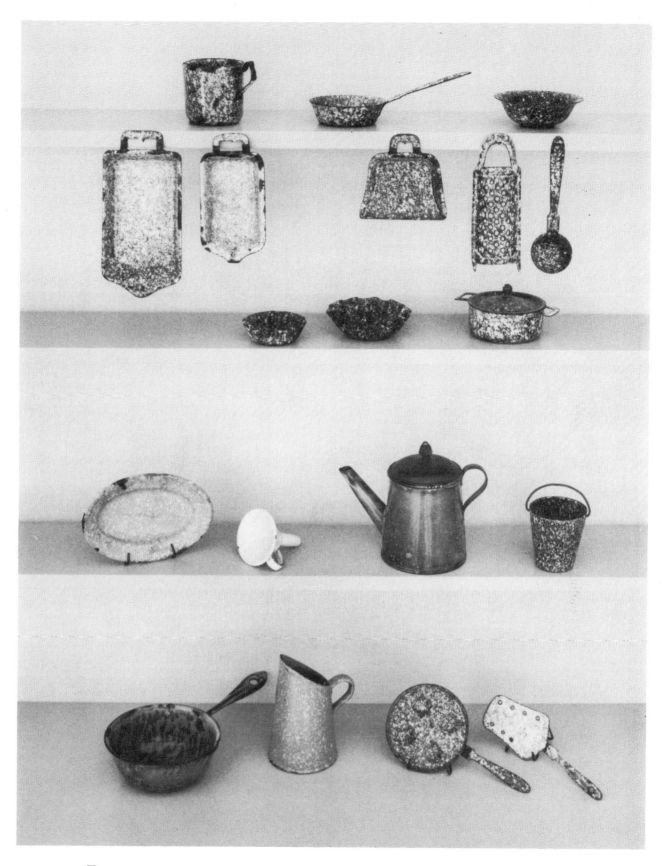

Toys

Row 1: Mug, $10. Saucepan, $12.50. Wash basin, $10. **Row 2:** Large roast pan, $10. Small roast pan, $10. Dustpan, $15. Grater, $6-20. Strainer ladle, $12. **Row 3:** Fluted mold, $10. Fluted mold, $10. Covered saucepan, $12.50. **Row 4:** Oval platter, $7.50. White funnel, $6. Teapot, tin lid, wood knob, very old, $37.50. Water pail, $10. **Row 5:** Saucepan, child size, very old, $10. Pitcher, $12.50. Egg pan, $15. Turner, $12.50.

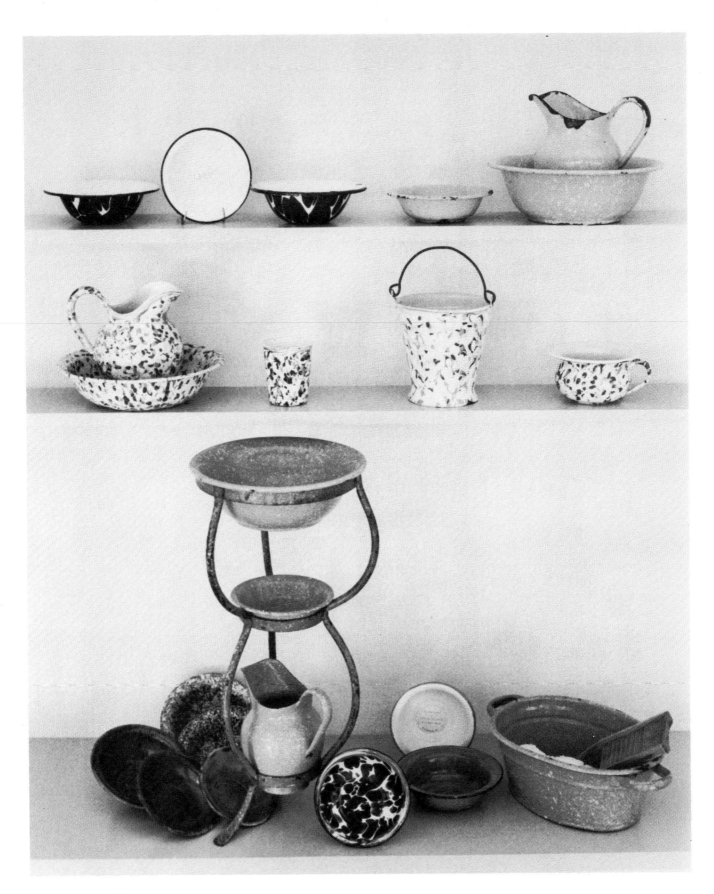

Toys

Row 1: Three enameled basins, signed "Lisk," $17.50 each. Blue soap dish, bowl and pitcher, $77.50.
Row 2: Wash set composed of bowl, pitcher, tumbler, waste chamber and potty, blue-green spatter, $175. *Row 3:* Assortment of basins—blue, brown, gray, white and blue-green, $6-17.50 each. Gray enameled iron washstand, complete with bowl, pitcher and soap dish, 14" high, $175. Wash tub, $25.

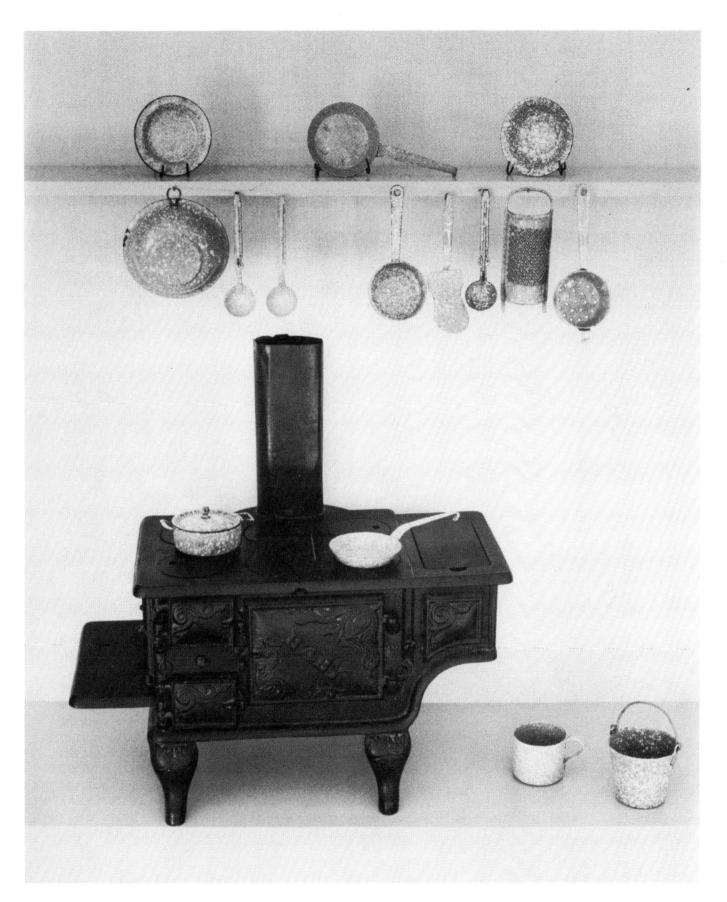

Toys

Gray and white speckled toy set: two plates, egg fry pan, basin, two ladles, saucepan, pancake turner, strainer, grater, gravy strainer, kettle, fry pan, mug and water bucket, Mint, $225. "Baby" range, cast iron.

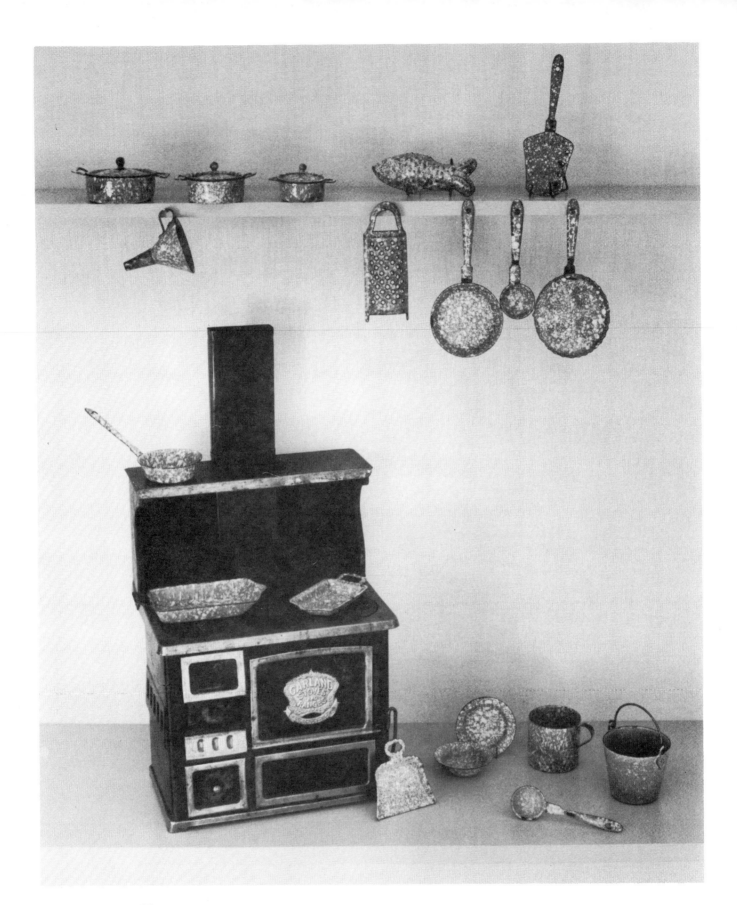

Toys

Complete gray toy cook set, twenty-one pieces: three covered saucepans (covers counted), fish mold, pancake turner, funnel, grater, fry pan, strainer ladle, egg fry pan, saucepan, large roaster pan, small roaster pan, dustpan, wash basin, plate, cup, bucket and dipper, $250. Stove signed "Garland Stoves and Ranges."

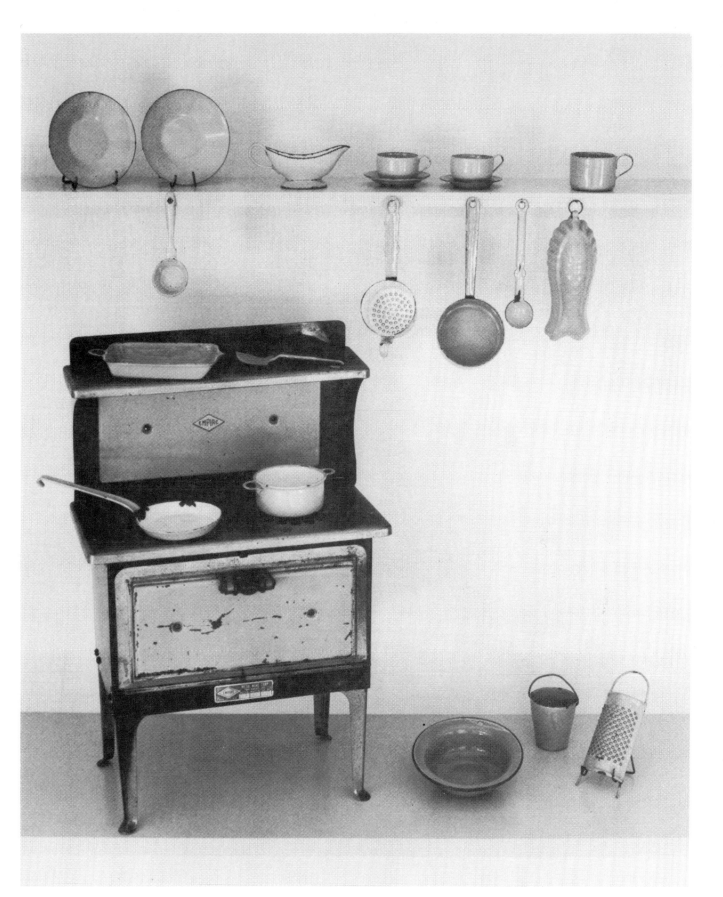

Toys

Blue toy cook set, twenty pieces: two 3½" plates, gravy boat, two cups and saucers, mug, dipper, strainer, fry pan, soup ladle, fish mold, roaster pan, pancake turner, hook handle fry pan, saucepan, wash basin, water pail and grater, $250. Blue "Empire" electric toy range.

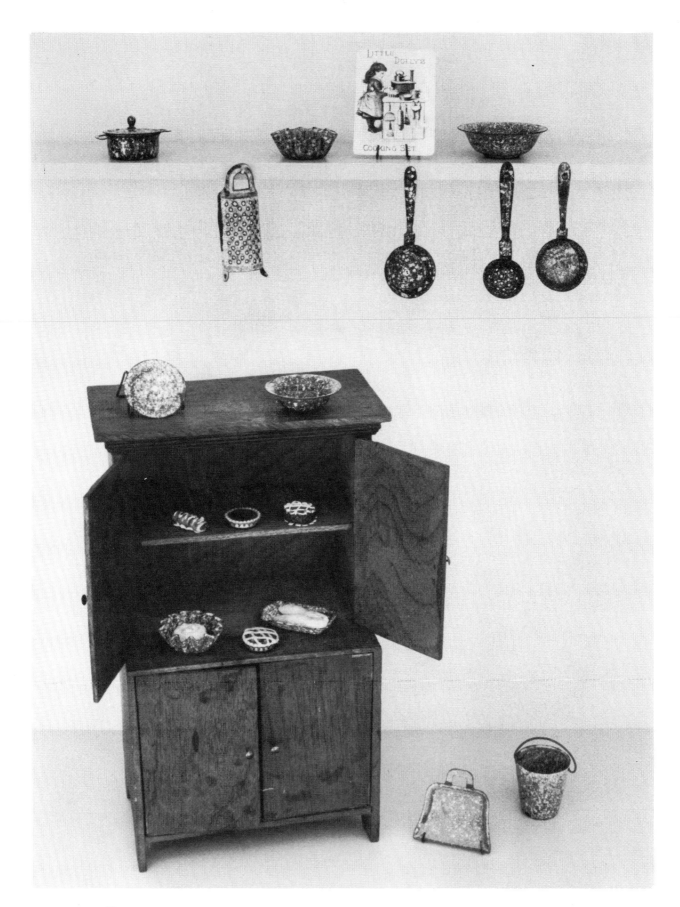

Toys

Toy set, dark blue and white, fourteen pieces: covered saucepan, mold, basins, grater, fry pans, strainer, plate, roaster, dustpan and water pail, $120. 75-year-old toy cupboard made from cigar boxes.

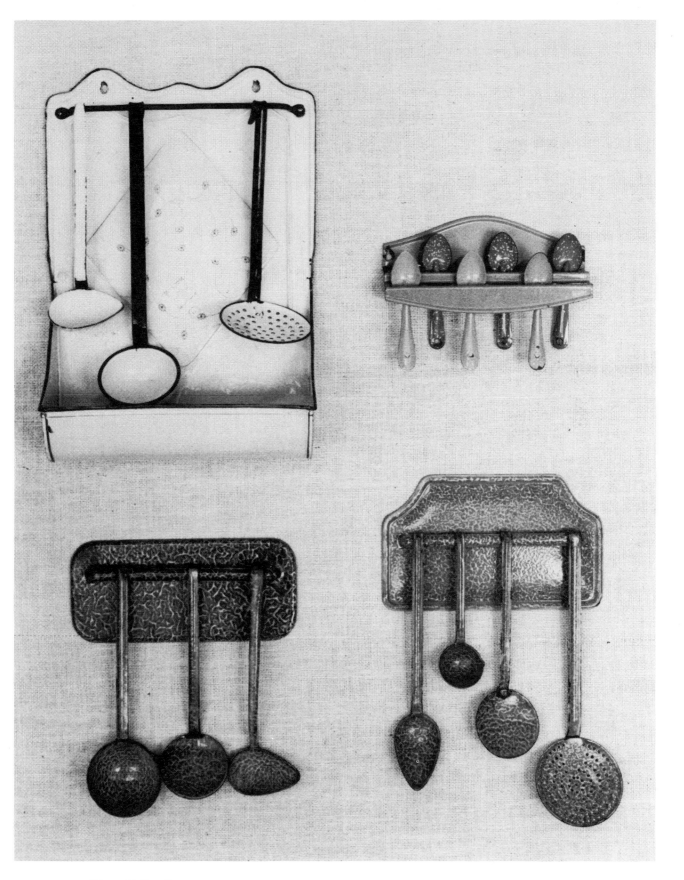

Utensil Racks

Row 1: Blue and white rack, utensils not part of set, $95. Blue spoon rack with two rows of six slots, new spoons, $65. *Row 2:* Rack with ladle, skimmer and basting spoon, $95. Rack with spoon, gravy ladle, skimmer and pierced skimmer, $95.

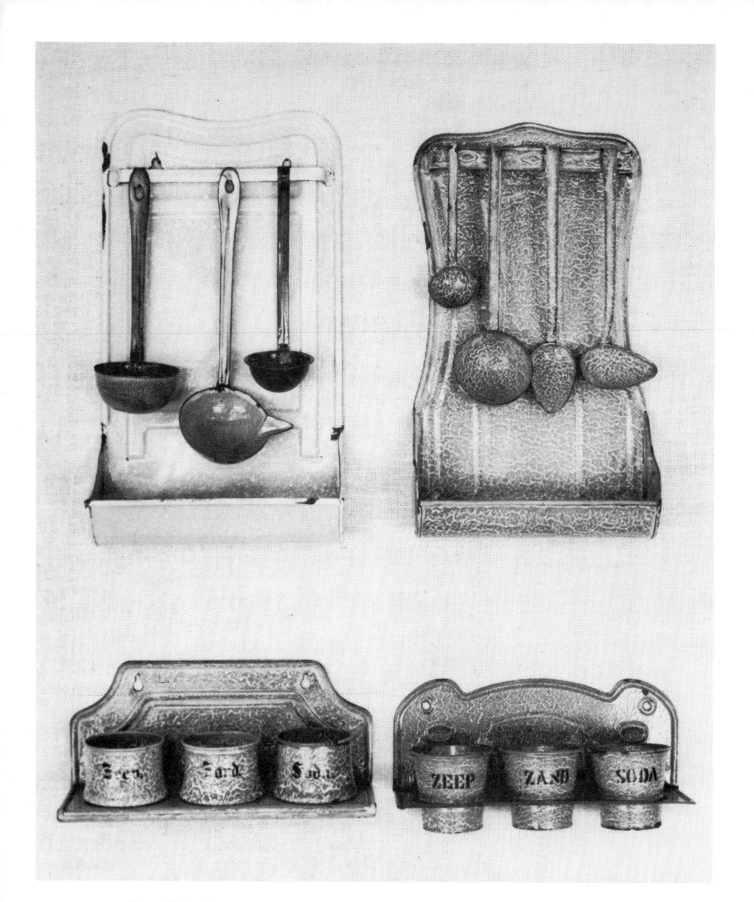

Utensil Racks

Row 1: Gray utensil rack, ladles not part of set, rack only, $85. Ladle, $15. "Agate L & G" snipe lip ladle, signed, $22.50. "Agate" flaring dipper, $12.50. Rack with three original utensils, $200. Gravy ladle, $28. *Row 2:* Utility rack, Mint, Dutch—"Zeep, Zand, Soda," $65. Utility rack, Dutch, holds soap, sand and soda. $55.

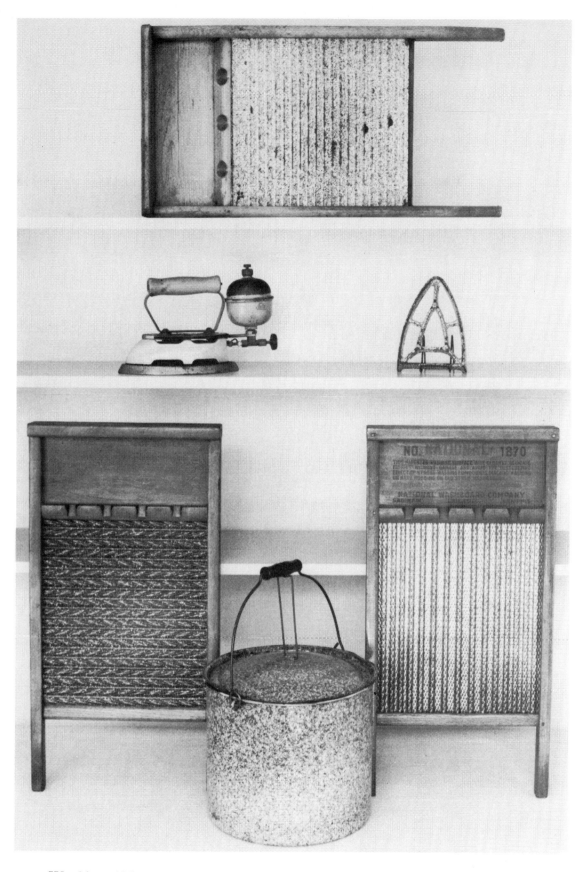

Washing Aids

Row 1: *Gray scrub board, $25.* ***Row 2:*** *Bright blue gasoline iron, $18-27.50. Gray enameled iron trivet, $12.50.* ***Row 3:*** *Dark blue enameled washboard, Mint, $17.50. Brown canning kettle, metal stand holds wood bail, rack inside, $15. Back view of enameled washboard, tin surface for delicate fabrics, $17.50.*

Washing Aids

Row 1: Vaporizer, $50. Clothes boiler with lid, $75. 1-cup measure, labeled "Primo," embossed "For Household Use Only," $35. **Row 2:** Washboard, $50. Water heater, $225.

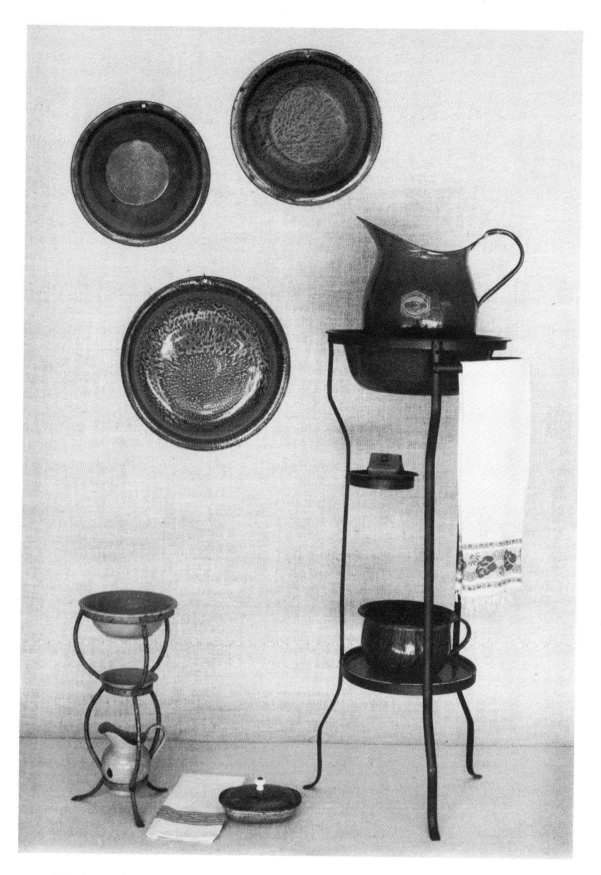

Washstands

Row 1: *9" basin, $15. 10" basin, $10. 12" basin, $15.* ***Row 2:*** *Toy enameled iron stand with basin, soap dish and pitcher, $175. Covered soap dish, knob not original, $25. Metal stand with "Hoosier"-labeled pitcher, $37.50. Basin, $22.50. Soap dish, $15. Chamber, $12.50.*

Bibliography

Atwater, Helen W. "Selection of Household Equipment." *Yearbook, Department of Agriculture,* 1914.

Bland, Ann S. "Graniteware Helped to Win the West." *The Spinning Wheel,* vol. 34, no. 7 (September 1978).

Booher, Fred and Rose. *Graniteware.* Paducah, Kentucky: Collector Books, 1977.

Compton's Encyclopedia, 1971 ed., s.v. "enameling" and "iron."

Cosentino, Geraldine, and Stewart, Regina. *Kitchenware, A Guide for the Beginning Collector.* Racine, Wisconsin: Western Publishing Co., 1977.

Franklin, Linda Campbell. *From Hearth to Cookstove.* Florence, Alabama: House of Collectibles, Inc., 1976.

Harris, Gertrude. *Pots and Pans, Etc.* San Francisco: 101 Productions, 1975.

Hibbard, Spencer and Bartlett Company Catalog. Chicago, Illinois, 1903.

Horton, Gilmore, McWilliams and Company Catalog. Chicago, Illinois, 1903.

Household Discoveries and Mrs. Curtis's Cook Book. New York: Success Company, 1908.

Kovel, Ralph and Terry. "Granite Kitchenware." *The Spinning Wheel,* vol. 25, no. 5 (June, 1969).

Lalance and Grosjean Manufacturing Company Catalog. New York: Macgowan and Slipper, 1894.

Lalance and Grosjean Manufacturing Company Price Catalog. New York, 1903.

Lalance and Grosjean Manufacturing Company. "Enamel Cooking and Sanitary Wares for Domestic Use." New York, Chicago: Bartlett Orr Press, 1922.

Lantz, Louise K. *Old American Kitchenware 1725-1925.* Camden and New York: Thomas Nelson Inc. and Hanover, Pennsylvania: Everybodys Press, 1970.

Leonard, J. W. *Industries of St. Louis.* St. Louis, Missouri: J. M. Elstner and Company, 1887.

Lifshey, Earl. *The Housewares Story.* Chicago, Illinois: National Housewares Manufacturers Association, 1973.

List Manufacturing Company, Limited, Catalogue No. 23. Canandaigua, New York, 1923.

Longwell, Chester R.; Knopf, Adolph; Flint, Richard F. *Outline of Physical Geology.* Washington, D. C.: John Wiley and Sons, Inc., 1944.

National Enameling and Stamping Company Catalog. New York, 1910.

Reed Manufacturing Company Catalogue No. 12. Rochester, New York: The Du Bois Press.

Republic Metalware Company Catalog. Buffalo, Chicago, New York, 1909.

Republic Stamping and Enameling Company. *Revised Schedule of Prices for 1916.* Canton, Ohio.

Strong Manufacturing Company. *Enameled Ware.* Cleveland: Artcraft.

Thompson, Frances. *The Enchantment of Enameled Cook Ware.* Kermit, Texas: Collector's Weekly, 1974.

U. S. Department of Commerce, Patent and Trademark Office, Deputy Director, Washington, D. C. Stümer, Charles, of New York, N. Y. *Improvement in Enamels for Iron.* Patent No. 5,681, July 25, 1848.

Revised Price Guide

The prices shown reflect the effect of condition, scarcity, and color on granite ware prices.

Page 28
Row 1: $30
Row 2: $35
Row 3: $17.50, $17.50, $17.50
Row 4: $75, $12, $75, $65
Row 5: $12, $125, $65

Page 29
Row 1: $47.50, $47.50, $125, $45, $200
Row 2: $165, $20, $195, $65
Row 3: $75, $200

Page 30
Row 1: $47.50, $45
Row 2: $17.50, $200
Row 3: $25, $175, $37.50

Page 31
Row 1: $45, $35, $65
Row 2: $55, $20, $55
Row 3: $125, $75, $35
Row 4: $85, $75, $50, $39

Page 32
Row 1: $47.50, $15
Row 2: $7.50 to $20, $45
Row 3: $125, $15, $10
Row 4: $45, $75, $37.50

Page 33
Row 1: $45, $42.50, $45, $45, $35, $45
Row 2: $45, $75, $45, $30, $35
Row 3: $25, $35, $45, $25, $17.50, $45

Page 34
Row 1: $25, $75, $65, $95
Row 2: $95, $125, $125, $95
Row 3: $165, $165, $125, $75
Row 4: $150, $25, $95, $150

Page 35
Row 1: $65, $75, $75, $25 each
Row 2: 125, $37.50, $100
Row 3: $200, $135, $15 each

Page 36
Row 1: $35, $35, $45, $35, $100
Row 2: $30, $50, $30, $30
Row 3: $35, $45, $75
Row 4: $45, $50, $45

Page 37
Row 1: $45, $25, $45, $50, $35
Row 2: $45, $45, $45
Row 3: $50, $45, $60
Row 4: $65, $45, $65

Page 38
Row 1: $95, $65, $75, $95, $95
Row 2: $100, $100, $45, $35, $45
Row 3: $35, $75, $95, $45
Row 4: $45, $45, $65, $45, $100

Page 39
Row 1: $25, $35, $20
Row 2: $15, $25, $15
Row 3: $15, $15, $25
Row 4: $65, $65, $65

Page 40
Row 1: $25, $20, $25
Row 2: $25, $25, $20
Row 3: $30, $45, $35, $25, $35
Row 4: $25, $10
Row 5: $25, $20

Page 41
Row 1: $12, $10, $12, $15, $10, $12, $12
Row 2: $12, $12, $12, $3, $10, $3, $3
Row 3: $15, $15, $35, $15, $12, $12
Row 4: $12, $15, $12, $35, $12, $12
Row 5: $12, $12, $20, $15, $15, $60 set of 6

Page 42
Row 1: $65, $65
Row 2: $65, $60
Row 3: $45, $40
Row 4: $35, $35

Page 43
Row 1: $65 each
Row 2: $65, $60, $65
Row 3: $75, $75
Row 4: $65, $75

Page 44
Row 1: $25
Row 2: $65, $15, $45, $25, $30
Row 3: $20, $25, $15, $15, $25
Row 4: $75, $75, $15, $25, $45
Row 5: $20, $25, $25, $25, $30

Page 45
Row 1: $175, $75
Row 2: $55, $75, $75, $55, $75
Row 3: $125, $125
Row 4: $195, $125

Page 46
Row 1: $65, $125
Row 2: $55, $75, $75, $75
Row 3: $95, $75 each
Row 4: $225, $175, $125

Page 47
Row 1: $30 pair, $75
Row 2: $15, $15, $10 each, $10, $25
Row 3: $10 each, $10, $25
Row 4: $9, $10, $10, $75 pair

Page 48
Row 1: $45, $30, $50
Row 2: $37.50, $15, $25, $35
Row 3: $15, $15
Row 4: $25 each, $35

Page 49
Row 1: $35
Row 2: $45, $25
Row 3: $65, $35, $45, $65

Page 50
Row 1: $20, $20
Row 2: $25, $20, $20, $25, $25
Row 3: $20, $35
Row 4: $45, $15, $45
Row 5: $20, $15, $35, $25

Page 51
Row 1: $25, $25
Row 2: $100, $100
Row 3: $20, $100
Row 4: $20, $25, $45, $15, $25, $25

Page 52
Row 1: $20, $45
Row 2: $25, $65, $45, $55 each
Row 3: $20, $45
Row 4: $20, $25, $25, $25, $45, $25, $65

Page 53
Row 1: $2 to $10 each, $10
Row 2: $25, $15
Row 3: $25 each, $5 to $20 each

Page 54
Row 1: $39, $45, $65
Row 2: $35, $20
Row 3: $50, $10 each

Page 55
Row 1: $20, $150, $20, $20
Row 2: $25, $20, $20, $35, $35
Row 3: $30, $15, $25
Row 4: $35, $75, $195, $45

Page 56
Row 1: $50, $29, $45, $35
Row 2: $55, $50, $45, $95
Row 3: $45, $65, $45

Page 57
$6 to $15 each, $15 to $50 each, $4 to $10 each

Page 58
$4 to $10 each, $4 to $10 each, Toy roaster $175

Page 59
Row 1: $100
Row 2: $6 to $15 each
Row 3: $6 to $10, $15 to $50, $6 to $10
Row 4: $75, $15 to $50, $6 to $15

Page 60
$6 to $15 each

Page 61
$35, $25 each, $10, $75, $6 to $15 each

Page 62
$8 to $20 each

Page 63
Row 1: $200
Row 2: $350
Row 3: $200

Page 64
Row 1: $65, $35
Row 2: $150
Row 3: $50, $150

Page 66
$600 to $1,500

Page 67
$350, $35, $50, $400, $150, $75, $15

Page 68
Row 1: $85, $10, $35, $8, $65, $20, $65, $85, $45
Row 2: $25, $65, $75, $25, $25, $95, $35, $15, $10, $20
Row 3: $35, $400, $10, $45, $50, $25, $95, $35

Page 69
Row 1: $35, $15, $25, $65, $8, $20, $25, $45, $10, $20, $45
Row 2: $8, $25, $15, $12, $65, $25, $20, $15
Row 3: $15, $10, $10, $200, $8, $10, $20, $10, $25, $3, $12, $45, $75

Page 70
Row 1: $125, $100, $125, $125, $65
Row 2: $150, $225, $250, $200
Row 3: $750 set, $100
Row 4: $225, $200, $225, $150

Page 71
$750, $65, $200

Page 72
Row 1: $95
Row 2: $225
Row 3: $195
Row 4: $250
$75, $30, $175

Page 73
Row 1: $75 each, $85, $15
Row 2: $25, $10, $15, $25

Page 74
Row 1: $15, $50, $25 each
Row 2: $45, $65, $25, $6
Row 3: $15, $65, $25, $25, $15
Row 4: $100, $45, $100, $45

Page 75
Row 1: $65, $45, $65, $45, $65
Row 2: $35, $45, $35, $35, $20
Row 3: $35, $35, $35, $35, $35
Row 4: $35, $45, $45, $45

Page 76
Row 1: $45, $35, $15, $15, $25
Row 2: $45, $35, $35
Row 3: $35, $45, $45, $65, $65
Row 4: $55, $50, $65

Page 77
Row 1: $65 each
Row 2: $65, $65, $45, $45, $65
Row 3: $65, $45, $25, $30, $65
Row 4: $75, $95, $40, $75, $75

Page 78
Row 1: $65, $35, $45, $45, $35
Row 2: $100 each
Row 3: $65 each
Row 4: $100, $50, $100, $100
Row 5: $45, $15, $15
Row 6: $35, $65, $15

Page 79
Row 1: $10, $45, $15
Row 2: $65, $95, $65, $3
Row 3: $85, $100 each, $135
Row 4: $45, $10, $95

Page 80
Row 1: $100 each
Row 2: $100, $45, $25, $45, $25
Row 3: $175

Page 81
Row 1: $125, $600, $400
Row 2: $75
Row 3: $200, $125, $300

Page 82
Row 1: $65, $140 set, $95
Row 2: $125, $25, $75 set, $25, $25
Row 3: $10, $20, $65, $200 set
Row 4: $65, $35, $50, $48, $25, $65, $20, $20

Page 83
Row 1: $150 each, $50 each
Row 2: $175 each, $50, $40, $35
Row 3: $35, $35, $35
Row 4: $35, $45, $35

Page 84
Row 1: $12 each
Row 2: $60, $50, $45
Row 3: $60, $75, $50
Row 4: $50, $65, $50

Page 85
Row 1: $15, $35, $35
Row 2: $40, $45, $45
Row 3: $35 each

Page 86
Row 1: $35, $15, $25
Row 2: $45, $35, $25
Row 3: $35, $25, $45

Page 87
Row 1: $49, $50, $45
Row 2: $20, $75, $20
Row 3: $25, $35, $35

Page 88
Row 1: $150 each
Row 2: $25, $40, $25
Row 3: $40, $40, $25, $40

Page 89
Row 1: $150, $40, $150
Row 2: $25, $100
Row 3: $50, $65, $25

Page 90
Row 1: $45, $50, $45
Row 2: $50, $35, $35, $35
Row 3: $25, $40

Page 91
Row 1: $125, $100, $200
Row 2: $600 each
Row 3: $350, $100, $275, $225

Page 92
Row 1: $175, $150, $250, $200
Row 2: $750 Tea Set, $175, $125
Row 3: $200, $200, $600, $250, $250

Page 93
Row 1: $200, $125, $175, $175, $125
Row 2: $225, $250, $250, $175
Row 3: $100, $175 each, $175 each
Row 4: $750 set, $750 set, $400

Page 94
Row 1: $200, $175
Row 2: $195, $150, $200
Row 3: $175, $400, $175, $400

Page 95
Row 1: $250, $200, $250
Row 2: $200, $175, $175
Row 3: $200 each

Page 96
Row 1: $100 each, $85 each, $55 each, $85 each, $100 each
Row 2: $125, $65
Row 3: $75, $95

Page 97
Row 1: $75, $35, $45, $45, $15
Row 2: $45, $65, $55, $55
Row 3: $50, $30, $25, $50
Row 4: $50, $75, $30, $65

Page 98
Row 1: $65, $35, $65, $200
Row 2: $90, $75, $30, $15
Row 3: $15, $10, $20
Row 4: $35, $95, $45

Page 99
Row 1: $25, $25, $25
Row 2: $20, $50, $35
Row 3: $20, $3, $100, $100, $175

Page 100
Row 1: $15, $12, $10, $9, $9, $12
Row 2: $29, $15, $30, $10, $5
Row 3: $120, $20, $15, $12

Page 101
Row 1: $29 each
Row 2: $25, $25, $15
Row 3: $15 each
Row 4: $20, $45, $45
Row 5: $25, $45, $25
Row 6: $40, $25, $35

Page 102
Row 1: $10, $15, $10
Row 2: $25, $15, $12
Row 3: $15, $20, $12
Row 4: $12, $12, $15

Page 103
Row 1: $35, $15, $24
Row 2: $15, $5, $15
Row 3: $25, $9, $15
Row 4: $12 each

Page 104
Row 1: $40, $45, $45
Row 2: $35, $35, $45
Row 3: $45, $60, $45
Row 4: $25

Page 105
Row 1: $35, $35
Row 2: $45, $35
Row 3: $40, $45

Page 106
Row 1: $175, $75
Row 2: $95
Row 3: $50, $125

Page 107
Row 1: $120
Row 2: $45, $120
Row 3: $95, $95, $90

Page 108
Row 1: $95, $60
Row 2: $95, $25

Page 109
Row 1: $10, $65
Row 2: $95, $75
Row 3: $10, $12, $25
Row 4: $75, $10

Page 110
Row 1: $50, $95, $65
Row 2: $75, $100, $95
Row 3: $65, $65, $50, $65
Row 4: $75, $50, $65, $65, $50

Page 111
Row 1: $65, $50
Row 2: $50, $60, $50
Row 3: $95, $95, $65
Row 4: $65, $65

Page 112
Row 1: $15, $15, $35, $25
Row 2: $35, $15, $25, $25
Row 3: $25, $15, $15

Page 113
Row 1: $25, $35, $25, $25
Row 2: $65, $29, $35, $35

Page 114
Row 1: $35, $35, $29, $35
Row 2: $35, $35, $65

Page 115
Row 1: $15, $25, $25
Row 2: $35, $45
Row 3: $35, $35, $40

Page 116
Row 1: $300, $225, $200
Row 2: $100, $125, $175, $35

Page 117
Row 1: $45, $125
Row 2: $85, $125

Page 118
Row 1: $35, $65, $25
Row 2: $50, $50, $35
Row 3: $95, $125, $95

Page 119
Row 1: $35, $37.50, $37.50, $49
Row 2: $35, $39, $35 each, $35
Row 3: $50, $75, $75, $100
Row 4: $45, $85, $55, $39

Page 120
Row 1: $45, $100 each, $45
Row 2: $35, $15, $125, $95, $35
Row 3: $45, $35, $35, $45, $50, $45
Row 4: $45, $37.50, $95, $45

Page 121
Row 1: $25, $8, $15, $8
Row 2: $20, $65, $45
Row 3: $20, $85, $25, $45
Row 4: $20, $45, $35, $85

Page 122
Row 1: $65
Row 2: $75, $30, $95, $35, $25
Row 3: $25, $75

Page 123
Row 1: $12, $15, $35, $35 each
Row 2: $35, $27.50, $25, $25, $55, $55
Row 3: $35, $30, $75, $75
Row 4: $35, $35, $35, $25, $20
Row 5: $75, $55, $75, $75, $45
Row 6: $35, $35, $25

Page 124
Row 1: $125
Row 2: $75, $20, $45, $30
Row 3: $300
Row 4: $195

Page 125
Row 1: $15, $35, $35
Row 2: $35, $25, $55, $75, $35
Row 3: $35 each
Row 4: $20, $15, $75, $45
Row 5: $25, $50, $45, $35

Page 126
Row 1: $30 each, $100 set
Row 2: $300 set
Row 3: $30 each, $300 set, $65

Page 127
$500 set

Page 128
$700 set

Page 129
$500 set

Page 130
$450 set

Page 131
Row 1: $150, $95
Row 2: $135, 135

Page 132
Row 1: $120, $20, $45, $15, $300 set
Row 2: $100, $80

Page 133
Row 1: $50
Row 2: $35, $45
Row 3: $60, $30

Page 134
Row 1: $75, $135, $45
Row 2: $65, $225

Page 135
Row 1: $20, $20, $25
Row 2: $300, $65, $100, $35, $35, $30